Michael J. Lewis is Associate Professor at the Department of Art, Williams College, Massachusetts. He teaches and lectures on art, architecture and culture throughout the United States, and is a regular contributor to *The New Criterion* and *Commentary*. His previous books include an award-winning study of August Reichensperger and a monograph on Frank Furness.

Thames & Hudson world of art

This famous series provides the widest available range of illustrated books on art in all its aspects.

If you would like to receive a complete list of titles in print please write to:

THAMES & HUDSON
181A High Holborn
London WC1V 7QX

In the United States please write to:

THAMES & HUDSON INC.
500 Fifth Avenue
New York, New York 10110

Printed in Singapore

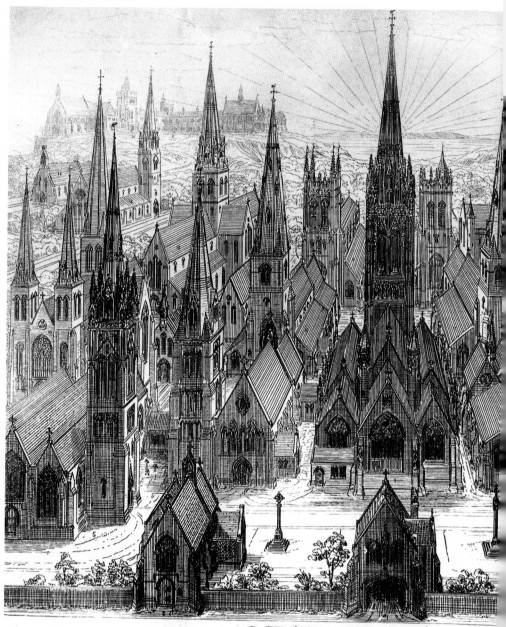

⚜ THE PRESENT REVIVAL OF CHRISTIAN ARCHITO

Michael J. Lewis

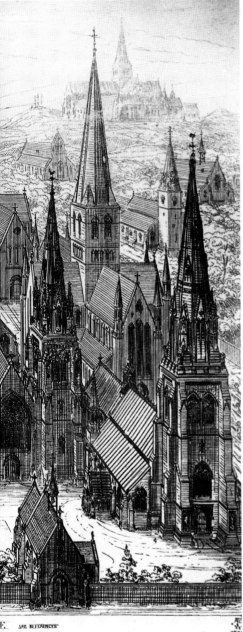

The Gothic Revival

181 illustrations, 33 in color

Thames & Hudson world of art

For Susan,
esto perpetua

1 (title page) A. W. N. Pugin's frontispiece from *An Apology for the Revival of Christian Architecture*, 1843

© 2002 Thames & Hudson Ltd, London

First published in paperback in the United States of America in 2002 by Thames & Hudson Inc., 500 Fifth Avenue, New York, New York 10110

thamesandhudsonusa.com

Library of Congress Catalog Card Number 2001094769
ISBN 0-500-20359-8

Printed and bound in Singapore by C.S. Graphics

Contents

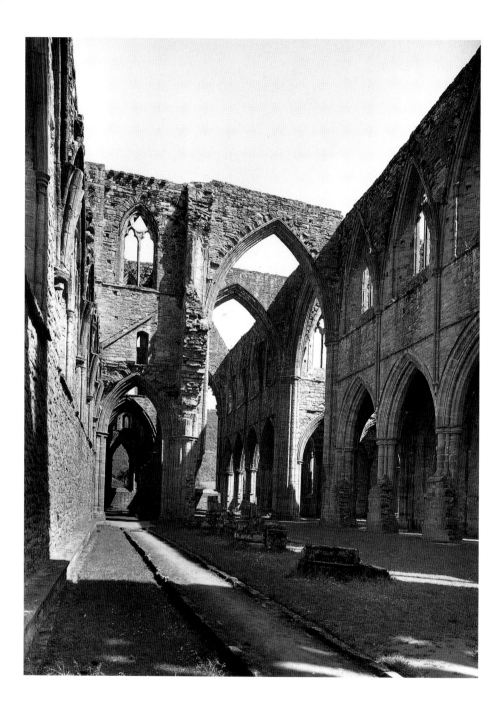

Introduction

When Kenneth Clark wrote his splendid *Gothic Revival* in 1928, he subtitled it 'An Essay in the History of Taste'. Indeed, in the history of taste and fashion, the revival forms an astonishing chapter. A style of architecture that stood condemned for three centuries as the apex of barbarism and irrationality was rehabilitated – at first playfully, then seriously and finally dogmatically. Within a lifetime, a semi-ludicrous garden novelty was solemnly authorized as the style of the English Houses of Parliament, then the governing centre of the world's most powerful economic and political power. But the Gothic Revival is rather more than a fashion craze for pointed arches and pinnacles. During its years of greatest influence, it subjected every aspect of art, belief, society and labour to intense intellectual scrutiny, using the Middle Ages as a platform from which to judge the modern world.

This seems a considerable burden to place on the back of what was, after all, just a style of architecture. But the Gothic always stood for ideas larger than itself. The eighteenth century admired it for its suggestive quality of decay and melancholy, the early nineteenth century for the religious piety it expressed, the late nineteenth for its superb engineering. In the course of the revival the Gothic was attached to social movements of every sort – from political liberalism to patriotic nationalism, from Roman Catholic solidarity to labour reform. Like Marxism, which also drew lessons from medieval society, the Gothic Revival offered a comprehensive response to the dislocations and traumas of the Industrial Revolution. In the broadest view, it is the story of Western civilization's confrontation with modernity.

It is easy to see why the Gothic exerted such a lasting hold on the Western mind, for there is no architectural experience comparable to that of stepping into a High Gothic cathedral, an intricate canopy of stone vaults suspended far overhead, morning light blazing through its coloured glass windows. In structural terms – in the ability to enclose a maximum amount of space with the least amount of material – it is the most efficient system of stone masonry ever devised. The Gothic originated in the Ile-de-France, in northwestern France, in the years around 1140, a time

2 Tintern Abbey, Monmouthshire, twelfth century. The Gothic had a special cultural meaning in England which, more than any country in Europe, was shaped by monasteries. Their looted and crumbling hulks suggested a vanished civilization, exerting a hold on the imagination like that of classical ruins in other places. For Romantic painters, the high roofless arcades of Tintern Abbey became a favourite subject.

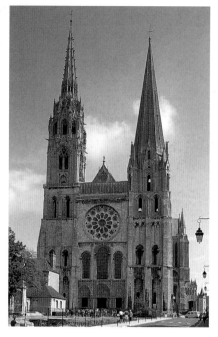

3 Flying buttresses at Mont-Sant-Michel. For the rational architects of the nineteenth century, such as Eugène Emmanuel Viollet-le-Duc, the bewildering array of buttresses about the apse of a Gothic cathedral was a diagram of structural logic. Each force was exactly matched with an equal and opposing one. Even the finials above, once ridiculed as meaningless flourishes, serve to weigh down the buttresses, giving them additional stiffness.

4 Chartres Cathedral, twelfth century. The architecture of a Gothic cathedral served as a receptacle for every type of decorative art, including painting, stained glass and statuary. Chartres Cathedral preserves its facade and transept sculpture, forming a visible summation of Christian faith. Such communal statements of belief made the cathedral the centre of public life in a medieval town.

of great cultural energy. A series of discrete structural improvements were made to the prevailing Romanesque style of architecture. The round arch of the Romanesque was raised to a point, which was both more widely applicable (there are an infinite number of pointed shapes) and more efficient structurally. The Romanesque groin vault was replaced by the much lighter Gothic ribbed vault. In place of the ponderous walls needed to support a groin vault, flying buttresses were aligned on the exterior to press against the ribbed vaults of the interior, matching the thrust with a countervailing pressure. These channelled the structural load of the lofty vaults directionally, carrying it away from the building as efficiently as drainpipes might carry away excess water. Structural members were placed only where they were needed, producing a truly skeletal architecture.

The highest development of this principle took place in the urban cathedrals of Christian Europe. In them the expressive potential of the new technology was fully realized, the wall dissolving into shimmering screens of glass, separated by the slenderest of piers. In the High Gothic churches of the thirteenth century, such as the royal chapel of Sainte-Chapelle, Paris (1242–47), the limits of Gothic lightness were reached. The Gothic was more than bold engineering: structural elements

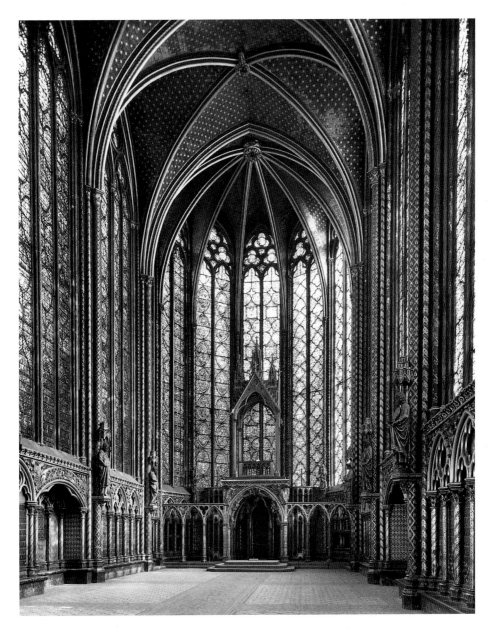

5 Sainte-Chapelle, Paris, 1242–47, is among the
finest of High Gothic buildings, a class which includes
the cathedrals of Amiens, Cologne and Beauvais.
Never again would the Gothic be so insubstantial,
and the architects of the Late Gothic tended to lavish
their energies on ornamental elaboration rather than
structural daring.

were embellished with all the colour and surface enrichment that the decorative arts could provide. In these cathedrals, the orchestration of light, sound and space brought Christian worship to a pitch of spiritual reverie.

This style reigned supreme for nearly four centuries, until the Italian Renaissance revived the architecture of classical antiquity. Then the Gothic came to be disparaged as irregular and savage, mocked by Vasari as the *maniera tedesca*, the 'German style'. He and like-minded critics ignored the invisible logic of Gothic structure. Although it was supremely rational in a technical sense, it did not *look* rational; the sixteenth-century mind saw only the grotesque water-spewing gargoyle. By 1450 pointed arches were out of fashion in Florence, a generation later in Paris, and by the middle of the sixteenth century fashionable Englishmen were building themselves classical manor houses. Still, the Gothic died hard, and Gothic churches were built well into the seventeenth century in parts of Germany and England. Gothic vaulting also persisted for a time, although it was often masked with the decorative forms of the Renaissance. This phenomenon is called Gothic Survival, whose latest examples overlap with the first examples of the revival.

In some cases, Gothic Survival was not mere provincial backwardness, but a matter of deliberate intellectual choice. During the late sixteenth century, following a wave of experimental classicism, Gothic buildings began to appear again in Elizabethan England, and at the highest levels of society. Lord Burghley, Lord High Treasurer of England, remodelled Burghley House along medieval lines, even giving himself a great hall under a lofty hammer-beamed ceiling. Gothic sentiment was strong among the nobility, the church and the universities, such as Cambridge, whose St John's College built a Gothic library in 1624. That these fundamentally conservative institutions were drawn to medieval imagery is not surprising. Each had recently undergone a jolting break with the past – the protestant Reformation, the dissolution of the monasteries and the radical reshaping of England's social order – and desired emblems of continuity, legitimacy and national identity. Such were the great preoccupations of Elizabethan England, and they flare through the historical dramas of Shakespeare.

The religious aspect, mingled with the national, complicated the issue. Classical architecture suggested Italy, France and Spain, all Catholic territories and potential rivals. During the years when fear of Catholicism blazed most strongly, the century

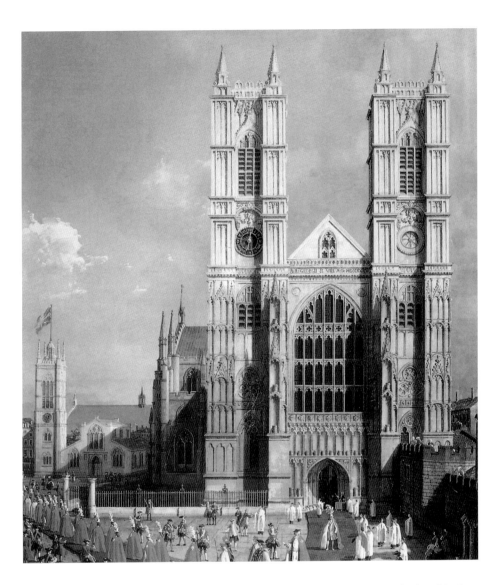

between the Spanish Armada of 1588 and the Glorious Revolution of 1688, the Gothic provided a pleasing emblem of Englishness. Even Christopher Wren's Office of Works, a cockpit of classicism, was able to draw on this living Gothic tradition. As late as 1681 it produced the church of St Mary Aldermary, London, a Gothic basilica complete with a clerestory, traceried windows and fan vaults – alas, a sham construction of plaster.

Not every use of the Gothic was a matter of ideology. In some cases, it was used 'innocently': simply to maintain visual continu-

ity with existing buildings. Wren felt that 'to deviate from the old Form, would be to turn [a building] into a disagreeable Mixture, which no Person of a good Taste could relish.' At Christ Church, Oxford, he built Tom Tower, a rather florid Gothic gatehouse. For the restoration of Westminster Abbey he made designs for a Gothic facade and transept, intending 'to make the whole of a Piece'. Wren also appreciated the structural refinements of the Gothic. At St Paul's, London, the crowning achievement of his classicism, he supported the great barrel vault of the nave with a mighty array of flying buttresses, although these were carefully masked from sight behind a blank second-storey wall. Here was the characteristic seventeenth-century attitude toward the Gothic: respect and admiration for its structural achievements, horror and disgust for its visual forms.

Throughout Europe, similar attitudes prevailed. Damaged or dilapidated cathedrals were patched with simplified Gothic elements, as at Noyon, France in the mid-eighteenth century. In some cases entirely new Gothic elements were designed: Gothic transepts were designed for the cathedral of Saint-Croix in Orleans in the 1620s; a Gothic facade followed in about 1708. This was no provincial outpost, but a major cathedral funded by royal contribution, and the decision to proceed in the Gothic was made personally by Louis XIV. And the quality of the work was uncommonly high, carried out in finely dressed stone, much finer, in fact, than much of the Georgian era that followed it.

At the other side of Europe, the Gothic was likewise enjoying a spirited afterlife. The Bohemian architect Giovanni Santini-Aichel (1677–1723) concocted a richly idiosyncratic blend of Baroque and Gothic forms, reviving the sinuous tracery and web-like vaulting of the late Gothic Parler style. Typically inventive was his pilgrimage church of St John of Nepomuk, Zelená Hora, now in the Czech Republic (c. 1720–). This was Baroque in its pentagonal central plan and undulating walls even as its laminated surfaces and its energetic ribbing were resolutely Gothic. These works and those of Wren represent the culmination of Gothic Survival, requiring just a speck of nostalgia and antiquarian pleasure to tip them over into Revival.

Ironically, even as the Renaissance dislodged the Gothic, it suggested by its own example that a discarded style might, at some distant day, be made to live again. Thus in 1700, just as the Gothic finally vanished as a structural system and a style, it was about to be revived as an idea.

Chapter 1: Literature

My study holds three thousand volumes
And yet I sigh for Gothic columns.
Sanderson Miller, 1750

It is a leap to go from writing poems about ruins to making ruins to represent poems, but in the early eighteenth century England did just this. The Gothic Revival began as a literary movement, drawing its impulses from poetry and drama, and translating them into architecture. It was swept into existence in Georgian England by a new literary appetite for melancholy, horror, gloom and decay. It revelled in the exalted psychological states of Shakespeare's characters, the love of the fantastic and the supernatural in Edmund Spenser and, later, the morbid graveyard poetry of Thomas Gray. All these themes, which stood in opposition to the classical values of clarity and orderliness, came to be associated with the crumbling Gothic landscape of England.

The medieval landscape of England had long been the focus of powerful cultural associations. It was exceptionally rich in its heritage of medieval monasteries and abbeys. Although dissolved and looted by Henry VIII during the protestant Reformation, these decaying monasteries were an essential component of the landscape. The English attitude toward this landscape was unusually reverent. Because of the social history of England – a Norman aristocracy arriving in 1066 to supplant an Anglo-Saxon kingdom – pedigree and dynastic continuity were matters of great symbolic weight. At the same time, England's aristocracy was rural, not urban, and enjoyed an intimate relationship to the land, as it does to this day. When the Puritans ruled England from 1646 to 1660, Tory aristocrats were exiled to their rural estates; barred from public life, many took refuge in antiquarianism, a favourite aristocratic diversion in troubled times. Most estates were built on or near the ruins of monasteries, whose antiquity seemed to offer historical legitimacy to their upstart possessors, albeit of a rather spurious sort. Such is the background to William Dugdale's *Monasticon Anglicanum* (1655), an extravagant compendium of these monasteries produced during

the Puritan interregnum. Wenzel Hollar's superb plates formed a rich sourcebook for the Gothic Revival, even into Pugin's day.

It was one thing to draw and research medieval monasteries; it was quite another to build copies of them. For this to happen required mental adjustments of a traumatic nature. Up to the start of the eighteenth century it was still taken for granted that a building must be beautiful to look at. This meant classical architecture, as revived by the Renaissance and proportioned according to the punctilious method of Vitruvius. In this system Gothic architecture had no place. To admit the merit of Gothic architecture, either one of two things must occur. Either the definition of beauty could be stretched so that the Gothic could be defined as beautiful, or the merit of a building could be seen to reside in values other than beauty. The eighteenth century, though it struggled to do the first, chose the second course. The consequences of this were not restricted to the Gothic Revival and came to affect much of Western culture.

The doctrine which came to compete with beauty as the fundamental end of art was that of associationism. According to this doctrine, a work of art should be judged not by such intrinsic qualities as proportion or form, but by the mental sensations they conjure in the minds of viewers. Such an idea has a long pedigree and it ultimately stretches back to John Locke's *Essay Concerning Human Understanding* (1689), which treated sensory experience as the source of human knowledge. The relationship of this concept to art was stated most succinctly by Richard Payne Knight (1750–1824), whose *Analytical Inquiry into the Picturesque* proclaimed that 'all the pleasure of intellect arise from the association of ideas'. For Knight, the real richness of a work of art was not in the opulence of its materials or elegance of its form but in its limitless capacity to induce thoughts and impressions: 'almost every object of nature or art, that presents itself to the senses, either excites fresh trains and combinations of ideas, or vivifies and strengthens those which existed before.' A wooded landscape might summon agreeable thoughts and memories of childhood picnics; a ruined abbey might call to mind melancholy reflections of the violence of the Middle Ages, or reflections on its piety. Payne Knight's book did not appear until 1805 but it only put into words what had long since become common practice.

The playground for indulging associations was the picturesquely landscaped garden, that essential creation of eighteenth-century English culture. These gardens recreated the rambling irregularity and contrasting scenery found in the

7 Gothic Temple at Shotover Park, Oxfordshire, 1716–17. If the point of a building was to evoke Gothic associations, it could never be crammed too full of Gothic motifs. Tyrrell's Gothic Temple at Shotover Park presented a full panoply of cathedral elements in shorthand form: an arcaded porch slung between two octagonal turrets, a rose window and a lonely finial atop its crenellated gable.

painted landscapes of Claude Lorrain and Salvator Rosa. In their paintings melancholy ruins were indispensable, serving to establish scale and perspectival depth, and in landscaped gardens they did the same. Of course, while Claude's ruins were classical, those of the English countryside were medieval. Thus from an early date the English landscaped garden introduced medieval vignettes among its classical pavilions. Some of these consisted of remodelled or altered monastic ruins while others consisted of entirely new buildings in the 'Gothick' style. Such lighthearted structures posed no menace to the classical tradition, which always tolerated grotesqueness in the Saturnalia of the garden. (The spelling 'Gothick' was gradually replaced by 'Gothic' in the 1750s. In the nineteenth century, 'Gothick' came to stand for any Gothic Revival building that was particularly naïve, flimsy or historically incorrect.)

One of the first of these new buildings was the solitary Gothic Temple built for Colonel James Tyrrell at Shotover Park,

Oxfordshire, in 1716. This was a modest arcaded loggia, which faced Tyrrell's manor house across a small lake, each structure offering a view of the other. Its function was purely scenographic: a flat frontispiece set among the trees as a picturesque accent. Its rose window lit no usable space and its crenellations sheltered no crouching archers. Only its Gothic details were novel while in every other respect, even in name, it was classical. With such amiable works the Gothic tiptoed back into Western culture through that most unguarded aperture, the garden.

Many of these early Gothic garden buildings were shoddily built in impermanent materials; they were fashioned by amateurs who knew little of design and even less of archaeology. But to mock these pavilions, gazebos and artificial ruins as architecture, as the nineteenth century came to do, misses the point. In them, composition, formal coherence and structural solidity were subordinated to the desired associations. Except for the fact that they were made of brick and stood on the ground, they were closer to book illustration than architecture, with the quality of a freehand sketch. In the communication of ideas their slapdash design was no obstacle; on the contrary, it helped. The worse a building was in architectural terms – its formal repertoire reduced to a few oversized pointed arches, buttresses and pinnacles – the more legible it would be as illustration. In some instances this thinking produced mere cartoons, a mouldering tower or a ruined abbey, often built out of canvas and board as eyecatchers on the fringe of a garden. Such manufactured stage scenery did not yet constitute a Gothic Revival. When they were built there was no more intention of reviving the Middle Ages than the building of a Greek temple meant a return to the worship of Zeus.

The growing cosmopolitanism of the day also cast a new light on Gothic architecture. England's trade ties to the Near and Far East revealed a wealth of architectural traditions that had little to do with the classical orders. Room for these styles was found in landscaped gardens, particularly at Kew, which in the late eighteenth century boasted a Hindu, Moorish and Chinese pavilion. Such structures were often organized in a didactic programme in a garden, which presented the viewer with a choreographed set of views and objects that unfolded sequentially. While these alien pavilions would have exotic associations, medieval structures often conveyed a distinctive political meaning. Tyrrell's Gothic Temple was built just after the Hanoverian king George I ascended the throne in 1714, an event which caused England to brood over questions of national identity. A German-speaking

8 The Gothic Temple, Painshill, Surrey, c. 1745, aroused the ire of Horace Walpole. 'The Goths never built summer houses or temples in a garden,' he complained. (Nor did they build panelled libraries and vaulted art galleries, the anonymous builder of Painshill might have retorted.)

protestant now reigned, while the Catholic Stuarts threatened invasion and rebellion from Scotland: this could not help but throw into doubt every aspect of English religion, nationality and culture. The Gothic assuaged these doubts, providing an assertive and haughty symbol of national independence, untainted by any association with the Roman Catholic courts of Europe, where Baroque taste reigned. The effectiveness of such symbolism depended largely on historical ignorance, of course: ignorance of the French origin of the Gothic and ignorance of its intimate relationship with medieval Catholicism. And a century would pass before this ignorance was dispelled.

Given this lack of basic historical knowledge, English pedants could cheerfully associate the Gothic with semi-legendary figures such as King Alfred or King Arthur. Likewise, they connected it not with Catholic cathedrals but with secular buildings, above all sturdy castles. Such imagery was entertained at the highest levels, up to the throne itself. In 1733 Queen Caroline commissioned the bizarre Merlin's Cave for Richmond Park in Surrey. This rustic little pavilion was a sort of subterranean grotto, whose Gothic arches and vaults were made of unshaped boulders, bark-covered tree trunks and thatched roof. Here was a Gothic for a protestant queen, suggesting nothing of Catholic cathedrals but evoking the Druidical origin of Gothic. Light filtered in from high windows above to fall upon a didactic exhibition of wax figures taken from English history – associating the newly arrived German court with the most ancient of English monarchs.

Merlin's Cave was built by William Kent, the painter and architect to Lord Burlington, the patron of England's neo-Palladians. It is ironic that the first champions of the Gothic should have come from Burlington's circle, which practised a rather narrow and bookish classicism and which cherished the sober and decorous Renaissance classicism of Andrea Palladio. Nonetheless, the same trait that made them susceptible to Palladio – the connoisseur's craving for fashionable novelty – made them sympathetic to the Gothic. At the same time, Burlington's circle consisted of Whigs, who upheld the authority

9 William Kent's Merlin's Cave, Richmond (1733) was an exercize in dynastic grafting, spuriously connecting the Hanoverian kings to Arthurian England at a time when the Stuart pretenders still posed a threat to the throne. The pavilion was as much an exercize in stagecraft as architecture, as the print from *Merlin or the British Inchanter and King Arthur, the British Worthy* (1736) shows, depicting it as a theatrical proscenium, complete with backdrop and cast of Georgian players.

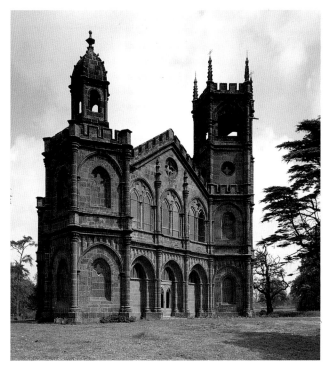

10 James Gibbs, the Temple of Liberty, Stowe, Bucks, 1741. 'I thank God I am not a Roman,' the Temple of Liberty was inscribed, proclaiming Viscount Cobham's disdain for continental absolutism and Catholicism. Ironically, his architect was a Catholic who had trained in Rome.

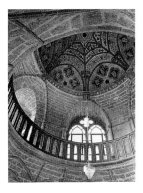

11 Rather than plastering the interior of the Temple of Liberty, Gibbs let its hardy masonry remain bare, a striking gesture in an age that was content with architectural illusionism. Before architects would again learn the expressive power of genuine materials and construction techniques a century would pass.

of Parliament in its struggles with the monarchy. They could argue that the Gothic was just as much a Whig style as a Tory style. The Tory could say that the Gothic was the style of tradition and legitimacy; the Whig could retort that it was also the style of the thirteenth century and the Magna Carta, when the power of the king was checked. Here, at the very outset of the revival, was the first indication of the infinite elasticity of the Gothic, which could be twisted by literary argument into justifying any cause – church or state, people or king, aristocrat or democrat. For the moment, however, it conveyed Englishness, a quality to which both parties were busily staking out a claim.

Kent became the favourite architect for medieval-minded Whigs, most of his work consisting of carefree garden follies, such as those in the garden at Rousham, Oxfordshire (1737–40). At Stowe something more serious was built. This was the Temple of Liberty, built for Richard Temple, the Viscount Cobham. It marks the culmination of the Whig Gothic. Cobham was the champion of the Whig faction in Parliament, standing up for the parliamentary tradition in defiance of continental absolutism. At the peak of his political struggle he built for himself a garden

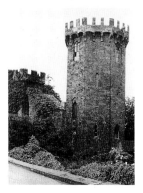

12 Sanderson Miller, Tower at Radway, Warwickshire, 1745–49. Miller's tower established the fad for the inhabitable ruined castle as well as its formulaic programme: the battlemented mass of the tower, a lower volume to offset the vertical and a spur of ruinous wall that trailed from it and died away. This was the minimal number of elements needed, a short story of a ruined castle rather than an epic.

13, 14 Batty Langley, 'The Fifth Order of the Gothick Architecture' and 'An Umbrello for the Centre or Intersection of Walks' (from *Gothic Architecture Improved*, 1741–42). Langley's impeccable draftsmanship set the stage for a century of paper Gothic creations, from which even Pugin, his great opponent, was not immune.

pavilion that represented his position in symbolic terms Unlike other examples, where a few contrived buttresses braced a rickety tower, the Temple of Liberty was a substantial piece of architecture. Its designer was James Gibbs, who had trained in the Baroque of Rome and who had far more feeling for the movement and massing of the Gothic than his paper-bound neo-Palladian rivals, who kept their noses in books. He gave the Temple of Liberty a compact triangular form with robust polygonal bays and richly sculpted blind arches, all executed in handsome sandstone. Its interior was perhaps more impressive, forming a dramatic well of space surmounted by a gallery and a glittering dome at the apex.

Temple's iconography was literary; it included statues of seven Saxon worthies, the motto 'I thank God that I am not a Roman', and even its punning title, 'the Temple of Liberty'. The imagery was a delirious swirl of ideas, a mixed metaphor in which Saxon freedom, Protestantism and the Gothic style were conflated to stand against Catholicism, Roman absolutism and Classicism. Its complex and interlocking programme, like that of an allegorical painting, was just the sort of witty performance the Enlightenment loved.

Gothic nostalgia burned brightly during the reign of the Hanoverian Georgian era. When Squire Sanderson Miller acquired the site at Radway, Warwickshire, overlooking Edge Hill, the culminating battle of the English Civil War – where Charles I was decisively beaten – he treated it as a national shrine.

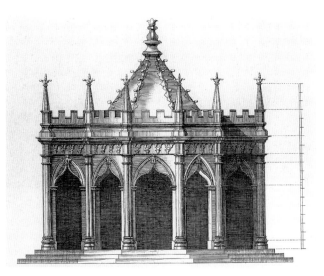

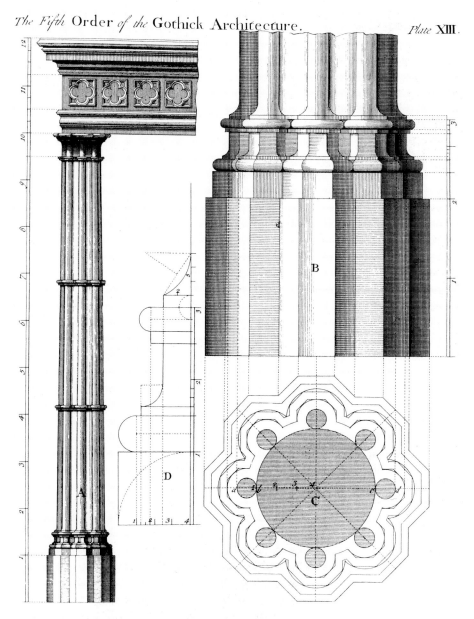

Botty and Thomas Langley Inv. and Sculp. 1741.

He raised an octagonal tower, whose form was loosely based on that of Guy's Tower of Warwick Castle, one of the first instances of an actual historical model being followed for a ruin. Miller's building was built on an agglutinative plan, in which parts were added by accretion and without regard for formal symmetry. This was probably happenstance rather than design. He added a section of wall to the original tower, along with a smaller square tower and a spurious draw-bridge, and clearly liked the results. Soon he was repeating the scheme for his neighbours. One of these was the Tower at Hagley, Worcestershire (1748), one of the first to feature an arcaded wall, a familiar sight from abandoned abbeys and now an essential component of the artificial ruin. Another was designed for the grounds of Lord Hardwicke's estate, Wimpole (although this was built to revised plans in 1768, apparently by the architect James Essex).

With the growing popularity of Gothic houses, a corresponding architectural literature arose. The most notorious entry was by Batty Langley, the enterprising landscape gardener and architectural publicist. In 1742 Langley brought out his eccentric *Ancient Architecture Restored and Improved by a Great Variety of Grand and Useful Designs, entirely New in the Gothick Mode for the Ornamenting of Buildings and Gardens*, reissued five years later as *Gothic Architecture, Improved by Rules and Proportions*. Despite the customary bombastic title, the book was a prim attempt to subject Gothic forms to classical discipline. Langley was a great foe of Palladian architecture but he was nonetheless a classicist through and through, who believed that any architecture worthy of the name was based on 'geometrical rules'. If no Gothic treatises on proportion survived and there was no medieval equivalent of Vitruvius, this was only because the ravages of history had obliterated them. Surely 'there were many ingenious Saxon architects in those times who composed manuscripts of all their valuable rules, which with themselves were destroyed and buried in ruins'. To reconstruct those rules was the burden of Langley's book. He presented five Gothic orders in analogy to the five Vitruvian orders, arranged from most robust to most delicate. He also showed that the proportions of the tiniest mouldings and subdivisions of parts were generated by the diameter of the column base, again like Vitruvius, making the design of a Gothic building a fussy matter of adjusting modules and proportions. This was hardly the Gothic of the great cathedrals, and in fact Langley's proportions were more classical than medieval. Like classical columns, the relationship of height to width was

14

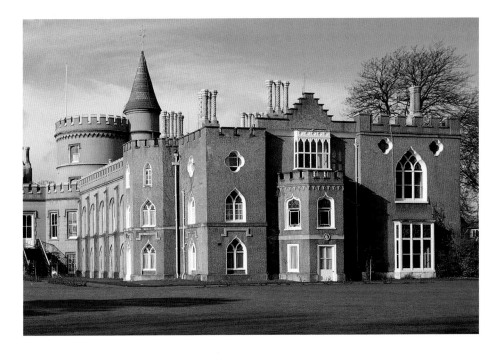

When Walpole announced that
'I am going to build a little Gothic
castle,' his friend Horace Mann
was aghast: 'Why will you make
it Gothic? I know it is the taste
at present, but I really am sorry
for it.'

eight or nine to one, while a genuine Gothic shaft might easily be
several times that.

For all of his painstaking work with compass and dividers,
Langley did not propose to rehabilitate the Gothic as a monu-
mental style. His ambition ran no higher than the making of
merry 'Umbrellos for the Centre or Intersection of Walks'. His
Gothic range was limited, consisting of buttresses, crenellations
and his ubiquitous ogee arch. This was a rather late Gothic fea-
ture, a hallmark of fourteenth-century English design, and it
comprised a four-centred arch each of whose sides traces a deli-
cate S-curve. Langley appreciated the form for its decorative
lightness and used it repeatedly, making the feature an essential
element of anything purporting to be Gothic. So indelibly did the
public associate the ogee with Langley that when he fell from
favour a half century passed before anyone used the feature again.

Far more influential than Langley's quaint book was
Strawberry Hill, the rambling and eccentric plaything of Horace
Walpole (1717–97), youngest son of prime minister Robert
Walpole. Unlike Langley, Walpole had no desire to domesticate
the Gothic or to remove its gloom; he cherished it for the melan-
choly tales it told. In 1750 Walpole bought a cottage at
Twickenham, on the Thames near London, which he altered and

13

expanded repeatedly over the next three decades. Its strongest point was its gradual growth by accretion, improvisation building upon improvisation, giving it a rich complexity which distinguished it from the schematic quality of most examples of early Gothic Revival.

Walpole designed his house as he had amassed his art collection: as a connoisseur, by scrupulous selection of individual treasures. To design the house he formed a Committee of Taste, comprising John Chute, Richard Bentley, Johann Heinrich Müntz and others, with Walpole as the controlling mind. He himself selected the Gothic models which they fitted to their new functions. The change in use was often extraordinary: the tomb of Archbishop Bourchier at Canterbury Cathedral, for example, became the fireplace in the long gallery; the screen at the high altar of Rouen Cathedral, the Holbein Chamber screen; the vaults of King Henry VII's chapel at Westminster Abbey, the plaster ceiling of the gallery; and the choir screen of old St Paul's Cathedral, the arched and crocketed bookshelves of the library. Scarcely any element – carpets, chairs or wallpaper – lacked an authenticated pedigree. These imaginative leaps across architectural categories are not surprising if one considers that Walpole often worked from books and prints, where his motifs were already flattened into outline form, and where a tomb was as useful a motif as a window, or even an entire facade.

That his motifs came from different countries and centuries

16 Strawberry Hill was built from east to west in successively bolder campaigns. The original cottage (at the bottom of the plan) was remodelled and given its stair and polygonal bays in 1750–53. In the campaign of 1758 the Holbein Room and a half-hearted section of cloister were added. Immediately thereafter came the more massive south cloister, the long gallery above it, the round tower to the west and the polygonal cabinet called the tribune. By 1763 visitors were admitted, although as late as 1776 Walpole was still tinkering, adding the Beauclerk tower to the northwest corner.

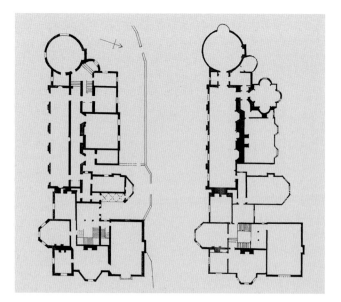

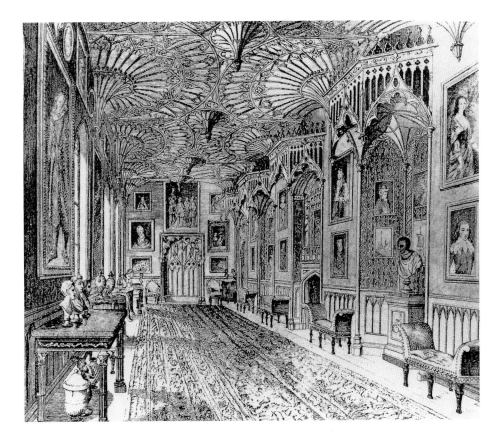

17 Strawberry Hill's long gallery was arranged so that visitors might inspect Walpole's collection without disturbing his privacy. Walpole was pleased with John Chute's design, especially its exterior: 'Well, how delightful! How the deuce did you contrive to get such proportion? You will certainly have all the women with short legs come to you to design high-heeled shoes for them.'

18 (overleaf) Strawberry Hill, Library. Walpole and his collaborators were generally indifferent to questions of materials and form. It made little difference to them that the pointed arches, buttresses and finials of his library were forms that had structural meaning when made of stone but none in wood.

caused Walpole no distress. He demanded the precise copying of medieval models – indeed, he was the first to do so – but historical accuracy mattered discretely. So long as each detail had a Gothic source, so he seems to have believed, the overall ensemble would take care of itself. Walpole had no wish to build a dank medieval keep; he wanted to live in Georgian comfort, in warm rooms with high ceilings and sash windows. His 'Gothic' house was a witty sham, an immense curiosity cabinet of architectural fragments heaped up into a building. There is no artistic unity other than that provided by Walpole's whimsical personality, much as a great art collection can evoke the taste behind it. The interior details, however, are of a piece. Most were by Bentley and show a similarly playful treatment, and a love of graceful, elegant lines. On his wainscoted walls and panelled ceilings Bentley draped a filigree of delicate, gossamer-thin detail whose spirit was as much rococo as it was Gothic, which was in keeping with his materials of choice: plaster and papier maché.

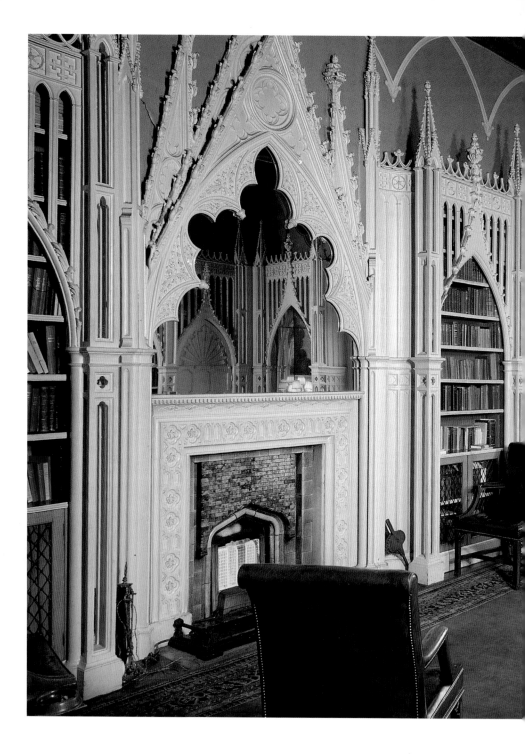

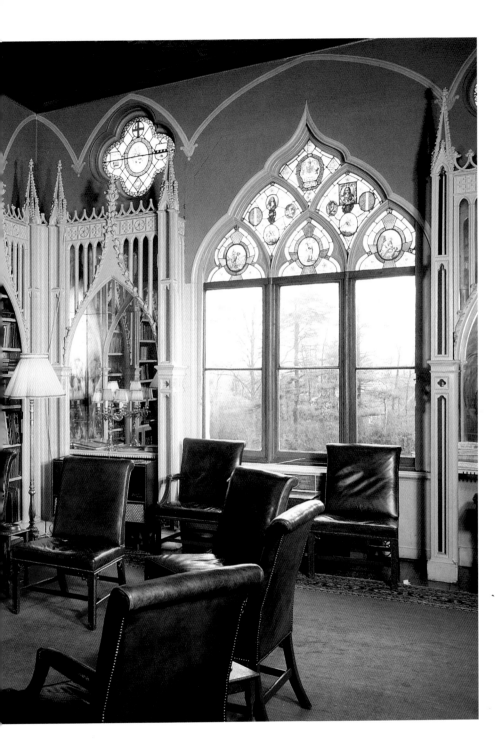

If the Gothic Revival was originally inspired by literature, Strawberry Hill took the process full circle. In June 1764 Walpole dreamed of a gigantic armoured hand hovering at the top of his staircase and he immediately elaborated his dream into a novel, the *Castle of Otranto: A Gothic Story*, which appeared in 1765. The story was overwrought and ridiculous: King Manfred, seeking to marry the intended bride of his dead son, imprisons her in his gloomy castle; she escapes, braves underground passages replete with spectral voices and the occasional skeleton, finds her true love, at which time the castle collapses spectacularly. The mixture of horror and romance strikes us as conventional but these are the conventions Walpole himself created. The *Castle of Otranto* begat a new and durable literary genre, the Gothic novel, whose pedigree extends from Walpole through Walter Scott and Edgar Allan Poe to the Stephen King novels of our own day. It is a more lasting achievement than Walpole's house. Even before Strawberry Hill was finished, it was widely copied. Walpole's Committee of Taste, his happy band of Gothic draftsmen and artisans, took its forms and lessons to other clients. By the 1760s there was a considerable number of self-styled Gothic architects, including Sanderson Miller, Henry Keene and the talented amateur Sir Roger Newdigate. A charming English eccentric, Newdigate insisted on making his own architectural drawings and designed a far-reaching series of additions to his sixteenth-century house, Arbury Hall, Warwickshire. Almost all of these men continued to work on the Walpole method, composing each room additively out of features copied from approved Gothic models. But the quality of work improved rapidly, spurred by the rivalry of fashion and the rapid movement of architectural ideas. Already by 1768 we find a Gothic design whose construction, detail and spatial character were all the product of a single unified conception. This was the Chapel at Audley End, Essex, of 1768, a jewel of rococo lightness whose authorship remains a mystery.

The Gothic Revival took a different course in Scotland, where the medieval past was not quite so distant. Conditions were quite feudal in some of the more rugged, less hospitable regions, where chieftains still held sway by personal authority, ensconced in their remote fastnesses. Unlike England, where the military features of a castle had become purely symbolic, the Scottish castle remained a useful place of retreat when warfare erupted, as it did during the Jacobite rebellions of 1715 and 1745. Many estates were rebuilt and reinforced during these upheavals, using the tough granite masonry of Scottish tradition. Nothing could be

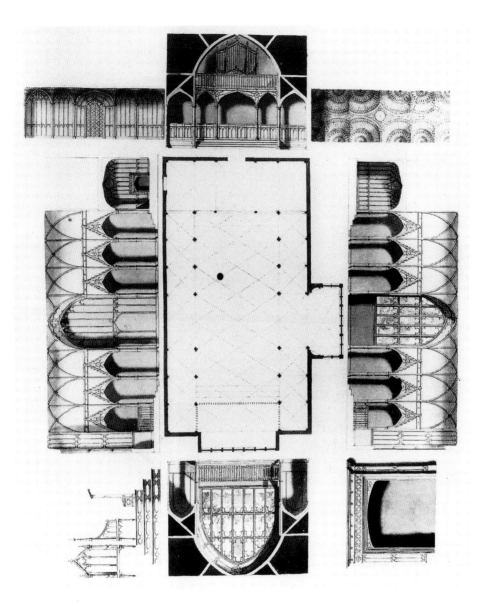

19 A lovely drawing of the Chapel at Audley End, Essex
(1768) shows the growing competence of professional
designers. Unlike the awkward improvisations of Walpole's
circle, this design shows an ability to conceive of the space
as a totality, to integrate its construction with its design and
also to use historical prototypes boldly, particularly the
vaulted ceiling, based on Henry VII's Chapel at Westminster.
Such is the quality that some scholars have attributed the
design to Robert Adam, who worked at Audley End, rather
than James Hobcraft, the London carpenter who built it.

20 Brizlee Tower (1777–81), Alnwick Park, illustrates Robert Adam's jaunty approach to the Gothic. The ornate window surrounds look as if they were glued to the solid wall behind them while the triangular arches at ground level have little architectural logic. But what is glaring to us hardly mattered to eighteenth-century eyes, which did not look at buildings for structural truth.

further removed from the dainty affectations of Walpole's Strawberry Hill.

The overlap of Gothic Revival and Gothic Survival in Scotland is shown at Inveraray Castle, Argyll. Some time before his death in 1726, John Vanbrugh made plans for an abstractly Gothic castle to replace the original medieval structure. This project came to nought but it was evidently dusted off in 1743 when Archibald Campbell (1682–1761) became Duke of Argyll. He chose Robert Morris (died 1749), the English Palladian architect, to make a new design, which was close in spirit to Vanbrugh's. The building, begun in 1745 and completed around 1757, was a prodigy of stern Scottish masonry. Four round tow-

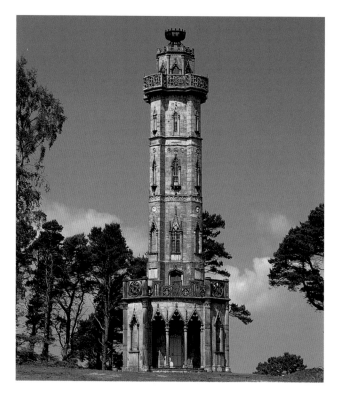

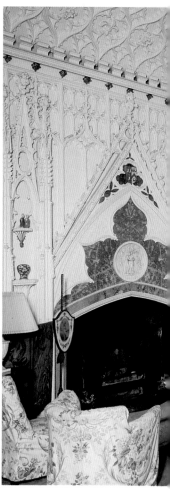

21 The sumptuous forms of the thirteenth-century tomb of Aymer de Valence, Westminster Abbey, appealed to eighteenth-century Rococo taste. Not only did Horace Walpole copy the tomb for his library shelves but Sir Roger Newdigate borrowed it for his drawing room chimney at Arbury Hall, Warwickshire (1762).

22 'What I admire here is the total defiance of expense,' wrote Dr Johnson of Inveraray Castle. He may have meant the impressive moat and array of crenellated battlements, a luxury at a time when there was little occasion for firing arrows or pouring boiling oil. Built by Robert Morris from 1743 to c. 1757, Inveraray was subsequently raised by a storey in the nineteenth century, losing its crenellations.

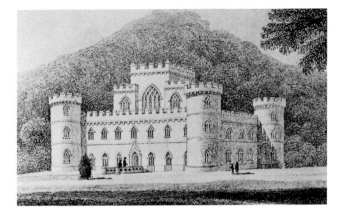

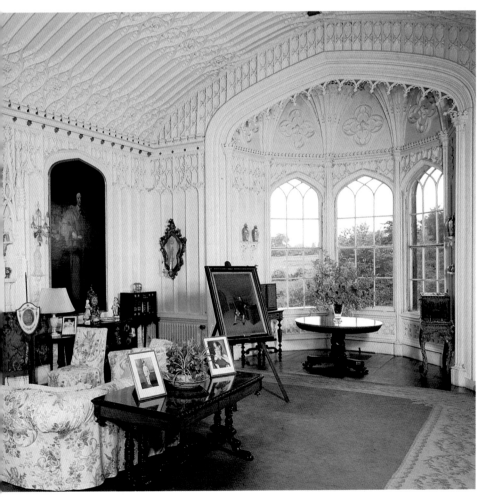

ers with battlements marked the corners of the square castle, which rose at the centre to form a mighty towered block, expressing the great hall within. Its medieval character depended almost entirely on size and the severity of its construction, for other than the traceried windows of the great hall and the arched portal, there was no ornament at all. The walls were taut ashlar planes, without any projection or recession to create a play of shadows – a sensible omission given Scotland's climate.

Strawberry Hill and Inveraray represent two distinct types of eighteenth-century Gothic. One was the self-conscious creation of fashionable antiquarianism, the other the adaptation of a local tradition that was sustained by a warring nobility of great antiquity. Strawberry Hill was an instrument for communicating associations, literary in its programme and pictorial in its execution. It was a pastiche, although a learned one. It mixed its sources indiscriminately: twelfth-century lancet arches, fourteenth-century crenellations and sixteenth-century Tudor window labels. Inveraray was also an invented Gothic, but as the work of a trained architect it had the unity of a single conception. Robert Morris's imagination was disciplined by two lively traditions, that of Palladian planning and of Scottish stone; there was nothing frivolous or calligraphic about it. And yet Inveraray was as much an intellectual creation as Strawberry Hill, a carefully orchestrated work of ancestral symbolism. Built during the Jacobite troubles, its immense stone mass stood for a desired dynastic stability that was in reality all too precarious.

The masons who built Inveraray Castle were William Adam and his sons John and Robert, who took its style throughout

23 After the death of Adam, the chief practitioner of the castellated Gothic in Scotland was James Gillespie Graham (1776–1855). His early Culdees Castle, Perthshire (1810) showed a love of vigorous outline and bold, blocky volumes that distinguished all of Graham's work. He was the first to recognize the architectural talent of young A. W. N. Pugin, whom he briefly used as his ghost designer.

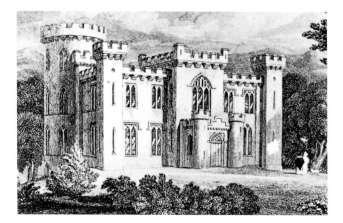

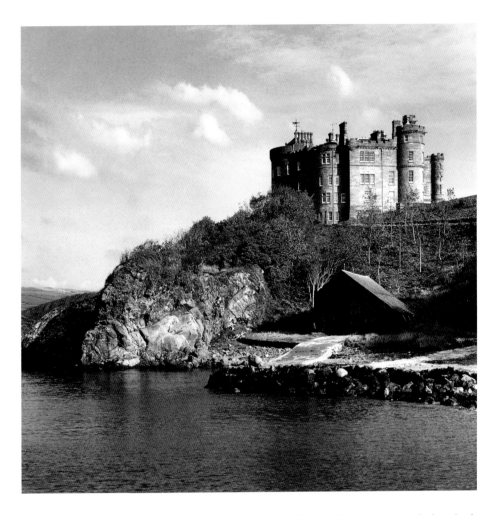

24 Culzean Castle (1777–90) is the summit of Robert Adam's castellated work. Recognizing that elaborate ornament and intricate carving was not appropriate in a rugged castle, he generated pictorial excitement through volumetric means alone, juxtaposing round towers, curved bays and compact cubical masses, creating a Scottish picturesque.

Scotland and beyond. In fact, Robert Adam worked at both Inveraray and Strawberry Hill – for which he designed a ceiling, fireplace and some furniture – and he drew on both buildings to form his own personal variant of the castle type. Of this there were many, including Dalquharran Castle, Ayrshire (1785), Seton Castle, East Lothian (1789) and Airthrey Castle, Stirlingshire (1790). Because of his training as a stone mason, Adam's castles were more solidly architectonic than those of any other early Revivalist. In part this came from his predilection for building around an existing medieval building, exploiting its historical associations. The most splendid of these was Culzean Castle (1777–90), superbly sited above a craggy promontory Like many Scottish castles, the character is late medieval, with

round or flat-headed windows. Only in the interior did Adam depart from Scottish rigour, providing gracious salons in the elegant Pompeiian taste that he had pioneered during his years of Italian study.

The Adam brothers were not the only architects to imitate Inveraray, which served as the model for a century of castellated Scottish houses. Its castellated style had two great merits: it evoked hereditary legitimacy and it did so cheaply, without the cost of raising a classical portico. Carved ornament was held to a minimum and each rambling volume in the picturesque composition contained serviceable rooms within. The style was immediately popular. Even Richard Payne Knight, the author of the *Analytical Inquiry into the Picturesque*, built himself a castellated house: Downton Castle, Ludlow. Knight had no ancestral nobility to celebrate. His stately castle was built by the wealth of the family iron foundry in Shropshire. Perhaps for that reason, Knight took pains to explain that the 'association of ideas' aroused by a building was a purely mental process, and did not need to reflect any actual state of affairs or historical truth. Such a doctrine could not help but be embraced at a time of colossal social upheaval.

It is ironic that Knight's doctrine should have produced so many tasteful and refined Gothic estates, for the associations that the Middle Ages conjured were still primarily ones of melancholy and gloom. In fact, the castellated style lived a double life, and the same forms that made mansions elegant served – with

25 Richard Payne Knight designed Downton Castle, Ludlow (1774–78), as an irregular composition that would complement its wild and rocky site. The experience helped him shape his doctrine of the picturesque, and it also gave him a lifelong contempt for the artificial picturesque, in which landscape was clipped and shorn to create contrived irregularity.

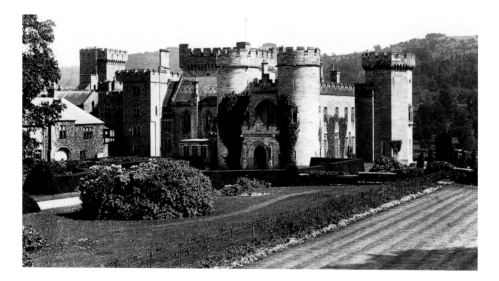

26 Eastern State Penitentiary, Philadelphia (1821–36) was designed by John Haviland, who was born in England and certainly knew Knight's celebrated Downton Castle. Unlike its prototype, the Gothic of Eastern State Penitentiary made functional sense: its stout walls were meant to be impregnable and sentinels actually paced its battlemented turrets.

slight changes – to make prisons terrifying. John Haviland's Eastern State Penitentiary, Philadelphia (1821–36), with its innovative radial plan and system of solitary confinement, was the world's most progressive prison. And yet its exterior was nothing more than an austere version of Downton Castle, the windows narrowed and the playful irregularity made rigidly symmetrical.

By the end of the eighteenth century, the Gothic had progressed a long way toward rehabilitation. It was now an essential part of the architect's repertoire, an indispensable mode for lighter commissions. Nonetheless, the rehabilitation was only partial. There was still only the most imperfect understanding of real Gothic architecture; it had yet to be attached to more serious cultural ideas than affectations of melancholy and gloom. While it was handy for country houses or inherently gloomy objects like prisons, it was not yet fit for the most important civic commissions. In short, the Gothic had still not gathered the irresistible cultural momentum that a true revival requires. This would happen only with the twin forces of Romanticism and the Industrial Revolution, which liberated the Gothic from the quarantine of the picturesque garden and placed it in the centre of public life.

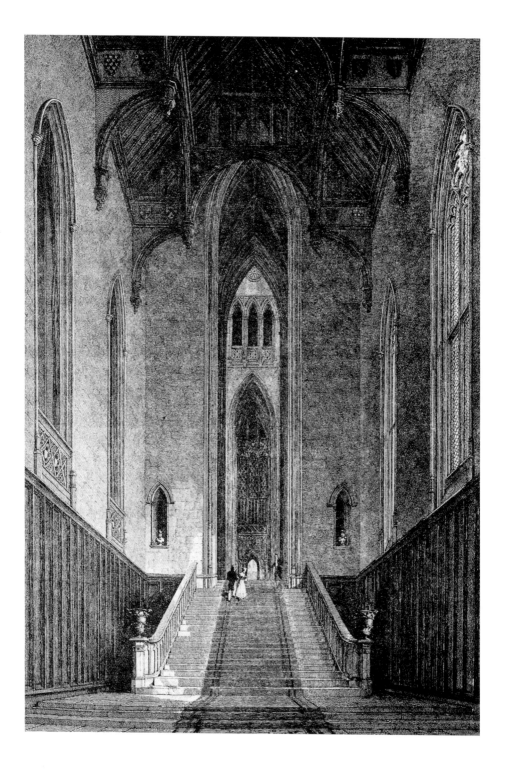

Chapter 2: Romanticism

Some people drink to forget their unhappiness; I do not drink, I build.
William Beckford

The literary Gothic of the eighteenth century had the limitations of literature as well as the merits. It was intelligent and variegated but at best it was the nature of book illustration, failing to exploit those abstract properties that are essential to architecture, the sculptural and the spatial. In the late eighteenth century this state of affairs changed, the Gothic at last being treated in architectural terms, and with an eye towards artistic unity. This was the achievement of that glib and overworked designer James Wyatt (1746–1813), the first of the Gothic romantics. Wyatt showed that a building might thrill by its sheer scale, confronting the imagination rather than merely titillating the intellect. In other words, a building might be sublime.

The concept of the sublime was the peculiar contribution of the philosopher Edmund Burke, whose *Philosophical Enquiry into the Origin of Our Ideas of the Sublime and Beautiful* appeared in

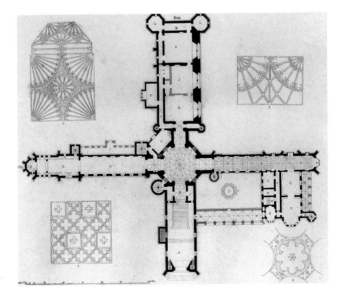

27, 28 The most awe-inspiring aspect of Fonthill Abbey was the Great Western Hall leading to the central octagon, a sumptuous processional space nearly ecclesiastical in character. There was much clamour to see it, despite Beckford's social disgrace – and he discreetly remained out of sight during visits. In general, however, his behaviour was indistinguishable from that of his imperious fictional creation *Vathek*; not even his architect was excepted. (In 1811 he demanded of Wyatt: 'Where infamous Beast, where are you? What putrid inn, what stinking tavern or pox-ridden brothel hides your hoary and gluttonous limbs?')

1757, when its author was twenty-seven. Burke noted that there were aspects of nature that were neither agreeable nor pleasant but which exercized a powerful effect on the mind. Phenomena such as ocean tempests or glaciers suggested the menacing vastness of nature and the seething, implacable forces within her, a rather different view of nature than that of Claude's benign landscapes. Burke subsumed these phenomena under the rubric of the sublime, which was not only a psychological but an aesthetic category, to be set alongside beauty. Artists were invited to explore the sublime, to call forth infinity and to plumb the emotions of dread and terror that this induced. Burke wrote in the spirit of the Enlightenment, seeking to analyze a misunderstood aspect of human experience, but his doctrine confronted something that was itself anti-rational. Inadvertently he helped plant the seeds of Romanticism. In short order architecture would not be judged according to the cool and dispassionate standards of Walpole but by its ability to inspire reverie and delirium. This entailed colossal scale but also contrast and the manipulation of darkness and shadow. According to Burke, 'all edifices calculated to produce an idea of the sublime ought to be dark and gloomy'. By the turn of the century this idea became the common coin of romantic artists and architects, and to Wyatt it was especially congenial.

An artist of rare imagination, Wyatt knew what the pious antiquaries did not, that the most potent aspect of the Gothic lay in its sublime and overwhelming vistas and not in its repertoire of crockets and pinnacles. He found his ideal client in the millionaire William Beckford, the tragic eccentric who built the most fantastic of Gothic prodigies. If Walpole lived at Strawberry Hill in an imaginary world of Gothic dreams, Beckford lived them. He fled England to escape charges of pederasty and while overseas wrote his novel *Vathek*, an Arabian tale of a cruel caliph living in his tower and flirting with the temptations of demonic genii. Beckford wrote his novel in French, perhaps to put at a distance what was otherwise a parable of his own life. Upon his return he built Fonthill Abbey (1796–1812) in Wiltshire, an appropriate 27, 28 setting for playing the part of the capricious despot.

Beckford's first idea was to create a fiction of a ruined abbey, with a few wings and fragments of cloister huddled at the base of his tower. The improvisation grew more elaborate over time, as more wings were added and the abbey turned from plaything to permanent residence. Its hub was a 278-foot-high tower which rose above a lofty octagonal hall from which four wings radiated. Wyatt's architectural tastes were in keeping with Beckford's

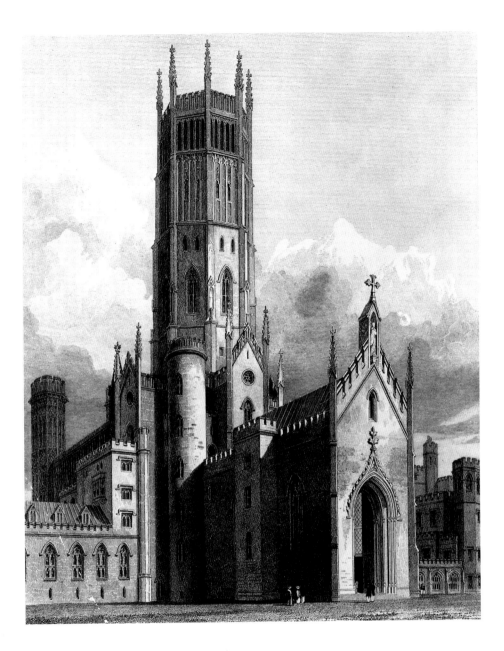

29 Fonthill Abbey, 1796–1807, by James Wyatt, was
composed much like a painting: sprouting pyramidally out
of a cluster of cloistered wings, the vertical of its tower
emerged to offset the bleak horizontality of the Salisbury
plain. Roughly 278 feet in height, the tower collapsed
twice.

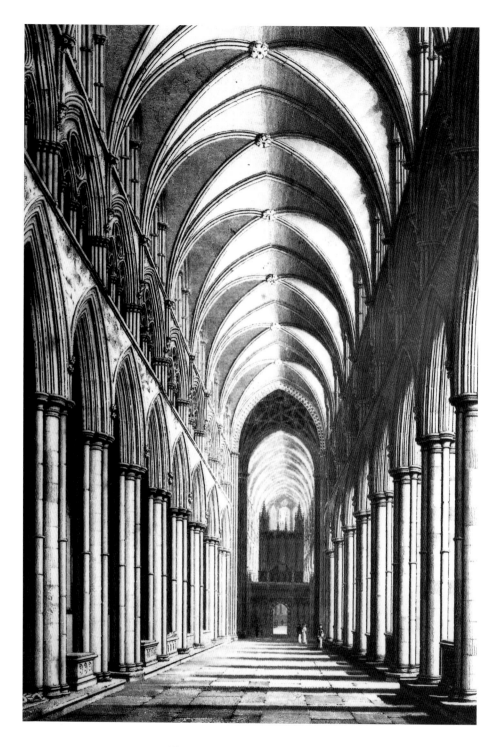

30 The nave of Salisbury
Cathedral, facing east, from John
Britton's *Cathedral Antiquities of
England*, 1814. Salisbury's
sweeping horizontal continuity
seems to have fascinated Wyatt
and he broke down the rood
screen, still visible here, to
accentuate the sense of
continuous vista. This axial
sequence is surely the origin of
Fonthill Abbey's most sublime
feature, its long nave-like hall.

megalomania; he appreciated absolute magnitude and the power of a long axial procession, and he treated the western hall as a long and solemn nave, surmounted by an intricate hammer-beamed ceiling and leading to a flight of stairs allegedly wide enough to drive a carriage up. The stunning complex effectively ended the Georgian phase of the Gothic Revival. Compared to Wyatt's performance, Strawberry Hill looked prim and polite. No longer did it suffice to equip a Georgian parlour with medieval chimneypieces and crocketed panelling or to furnish a Palladian facade with a matched pair of bay windows.

Beckford's abbey recalls the biblical parable of the man who built his foundations on sand. Wyatt's builders, working day and night by torchlight, skimped on foundations, a fact belatedly revealed by the builder on his deathbed. But no heed was taken and in December 1825 his mournful tower collapsed spectacularly. For Beckford's architectural folly this was an appropriate end, like the striking of the sets after a play. But Wyatt has come in for harsher historical judgment. His romantic impulses may have been virtues in his imaginative work but they were vices in his architectural restorations, the most notorious aspect of his career. His freewheeling restorations of Durham, Salisbury and Hereford cathedrals, as well as Westminster Abbey, earned him an indelible reputation for ruthlessness, 'Wyatt the destroyer' in Pugin's epithet. And indeed, his habitual destruction of medieval chapels, tombs and rood screens in the name of architectural purification is lamentable.

Salisbury (begun 1789) is typical of the lot. There his charge was to 'clean and colour the Church', to 'clean and varnish the stalls' and to remove the rood screen that divided the choir from the Lady Chapel. But Wyatt was operating upon firm aesthetic principle, as at Fonthill Abbey. His controlling idea was to treat the cathedral as an artistic whole, to unify its disparate parts into one overwhelming space. The stirring emotional effect, touching on the sublime, was one that Burke himself might have endorsed, even though a good deal of historical evidence was moved or lost in the process. Moreover Wyatt's restorations were always excessively tidy, eliminating the sense of congealed time that is the principal charm of cluttered old buildings. Nonetheless, his were the first systematic reconstructions, where historical and aesthetic considerations were consciously at the forefront.

Wyatt's self-consciously artistic restorations showed how speedily pictorial values had become ascendant. Of course, painters were now discovering Gothic architecture as subject

matter, but inversely, a building was now more likely to be conceived as a painting, its features organized pictorially, its lines and contours arranged for visual effect. This meant a great increase in the amount of picturesque interest of a design, and in general irregularity and movement. A sign of this shift in values was the sudden emergence of the picturesque rendering. Architectural drawings were heretofore simply a means to an end. This is not to say that there were not attractive renderings of Strawberry Hill, for example, but these were made after the fact; the architectural amateurs who conceived these buildings and the carpenters who assisted them made no ravishing drawings. But in the middle of the eighteenth century the Italian architect and artist Piranesi had shown that architectural drawings might themselves be objects of intrinsic aesthetic interest – an idea that was intensely exciting to Gothic architects. Soon they devised a rendering style befitting their architecture. Atmospheric watercolour drawings depicted the buildings in wooded or mountainous settings whose jagged lines echoed the towered forms of the churches themselves. Thomas Sandby (1721–98), professor of architecture to the Royal Academy, was exceptionally adept at the romantic rendering, integrating building and landscape in a seamless ensemble.

The relationship of architecture to landscape was something to which English designers gave much thought. Since the 1730s the picturesquely landscaped park had arisen in opposition to the stiff formality of the French and Dutch tradition, with its insistence on subjecting nature to geometric order. The chief apostles of the new style were first William Kent and then the prolific

31 The neurotic fascination for violence and madness that is so strong in Gothic literature of the eighteenth century is usually absent in its architecture. The Gothic churches of Thomas Sandby (1721–98) were thoroughly Georgian in their reticence, dignity and well groomed politeness. Unidentified church, c. 1790 (from the Architectural Archives of the University of Pennsylvania).

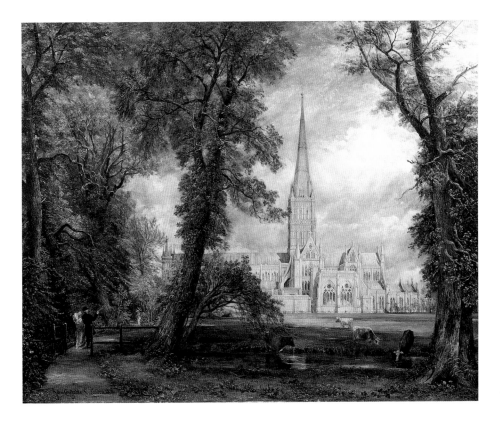

32 John Constable painted Salisbury Cathedral in 1826 for Bishop John Fisher, shown pointing to the apex. Constable clearly appreciated the intrinsic pictorial qualities of the cathedral, framing it so as to emphasize its noble silhouette and accentuate its verticality.

Lancelot ('Capability') Brown, who tormented gardens and parks throughout England into serpentine lines punctuated with clumps of trees and meandering lakes. Brown applied his studied irregularity without much variation or subtlety and after his death in 1783 it became fashionable to deplore his highly artificial conception of naturalness. A more sophisticated doctrine of the Picturesque emerged in the 1790s. Its chief advocates – Richard Payne Knight, Uvedale Price and Richard Gilpin – argued that the inherent qualities of a landscape must always be taken into account and that any process of landscaping should work to strengthen these qualities through a process of intelligent correction and pruning. The optimistic era termed the process 'improvement'.

The greatest of the improvers was Humphry Repton (1752–1818), the author of *Sketches and Hints on Landscape Gardening* (1795) and *Observations on the Theory and Practice of Landscape Gardening* (1803). Repton made his fame with his 'Red Books', portfolios of recommended alterations which he would

prepare after his site visit, superbly illustrated by before-and-after views and bound in red leather as a book. This clever presentation technique was fully in the spirit of picturesque doctrine, the comparisons showing how his interventions followed logically and inevitably from the natural traits of the landscape itself. Often Gothic buildings were proposed, whose rambling wings complemented the undulations of the setting Repton's reassuring landscapes hinted at permanence and stability, and were dearly valued during an age when the landscape was roiled by immense physical changes, brought on by the Industrial Revolution and the disruptive enclosure movement – which was bringing unpartitioned common land under cultivation at a considerable human cost, dislodging countless thousands of agricultural labourers from their homes and livelihoods. The great theme of Repton's landscapes was the continuity of English culture and life, a theme expressed in the architecture as well as the planting. Here he found an ideal complement in John Nash, his architectural partner. Nash had a particular knack for the making of picturesque castles, which evoked the same associations of hereditary continuity and legitimacy as did Repton's parks. From 1796 to 1802 they worked together, the summit of the Gothic Revival in its pictorial mode – the counterpart to the blithe and graceful world of Jane Austen, although it masked forces and social pressures that were convulsive and terrifying.

Nash was a genius at architectural pastiche, untroubled by qualms about historical accuracy. Nonetheless, during these years the archaeological quality of neo-Gothic work made a sudden and remarkable leap. Up until the end of the eighteenth century, the Gothic Revival did not scruple to distinguish between military, ecclesiastic and domestic Gothic, nor between the various epochs of medieval architecture. There was no great advance beyond Wren's division of medieval architecture into an older Saracenic style and Gothic (that is between Romanesque and Gothic). In fact, according to associational theory it was no violation to place a sixteenth-century Tudor window above a twelfth-century archway. All the better, if such a juxtaposition heightened the aura of chivalry, romance and gloom. But there now came into being a growing corpus of documented buildings, plans and elevations reproduced in accurate line drawings, largely achieved through the patient spadework of local antiquaries. The key figure was the industrious architect John Carter, who produced *Views of Ancient Buildings in England* (1786–93); he systematically measured and drew the nation's cathedrals and

33, 34 Humphry Repton's view of Rivenhall
Place (above) and his proposed alterations
(below). Repton produced his quirky Red Books
with astonishing speed. Believing that the
peculiar genius of each landscape should be
intuitively perceived at the first encounter, he
swept through an estate in a day and recorded
his ideas that evening. Something of the same
overwhelming sensation must also strike the
viewer who opens the flaps of Repton's drawings.

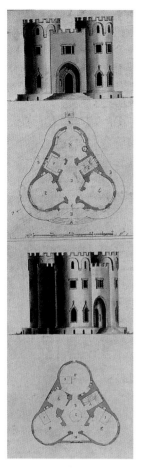

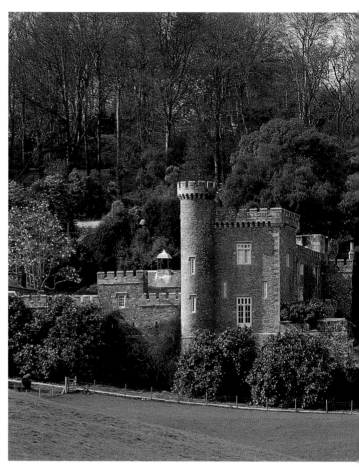

35 Design for a castellated residence, from John Carter's unpublished album of original designs, c. 1790. With his habit of composing amateur operas set in the Middle Ages, Carter narrowly escaped being a medieval dilettante; instead he became England's most knowledgeable scholar of medieval architecture. Fellow architects often turned to him to critique their efforts and much of the period's growing competence in neo-Gothic design reflects his behind the scenes activities.

abbeys, subsequently etching them for the Society of Antiquaries' *Cathedral Series* (1795–). These books established the mould for all subsequent compendia of Gothic architecture, such as John Britton's *Architectural Antiquities of Great Britain*, which appeared in forty lavish instalments from 1805 to 1814. Carter was influential in another respect, for as the chief architectural writer for the *Gentleman's Magazine* he brought learned and intelligent – if not dispassionate – discussion of Gothic architecture to a wide popular audience. Frequently he commented on Wyatt's freewheeling restorations which to Carter, the best-informed Gothic scholar of his day, were acutely painful. His diatribes against these were conducted on a plane of furious invective, injecting into the Gothic polemic a dogmatic, almost theological tone that would resound in the works of Pugin, Ruskin and the Ecclesiologists.

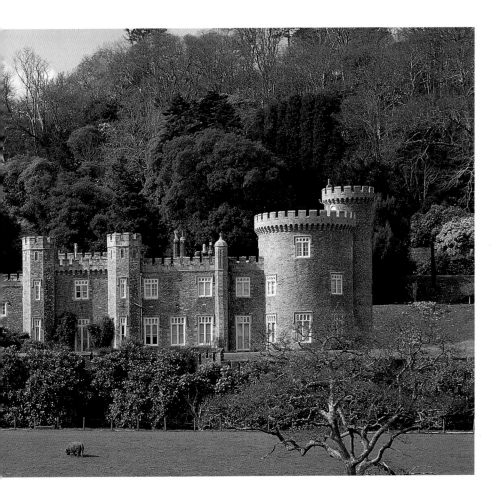

36 Caerhays Castle, Cornwall (1808). John Nash's rugged, low-slung castles were intended to communicate dynastic perpetuity. Ironically, of his four greatest ones, only Caerhays survives.

Through the efforts of Carter, Britton and others, it gradually became possible to identify the various phases of the Gothic style and to classify them in terms of their internal process of development. When this first happened in the years around 1800, it was inevitable that the whole mental framework of the classification be borrowed from classical scholarship. There the concept of stylistic development was at that time a novel insight. Until the third quarter of the eighteenth century, the classical heritage was commonly seen as one long unchanging afternoon of perfection. This understanding was shaken by recent archaeological discoveries at either end of classical antiquity, which could not be reconciled with the seemingly timeless proportions of Vitruvius. Rather, they seemed to show an unfolding continuum from the archaic Doric of Paestum to the late Imperial style of Diocletian's

palace at Spalato, a trajectory which progressed inexorably from a state of early vigour and vitality to one of overelaboration and degeneracy. This seemed to suggest that inexorable laws of organic development and decline might apply to any style, and this was the insight that John Milner applied to Gothic architecture.

A Catholic priest, Milner was an antiquary of unusual sophistication. In 1798 he was the first Englishman to argue that the pointed arch itself was the fundamental element of all Gothic architecture, in distinction to its various decorative features. He elaborated the concept in his *Treatise on the Ecclesiastical Architecture of England during the Middle Ages* (1811), which divided the Gothic into three orders of 'Pointed Architecture' which, like the architecture of antiquity, progressed from uncouth vitality to corruption. This suggested that an ideal Gothic might be found, midway between the periods of birth and decay, in which the properties of vigour and refinement were exactly counterbalanced, neither too brutal nor too decorative. This was the 'chaste grandeur' of the Middle or Second Pointed, which Milner illustrated by the forms of York Minster, which dated from about 1300. Here was a fateful turn for the Gothic Revival, for this way of categorizing Gothic architecture simultaneously permitted the making of moral judgments about it. Like Carter, Milner's ability to recognize the period styles made him an indignant critic of contemporary restoration practice. He came to enjoy the accumulated stylistic phases of the great cathedrals. Beneath the visual disorder he saw the orderly and poetic march of time, each successive building campaign contributing elements in its distinctive stylistic voice. Wyatt's crime was the attempt to give these parts a spurious unity, which led unfailingly to 'the destruction of the proportions, and of the relation of the different parts of the Cathedral'.

Milner's chronology was further refined by Thomas Rickman (1776–1841), who in 1819 published his *Attempt to Discriminate the Styles of English Architecture*, a practical handbook intended to make clerics 'more capable of deciding on the various designs for churches in imitation of the English styles'. Rickman accepted Milner's three 'pointed orders' but he renamed them Early English, Decorated English and Perpendicular English. To these he added an earlier fourth order to describe the Romanesque architecture that followed the Norman conquest. Recognizing its imported quality, he gave it the term Norman rather than English. Rickman's terms, coming after the long isolation of

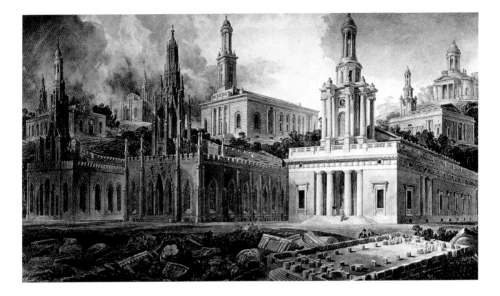

37 The Gothic as a cloak that could be put on at will, without any change of plan or materials. Such was John Soane's vision of the Commissioners Churches (1818), a drunken masquerade party of the styles. To Soane's generation this was a thrilling display of facility, but to the next it seemed to show a lack of moral conviction about style. J. M. Gandy made the striking rendering.

England during the French Revolution and Napoleonic wars, inevitably assumed a patriotic cast. Once applied to the Gothic, this patriotic vocabulary and the associations it aroused – like Milner's moral ones – would be difficult to extirpate.

Unlike Milner, Rickman was no moralist but a practising architect who worked happily in the Perpendicular – the first to know consciously that he was doing so. Never before had an architect conceived his Gothic designs as stylistic unities, based on a specific moment of historical development. His notion of historical fidelity ended at the walls, however, and his interiors were modern creations in both the spatial and technical sense. Rickman was a Quaker and he gave his interiors something of the open spatial sense of a Quaker meeting house, using spindly cast iron columns to support brittle galleries. 38

The early efforts won acceptance for the use of the Gothic in Anglican churches. The trickle of essays soon rose to a torrent, as shown by the Church Building Act of 1818. This sought to meet the demand for new churches brought about by the dramatic population spurt that coincided with the Industrial Revolution and the consequent enormous urban overcrowding. In the initial campaign, 214 churches were built, the vast majority of them Gothic. The increase in medieval knowledge was also palpable, although most architects continued to use the Gothic as a cladding, as did John Soane, not taking into account its peculiar spatial and structural qualities. There was one notable exception.

St Luke's, Chelsea (1820–24) was a true basilica, with low aisles and a lofty nave, instead of the customary barn-like auditorium. It was also vaulted in stone, a radical advance over the plaster and lath vaults of the eighteenth century. This gave the church an unmistakable sense of structural reality, even to the flying buttresses of the exterior, no affectation but structurally necessary elements Perhaps not surprisingly, its designer was a bridge builder, James Savage (1779–1852). Here at last, after a century of paper Gothic by draftsmen, was a building whose artistic form and structural system were the work of the same mind. It instantly made Wyatt's work look like sham and gimcrack, raising both the aesthetic and technical standards of the Gothic.

The new fad for precise period accuracy was apparent in other arts, especially literature. The novels of Walter Scott's *Waverley*

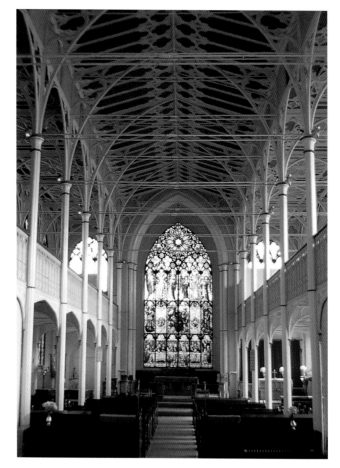

38 St George's, Everton, Liverpool, 1813–14. Cheap, efficient, historically accurate without being pedantic: the Gothic of Thomas Rickman made him the star of the Church Building Act of 1818. Of the 214 churches built in the first campaign, he was responsible for twenty-one, a splendid haul considering that he was a Quaker. St George's shows the open and well lighted interiors that suited Regency taste.

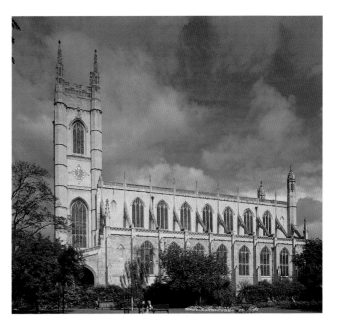

39, 40 St Luke's, Chelsea, London (1819–24), by James Savage, was in the Perpendicular style, with its crenellated parapets, strongly stated rectilinearity and net of thin mouldings suggesting fussy wood panelling. The mature Gothic Revival would condemn these features, and also the lack of a chancel and the reliance on galleries to increase the capacity; nonetheless, its use of stone vaulting was revolutionary.

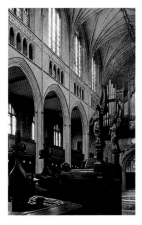

series, such *as Ivanhoe* (1819) and *Kenilworth* (1821), depend on the accuracy of their setting, language, costume and overall mental atmosphere; they can rightly be called the first historical novels in the modern sense. (In comparison to their vivid recreation of medieval life, *The Castle of Otranto* and *Vathek* were no more than fairy tales.) His instant financial success showed that there was a thirst for medieval romance in England – and in France as well, where he was wildly popular and where Victor Hugo copied both the technique and the medieval subject matter. Scott was one of the revival's most influential propagandists, whose readers carried away a vast mental storehouse of characters and events which was agreeably activated whenever they gazed on a Gothic building. Surely many of the Gothic houses and churches built in increasing numbers from the 1820s onward trace their origin to a happy encounter with Scott.

The pursuit of period accuracy also characterized Scott's own house, Abbotsford, which followed the baronial style of the sixteenth and seventeenth centuries. It is unfortunate that Scott did not choose as his architect William Burn (1789–1870), the chief practitioner of the baronial style, for this would have brought together the two greatest artists of Scottish medievalism. Burn had the strongly architectonic sense of Scottish architecture, and the memory of the quarry. His favourite sources were Jacobean

41

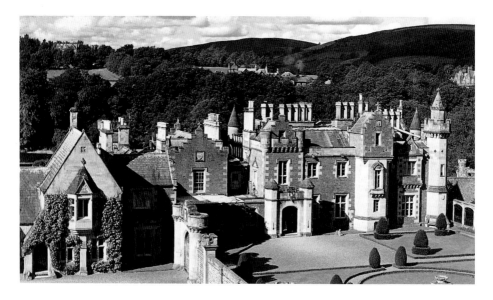

41 Walter Scott's house, Abbotsford, Roxburghshire (1816–18) was not generically Gothic, despite the author's ardent medievalism. It is an essay in the rugged Scottish Baronial style, with massive walls, crowstep gables and polygonal bartizans. It was designed by William Atkinson in consultation with Edward Blore, and preserved fragments of actual medieval buildings – a touch not all that different from the cleverly integrated historical learning in Scott's novels.

42 The Sir Walter Scott Monument, Edinburgh, 1840–46, by G. M. Kemp, was in the spirit of his novels: the Middle Ages of happy jousts and chivalric romance, not the gloomy, brooding Gothic of Beckford. The excessively pinnacled composition recalled the flamboyant spires of the late-Gothic churches of Belgium or Holland.

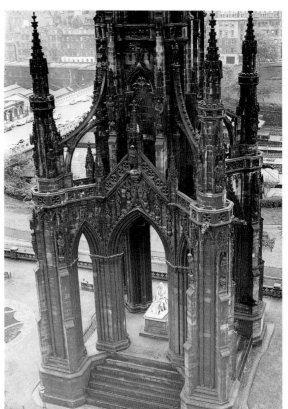

and Elizabethan – merged by him into a solid and elegant 'Jacobethan' synthesis – without Nash's dainty flourishes. While earlier revivalists deployed their irregular rambling wings in order to manufacture pictorial drama, Burn's compositions were sober and stately, in which the occasional asymmetrical wing was motivated by function. His greatest importance was in planning, and he designed the era's most efficient and comfortable domestic interiors, becoming one of the most brilliant planners of the entire revival. He intelligently wove together three types of spaces – the family's private dwelling quarters, the servants' rooms and the principal public chambers – which in chilly Scotland might only periodically be heated for use. By making the family's private rooms the spatial heart of the house, and subordinating the rest of the plan to them, Burn singlehandedly abolished the tyranny of the Palladian plan, with its compulsory symmetry and its obligatory formal salons. This revolution would long outlive the Gothic Revival itself.

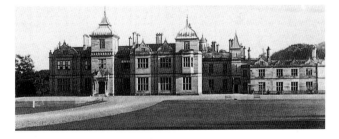

43 Dupplin, 1828–32. William Burn's house for the Earl of Kinnoul was built in a highly accomplished Jacobean style. As in all the architect's work, the asymmetry was motivated by internal planning needs and handled with the classical discipline that might be expected of a pupil of Robert Smirke.

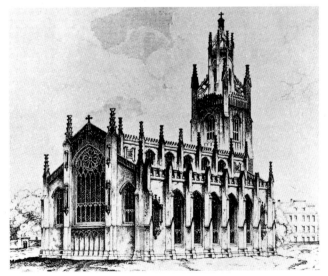

44 Burn was also an accomplished church architect and St John's Episcopal Church, Edinburgh, 1814, built in the Perpendicular style, is one of the finest. Although the subsequent Revival would come to scorn the Perpendicular, the early nineteenth century was particularly fond of it, perhaps because its emphatic cornices and strong delineation of borders matched the neo-classical taste for clearly defined volumes. Burn's church was an early example of a Gothic basilica, with its raised central nave, lighted by a clerestory, and shouldered between two lower aisles.

45 Despite independence, America continued to look to England for architectural leadership. The emigré Benjamin Henry Latrobe (1766–1820) arrived in the 1790s, bringing with him the fashionable taste for Gothic villas and informal landscaping. His house for William Crammond, Sedgely, 1799, overlooking the banks of the Schuylkill at Philadelphia, applied elegant Gothic flourishes to a resolutely four-square neo-classical cube.

46 Glen Ellen (1832), Towson, Maryland. Following his encounter with Walter Scott at Abbotsford, Robert Gilmore commissioned a Gothic house, the first important work of A. J. Davis, the 'architectural composer' who was the picturesque lobe of a partnership with Ithiel Town. Both the irregular plan and informal asymmetry of Glen Ellen were radical departures in American architecture.

During the first quarter of the nineteenth century the taste for Gothic had become a middle class phenomenon. The landscape gardener John Claudius Loudon (1783–1843), yet another Edinburgh-trained product of the Scottish Enlightenment, deftly served this market. His *Encyclopedia of Cottage, Farm and Villa Architecture* (1832) democratized the taste of Nash and Repton, transposing their castles and landscaped parks to the format of cottages and gardens, suitable to the smallest budget – 'appropriate to every Class of Purchasers', as he termed it. The success of the book led him to launch the *Architectural Magazine*, which he edited from 1834 to 1838. A flurry of illustrated pattern books now appeared.

Loudon was even more influential in the United States, where there were few ancestral estates to speak of and where modern villa and cottage design was a matter of great public interest. In America, the aristocratic symbolism of the castle was suspect, and a different picturesque doctrine was required. Here there was little sympathy for the Tory view of landscape promulgated by Repton and Knight, with its reverence for continuity of ownership; instead a universal consensus held that the conquest of nature and the improvement of the landscape was America's providential destiny. Nonetheless, the unfolding of this destiny was traumatic. In 1826 the Erie Canal opened, connecting New

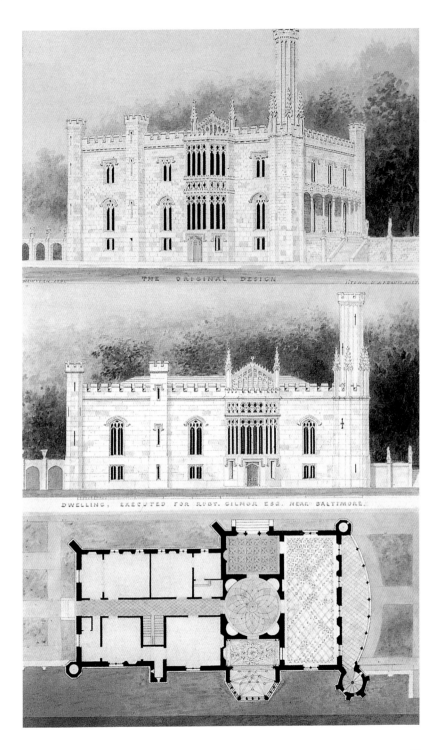

THE ORIGINAL DESIGN

DWELLING, EXECUTED FOR ROBT. GILMOR ESQ. NEAR BALTIMORE.

York City to the American interior, and transforming the majestic Hudson River into something of an industrial corridor. This event, coupled with the rapid deforestation of the settled regions, unleashed a great wave of nostalgia for America's vanished forests. In painting this led to the Hudson River School; in literature to the Leatherstocking Tales of James Fenimore Cooper (who admired Walter Scott so much that he visited Abbotsford and modelled his own house after it). The canal's completion also coincided with the introduction of the naturally landscaped park, which had been irrelevant during the initial period of settlement. The new mode was introduced, strangely enough, in several rural cemeteries – Mount Auburn, near Boston (1831), and Laurel Hill, Philadelphia (1836) – where the conventional classical monument now competed with a rising tide of Gothic tombs and chapels.

The mania for Gothic cottages followed, and the Hudson River became the showplace of the new style. Here was some of America's most picturesque scenery and here was poured the commercial wealth that was transforming it. A. J. Davis (1803–92) and his friend Andrew Jackson Downing (1815–52) were the leading figures of the movement, the former its most imaginative designer and the latter its outstanding theorist. Downing's influence was sensational. Like Loudon, his model, he too was a landscape architect who was inevitably drawn into architectural matters. He produced a torrent of gardening manuals and pattern books which culminated in *The Architecture of Country Houses* (1850), America's first great work of architectural theory. Downing brilliantly presented English landscape theory and its fashionable Gothic architecture – which had arisen in a nation whose understanding of history and landscape was almost diametrically opposed to prevailing American views – in a way that was acceptable to American patrons. Downing recognized that American attitudes towards art were still coloured by the Puritan heritage. Art was still perilously close to being a 'graven image', disallowed by the Second Commandment, although it was tolerated if it was useful. Here Downing found his opening, repeatedly stressing the utility of the picturesque cottage, not only in crassly functional terms but in moral terms as well. For him the cottage was an instrument of moral improvement. Rather than evoking medieval nostalgia and cultural continuity, as in England, he praised the cottage as a symbol of Republican simplicity, unaffected natural life and an absence of pretence.

Downing created the foundation for the picturesque American suburb, of which Llewellyn Park, New Jersey, with its Gothic houses and picturesque wooden 'ramble', was the first example. This was the democratization of the picturesque landscaped garden of Uvedale Price and Humphry Repton, its visual irregularity and continuity preserved even as it was carved into saleable parcels. These picturesque suburbs remain the preferred model for American living to the present. Although their specifically Gothic features have been abandoned, modern suburban tracts continue to be characterized by architectural informality, winding serpentine roads and continuous swaths of lawn. Probably no other contribution of the Gothic Revival to the form of the modern world was so sweeping, or is so little recognized.

47, 48 Davis's design for 'A Lake or River Villa' was widely distributed in A. J. Downing's *Architecture of Country Houses* (1850) and paraphrases are found throughout the United States. Seldom did the imitators work so rigorously to achieve 'local truth' as Davis and Downing did. Here the sprightly roofscape of gables, dormers and chimneys mimics the jagged lines of the distant mountains.

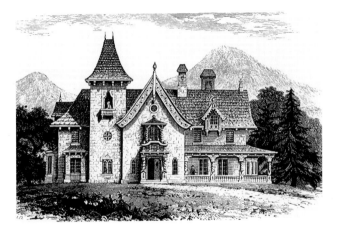

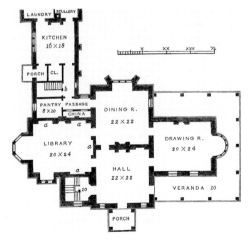

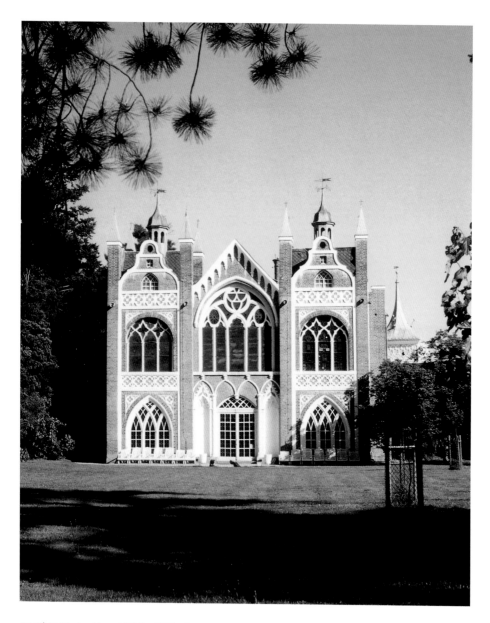

49 The Gothisches Haus at Wörlitz, 1783–1813, was
designed by the Duke of Anhalt-Dessau's valet-cum-
architect, Georg Christoph Hesekiel. Just as he dressed
his prince, Hesekiel draped his building in fashionable
English garb, applying Gothic detail in stucco and plaster
to the house's brick core to strike a festive Venetian note.
For its windows, genuine sixteenth- and seventeenth-
century stained glass was reused.

Chapter 3: Nationalism

A German ought to thank God to be able to proclaim aloud: that is
German architecture, our architecture... the Italian can boast none of
his own, still less the Frenchman.

J. W. von Goethe, *On German Architecture* (1772)

By 1800 most of the elements of the mature Gothic Revival were
already in place in England. Substantial and handsome buildings
were being built, informed by ever more accurate archaeology,
and there was a growing tendency to link the style with medieval
piety and Christianity. There were also the first glimmers of
awareness that the essence of the Gothic comprised its structure
rather than its ornament. England's wealth and cultural prestige,
assured by the defeat of Napoleon in 1815, guaranteed that these
ideas would gain an international audience. The only exception
in this pattern of leadership was in the field of aesthetic philo-
sophy, never a strong suit in traditionally empirical England.
Here Germany contributed one of the most alluring ideas of the
entire Gothic Revival, that the Gothic was an expression of
exalted creative genius.

In many respects, Germany was closer than England to the
Middle Ages, which accounts for the different course of her
Gothic Revival. The Reformation and Thirty Years War had
delayed German development and brought about severe depopu-
lation, resulting in a less industrialized and far more agrarian
landscape than in England or France. In political and social orga-
nization, Germany remained feudal in structure, fragmented on
primarily religious lines into thirty-eight principalities. Likewise
her physical character was strongly medieval, preserving a living
tradition of half-timber construction. And although the home of
the protestant Reformation, Germany had been spared the worst
ravages of iconoclasm, most churches still possessing their eccle-
siastical furnishings and art, unlike England.

At the start of the Revival, German patrons ignored this
legacy of Gothic survival and the movement began as an
imported affair, swept in with a general enthusiasm for English
fashion. At Wörlitz the Duke of Anhalt-Dessau built two houses,

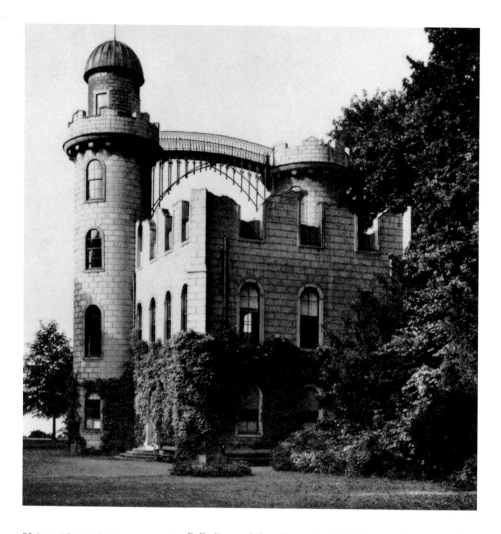

50 In good German fashion, artificial ruins were made tidy. The faux castle on the Pfaueninsel in Berlin, designed by J. G. Brendel (1791–96), looked more like a building interrupted in the process of construction than a mouldering heap of stones. Below the contrived ruin a working dairy was installed.

one Palladian and the other a Gothic folly, both of them English affectations. The Gothic house was a plaything, a frolic in the spirit of William Kent's rococo Gothick, with playful ogee arches to remind the Duke of his journeys to Venice. Its style was half a century out of fashion in England but sensational in Germany. Another English import, a taste for Gothic ruins, came in with the German mania for laying out naturally landscaped English gardens. So strong was the demand that a journal was launched in 1796 – Johann Gottfried Grohmann's *Ideenmagazin für Liebhaber von Gärten, englischen Anlagen*, etc. – to illustrate tasteful garden pavilions and cottages, a good portion of which were Gothic. Grohmann made pastiches of English pattern books,

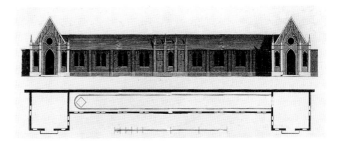

51 Illustration from Johann Gottfried Grohmann's *Ideenmagazin für Liebhaber von Gärten, englischen Anlagen* etc.: medieval pageantry enlisted in the war against boredom, adapted here to a skittles alley (Kegelbahn), fitted against the wall of an aristocratic pleasure garden.

sometimes to ludicrous effect, or purloined them outright. When German architects had first-hand knowledge of recent English architecture, the results were more learned. This was the case with Heinrich Christoph Jussow (1754–1825), architect of the Löwenburg at Wilhelmshöhe, a mock castle for Landgrave Wilhelm IX. Unlike the two-dimensional scrim at Wörlitz, the restless Löwenburg was executed in cut stone, the details meticulously drawn from medieval precedent and organized in an ensemble of considerable drama and conviction. This was an exception, however, and in general these works of garden Gothic were hothouse creations, not the outgrowth of an indigenous tradition. In the realm of theory, however, far more serious and original contributions were being made. The decisive work was Johann Wolfgang von Goethe's meditation on Strasbourg cathedral, ambitiously entitled *Von deutscher Baukunst* (On German Architecture, 1772). Although the arch-classicist Goethe later disavowed his youthful medievalism, his essay was prophetic for the future course of the German Gothic Revival.

Goethe was no antiquary and had not the slightest interest in deciphering the stylistic grammar of Strasbourg cathedral; what excited him was its very incomprehensibility. His essay opens with a futile search for the tomb of Erwin von Steinbach, then believed to be the cathedral's architect (now credited with the design of only a portion of the facade); later, Goethe dozes in the cathedral and the architect's spirit comes to him in a dream. Erwin's creativity is presented as the outcome of intense feeling and imagination, poured out as if in a fever, and congealed in stone. Likewise its swirling skeins of tracery and crockets could not be understood rationally but must be experienced in a state of emotional rapture: 'An impression of oneness, wholeness and greatness filled my soul – an impression which, because it consisted of a thousand harmonizing details, I could savour and enjoy, but by no means understand or explain.' In this was an

52

emotion akin to religious reverie, although for Goethe, something of a pagan, this was less Christian than it was romantic pantheism, perceiving divinity manifested in all things.

Goethe's *Von deutscher Baukunst* introduced the notion of the Gothic as an expression of unconscious spiritual energy. The concept had terrific potency in Germany. Georg Forster's *Ansichten vom Niederrhein...* (1791–94) compared the Gothic to 'phenomena out of another world, like fairy palaces, set there to provide evidence of the creative power in man'. There was no counterpart to this thought in England. To be sure, Goethe's exalted idea of creativity was not original to him but owed everything to Jean-Jacques Rousseau, who was then promulgating the cult of the romantic genius. Goethe merely applied it to Gothic architecture, adding the incendiary notion that this genius was the collective spirit of the German nation and demanding that it be called 'deutsche' architecture. The old jibe that the Gothic was a German invention now rebounded into a badge of national honour.

Goethe's essay inspired a wave of patriotic scholarship. Friedrich Gilly, the youthful architectural genius, dazzled Berlin in 1795 when he unveiled his sepia drawings of the Marienburg, one of the most important Gothic monuments of Eastern

52 No German princeling built a more fanciful piece of living theatre than Landgrave Wilhelm IX, whose Löwenburg at Wilhelmshöhe was both pleasure palace and mausoleum. Guarded by a sentry in medieval garb, it was the first of a long line of German romantic castles, which would later pallisade the Rhine and beyond, stretching from Bavaria to Disneyland.

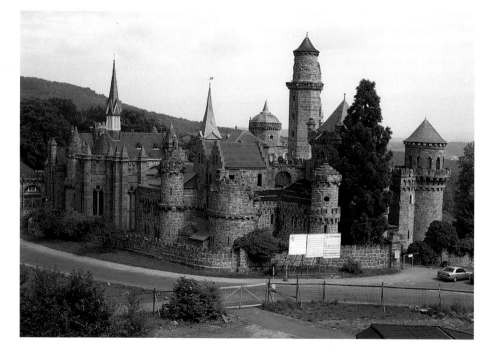

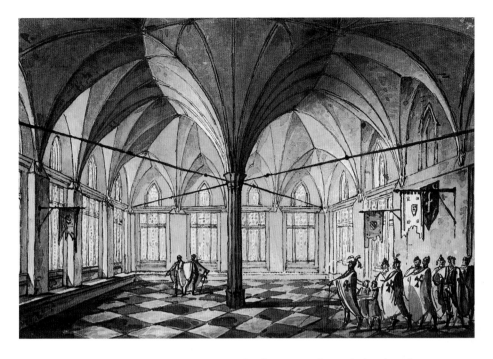

53 Friedrich Gilly published
Schloss Marienburg in Preussen
in 1799, calling attention to
northern Germany's brick
architecture and helping inspire
Schinkel's subsequent restoration
of the abandoned castle. Gilly
conflated romantic imagery with
practical preservation concerns, a
mixture that came to characterize
the Gothic Revival in Germany.

Prussia, now Poland. It was a clever choice since for protestant Prussia, as for England, the spectre of Catholicism still clung heavily to the Middle Ages. These associations did not taint the Marienburg, which was a secular monument, the great fortress of the Teutonic Knights and their redoubt to the East. To Gilly's contemporaries it was a symbol of Germany's holy mission to civilize Europe. In the wake of the French Revolution and the subsequent Napoleonic invasions, these political overtones only grew stronger.

Such patriotic interpretations of the Gothic could not always be squared with the archaeological evidence, a perennial conflict in German scholarship. Friedrich Schlegel approached these issues with exceptional clarity in his writings, beginning with his *Briefe auf einer Reise* (1806). There he followed Romantic doctrine by asserting that the Gothic aspired to the 'Infinite', unlike the closed and contained forms of classical tradition. Far from being freakish and disordered, Gothic forms had an 'organic complexity' like that of the natural world, where simple primary forms give rise to ever more complex organizations. This was an echo of Goethe and Forster, but for once Schlegel examined the buildings themselves with care, becoming the first German to distinguish systematically between the Gothic and the

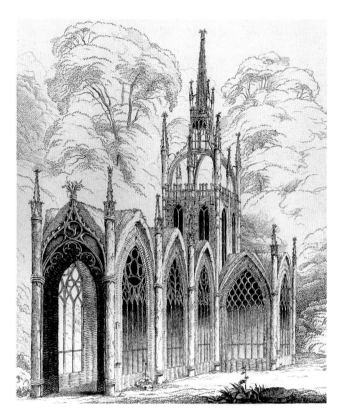

54 Sir James Hall's design for a 'Wicker Cathedral,' from his *Essay on the Origin, History and Principles of Gothic Architecture* (illustrated edition, 1813). The idea that Gothic architecture emerged out of the forms of trees exercized a considerable pull in Germany, whose forests were powerful patriotic symbols. Hall, a noted geologist, refined the idea by claiming that Gothic ornament was derived from woven forms and basketry. Friedrich Schlegel was the first to use archaeological evidence to refute such theories.

Romanesque. He furthermore noted the close correspondence of the physical forms of the Gothic with its spiritual function, stressing its explicitly Christian character, a theme that had not interested the enlightened eighteenth century. For Schlegel, Christian meant Catholic, a reading which many protestants took pains to refute, with fateful consequences for the revival in Germany.

Schlegel's intelligent scholarship cleared away much of the clutter of romantic nonsense clinging to the Gothic. He rejected its alleged vegetal origin, an idea probably drawn by analogy with classical architecture, with its myth of an original primitive hut of tree trunks and branches. This was a hardy myth, impossible to extirpate, for it offered a satisfying way of explaining the bewildering clutter and complexity of Gothic forms. But if the antecedents of the Gothic were really to be found in the forest canopy, the Romanesque style – its immediate predecessor – ought to have even more striking evidence of vegetal forms; it did not, Schlegel observed. He also addressed another durable myth,

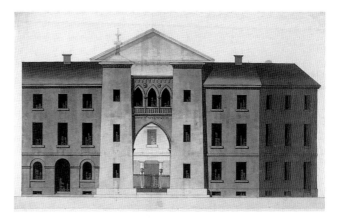

55 Friedrich Weinbrenner's Karlsruhe Synagogue, 1797, was the first of a series of Gothic synagogues in Germany. A Gothic arch and arcaded loggia were suspended between sharply battered Egyptian pylons, while the synagogue entrance itself was in the Greek Doric style. Later architects built Gothic synagogues but on different historical premises. Edwin Oppler, Germany's most important synagogue architect of the late nineteenth century, argued that since there were large Jewish communities in thirteenth-century Germany, the Gothic was historically appropriate.

that the Gothic was eastern or 'saracenic' in origin. This was a widely held belief in eighteenth-century Germany, traceable, so it seems, to Christopher Wren; by 1789 the art critic Alois Hirt was speaking confidently about *'Arabischgothische'* architecture. This too Schlegel refuted, although the notion had one direct architectural consequence: the Gothic synagogue, which was felt to be a fitting expression of the Eastern sources of Judaism. The first of many of these was the odd Karlsruhe synagogue, an eclectic melange by Friedrich Weinbrenner that freely blended Gothic, Egyptian and Greek elements.

The theoretical advances of Goethe, Forster, Schlegel and other Romantics liberated Germany from the stultifying doctrine of association. According to that theory, a work of art was secondary to the associations it produced; it was the degree and multitude of mental images that determined its quality, not its materials or correct proportions. Such thinking produced the caricature Gothic of the landscaped garden or coquettish ruins

56 The Drill Hall in Berlin, 1799, represented something new in Gothic architecture. Where architects like Wyatt drew Gothic fantasies and then translated them haphazardly into brick or stone, this building was the logical realization of its structural system. Unlike Wyatt's work, its facade was the last thing to be designed, rather than the first.

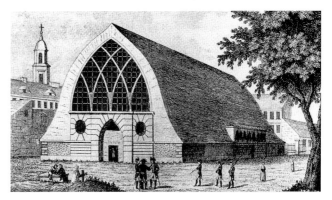

57 Caspar David Friedrich's *Abbey in Oak Forest*, 1809, ostensibly depicts the burial of a monk near the choir of a ruined Gothic abbey, hemmed in by gnarled oaks whose agonized limbs underscore the bleakness. To Friedrich's viewers these national symbols would inevitably have recalled the prostration of Germany under French occupation, and the hope of imminent dawn.

like that on the Pfaueninsel, Berlin. But Goethe and Schlegel took the Gothic seriously as architecture, in its own right and in terms of its own intrinsic properties, more than a mere instrument for communicating sensations. German architects made the most of this lesson. Encouraged to explore the architectural as opposed to the literary qualities of the Gothic, they produced works of daunting originality. Material backwardness also played its part. Germany's reliance on wood construction, with its lightness and flexibility, allowed unusual imaginative freedom in composition and form. In 1799, a bold drill hall was built in Berlin, based on the curved roof truss type invented by the sixteenth-century French architect Philibert de l'Orme, a form which David Gilly (Friedrich Gilly's father) revived. Here it was expressed in the form of a colossal Gothic arch, free of any associational paraphernalia or the customary cladding of finials and crockets. In its crystalline structural logic it suggested the technostatic principles underlying a Gothic cathedral, if not its literal forms.

This promising beginning was cut short by the Napoleonic wars. During the peak of the French occupation, from 1808 to 1813, German art turned chauvinistic and frustrated national sentiment was sublimated in metaphors of sturdy oaks, endless forest and gloomy ruined abbeys. Caspar David Friedrich com-

bined oak trees and Gothic architecture, conflating both the pagan and Christian symbols of German identity. Architecture requires more resources than painting or literature, however, and was slower in reflecting the national awakening. The occupation awakened the patriotic sentiments of the Prussian architect Karl Friedrich Schinkel (1781–1841), who had been trained by David and Friedrich Gilly as a classicist. Now he produced a cluster of Gothic projects, including a cathedral for Berlin and a poignant mausoleum for the Prussian queen. These were designs of great poetry, their masses dissolved to slender filaments, glowing with mystic inner light, but they exceeded the meagre resources of occupied Prussia. Only on canvas was his vision realized.

With the defeat of Napoleon in 1814, Gothic nationalism reached its zenith. To commemorate the German liberation, various classical monuments were proposed but the historian and critic Joseph von Görres (1776–1848) condemned them as symbolically inappropriate. Germany required a German monument, he insisted – in other words, a Gothic one. He suggested the unfinished cathedral of Cologne. Begun in 1248 as Europe's largest cathedral, only the choir, part of the south tower and a few

58 Cologne Cathedral as it stood in 1798, its construction crane idle atop the south tower while only the immense choir stood complete, looming above the houses that were built against its walls. Engraving by Johannes Ziegler after a drawing by Lorenz Janscha.

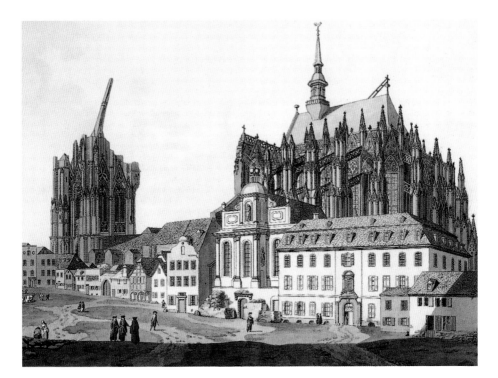

other fragments were finished when work was halted in 1560. To Görres this made the cathedral a fitting metaphor for Germany: 'In its ruinous incompletion, it is an image of Germany…. Likewise it will be a symbol of the new empire that we want to build.' Görres's proposal to complete the construction of the cathedral was reinforced when the antiquary Sulpiz Boisserée acquired two medieval drawings that showed its facade as originally envisaged. Using them as a guide, Boisserée prepared a portfolio of drawings of the completed building, contrasting it with its present disfigured state.

The effort faltered at first. With the impetus of invasion and national humiliation removed, the Gothic Revival lost its patriotic urgency. In fact, Görres's incendiary language about national unity threatened the dynastic authority of the principal

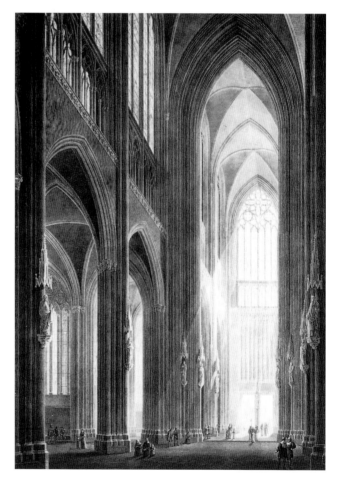

59 View of the nave of Cologne Cathedral, from Sulpiz Boisserée's *Ansichten, Risse und einzelne Theile des Doms von Köln* (1821). Together with his brothers Melchior and Bertram, Boisserée came under the influence of Schlegel and began to collect and document the medieval art of the Rhineland. His study of Cologne Cathedral began in the winter of 1808, widely felt to be Germany's moment of greatest national humiliation.

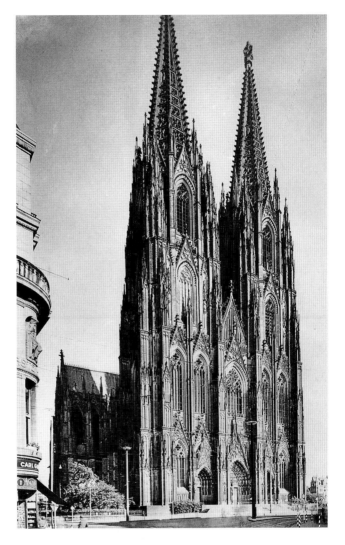

60 Cologne Cathedral, begun in 1248, abandoned around 1560, and then completed 1840–81. Zwirner's facade closely followed the design shown in the drawings of *c.* 1300 recovered by Boisserée. Only the lower two stages of the southern tower (on the right) are authentic medieval construction.

German states. Agitation for nationhood was regarded with icy disfavour by the kings whose legitimacy had just beenconfirmed by the Treaty of Vienna. The public buildings of Berlin, Munich and other German capitals turned instead to Greek models, projecting an image of enlightened city-states. Schinkel himself returned to classicism and his occasional essays in the Gothic became more earthbound, losing their romantic aspiration to infinity. His Friedrichs-Werdersche Kirche (1824–30) had the volumetric clarity of neoclassicism, with its strongly marked boundaries and decisive balustrade, neatly shearing off any

63

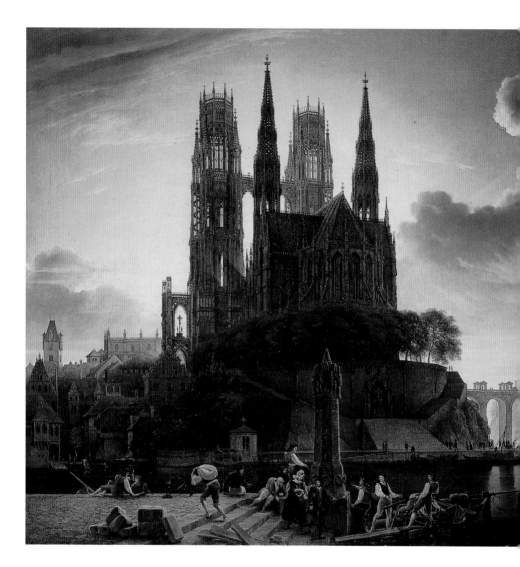

61 Karl Friedrich Schinkel's *Gothischer Dom am Wasser* (1813) implausibly combines the two great loves of German Romanticism – Gothic architecture and Italian landscape. The cathedral is a fantasia upon Cologne, transplanted onto a hill, so that the setting sun flares through the openwork spire and dissolves it into the infinitely writhing filigrees that had charmed Goethe.

unruly finials and avoiding a vertical Gothic roofscape. All of the delirious reverie that Goethe had experienced in the style was now extracted, leaving a highly rational and comprehensible Gothic. During these years Schinkel drew up proposals for completing Cologne Cathedral, which were alarmingly classical. He would have placed a flat roof over its nave, truncating the building and giving it stubby towers. It was the solution of a frugal state servant, no longer the ardent Romantic. It would have been an artistic disaster of the first magnitude and fortunately nothing came of it.

62, 63 Two phases of Schinkel's Gothic practice. His War of Liberation Monument, Kreuzberg, Berlin, 1818–21, built in cast iron, shows a Romantic vision of the Gothic much like his youthful medieval paintings. His Friedrichs-Werdersche Kirche in Berlin, based on the late Gothic collegiate chapels of England, was more sober. Its austere and cubical massing reflected his mature belief that the Gothic could be improved through correction and discipline of its proportions (a belief he shared with Batty Langley).

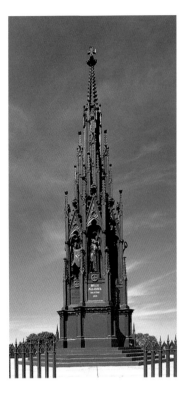

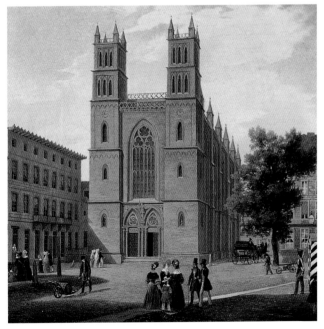

Despite official opposition, the longing for German unity remained strong, especially among university students, who assigned political significance to medieval imagery. Students read Romantic novels, grew beards – a medieval gesture – and organized *Burschenschaften*, fraternal societies patterned after medieval guilds. (This medievalism was not always benign; in 1819, at the notorious nationalist rally on the Wartburg, students revived the medieval practice of book-burning.) Many young architects, including such future luminaries as Heinrich Hübsch and Friedrich von Gaertner, gravitated to the Gothic to proclaim their political liberalism, perhaps also to irritate their classicist elders. Gradually the political meaning of the Gothic changed. Because these were the very years in which Germany was painfully moving toward nationhood, architectural style inevitably acquired political ramifications. The choice of architectural style conjured a particular vision of Germany identity, whether constitutional monarchy or free republic. Now it was asserted that it flourished during the era of Germany's greatest political freedom, the high Middle Ages, when the politically independent cities of the Hanseatic League practised self-government, and a vigorous culture of voluntary associations and guilds characterized urban life. This was the insight of Joseph von Görres, the first to bring political and social analysis to his appreciation of Gothic architecture. Unlike Goethe's abstract love of the Gothic, Görres's medievalism was informed by the lessons of recent political history. He identified the centralizing of power in the omnipotent state as a pernicious hallmark of modernity, which distinguished both regimes of the left (the French Revolution) and of the right (Prussian reaction); the consequence was tyranny. Against this he juxtaposed medieval society, which decentralized political authority among various princely, religious and municipal entities, each serving to check and offset one another. Thus Görres took the German revival from the romantic phase, with his 1814 call for completing Cologne Cathedral, to its mature mid-century phase.

Görres's ideas were put in action by Theodor Bülau (1800–61), a Gothic firebrand in Hamburg who insisted that the Gothic was the 'free creation of Republican peoples', by which he meant those northern races that had not been subject to Roman authority – i.e., the Germans, English and Scandinavians. In 1845 Bülau built the house of the Patriotische Gesellschaft, a cooperative society which served a wide array of cultural and social functions, suggesting the thriving medieval civic associations

64 Theodor Bülau's building for the Patriotische Gesellschaft in Hamburg, 1844–45, was one of the first German buildings based on the anonymous domestic and commercial architecture of the Middle Ages. The city's political independence and strongly commercial culture made Hamburg much more receptive to medievalism than other German cities, where architecture was dominated by the taste of the royal court and state architectural bureaucracy.

praised by Görres. The building was a bold essay in the local brick vernacular, with little ornamental detail other than that provided by its robust array of pilaster strips, belt courses and corbels. Bülau's vernacular came to exert a great influence although for the moment most of his contemporaries eschewed the Gothic for the Rundbogenstil, or 'round-arched style'. This was a synthetic style based on Romanesque, Byzantine and other prototypes, although its theory was influenced by Gothic doctrine, respecting the properties of materials and treating form as the direct expression of construction. In this the Rundbogenstil differed from classical doctrine, which treated form in ideal terms, to which the process of construction was subordinate. It also differed from classicism in its defiant nationalism. Here it took its patriotic symbols not from the high Middle Ages, cherished by Gothic Revivalists, but from the twelfth century, when the Holy Roman Empire, and German culture and political power, was at its apogee. The Rundbogenstil was swiftly

65 Johann Claudius Lassaulx, St Arnulph's, Nickenich, 1846–49. Despite its round-arched windows the church is Gothic in spirit, its strident surface colour clearly delineating its structural piers of black basalt from its infill of sandstone rubble. Like most revival churches in Germany, it is entirely vaulted in stone.

embraced as an alternative to the Gothic in both progressive and protestant circles, which preferred a medievalism stripped of Catholic and mystic overtones.

Despite the popularity of the Rundbogenstil, the Gothic retained the patriotic prestige of the Napoleonic wars, still evoking the hope for a constitutional Republic. Now it took on another, quite different meaning, neither pan-Germanic nor liberal but Catholic. In the Rhineland, annexed by protestant Prussia in 1815 and now roiled by Rhenish separatism, this association was particularly forceful. These different interpretations converged violently around Cologne Cathedral in 1837. In that year the Prussian authorities arrested and confined the Archbishop of Cologne for defying Prussian law on mixed faith marriages, an action that unleashed furious sectarian strife. Only with the death of the Prussian king in 1840 and his replacement by Friedrich Wilhelm IV, a tolerant and artistically inclined ruler, did the furore subside. The new monarch eagerly promoted the completion of the cathedral, a brilliant ploy that simultaneously assuaged Rhenish Catholics and linked Prussian munificence with a pan-Germanic symbol.

Had the cathedral been begun in 1815 it might well have been the great monument to pan-German nationalism that Görres

envisaged. As it was, the cornerstone was laid in 1842 and the cathedral was built over the next four decades with much more tangled associations in which Catholicism, Rhenish separatism and pan-Germanic ambition intertwined, and not always pleasantly. It was intended to complete the building exactly as it had been designed, although this was easier said than done. The few surviving drawings did not always agree with the actual medieval construction, forcing the architect, Ernst Zwirner, a pupil of Schinkel, to extrapolate from the conflicting evidence. His transepts were original creations, splendidly scaled, respecting the original fabric but without tentativeness or hesitation. Equally as important as Zwirner was August Reichensperger (1808–95), a Catholic judge, political leader and author, the most influential member of the cathedral building society. He watched over building operations as a kind of Gothic conscience, speaking for scrupulous archaeological fidelity and fighting against every use of modern materials, even the iron of the roof truss, although it would not be visible. Reichensperger also fought against the establishment of a lottery to pay for construction, wishing instead that it be funded by private donation, as in the Middle Ages. He lost these battles but the tug of war between him and Zwirner ultimately benefited the project.

Ironically, Reichensperger also personally removed one of the linchpins of the Gothic Revival: the myth of German origin. Until the 1840s it was still widely believed that the Gothic was first developed in Germany, despite an increasingly accurate chronology which now clearly pointed to France. German scholars adopted a fallback position: if the Gothic was not begun in Germany, it was perfected there, with Cologne Cathedral the apotheosis of the Gothic. Reichensperger dispelled the myth in an 1845 article in the *Kölner Domblatt*, the journal of the Cologne Cathedral building society. In it he followed the chronology still used today: the Gothic style originated in the Ile-de-France in the early twelfth century, reaching its High Gothic perfection in the early thirteenth century at which time the style moved into Germany. Not only was the German Gothic later than the French, but its most revered monument was derivative. Reichensperger clearly showed that the most German of all cathedrals was modelled quite closely on that of Amiens. This was a jolt to German nationalists, particularly to furious Boisserée, but the episode marked the changing of the guard. The German revival now shifted from a chauvinistic preoccupation with German identity to a more international movement, in

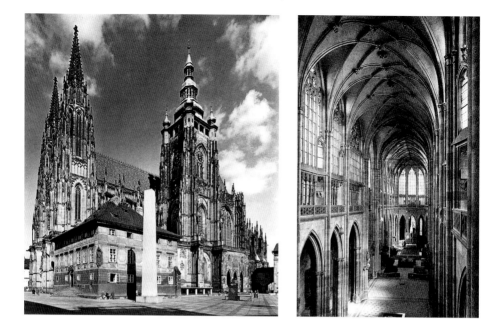

66, 67 Kranner's west front of St Vitus's is an imaginative speculation as to the kind of facade Parler might have intended for his cathedral. Its details are late Gothic, although purged of the frivolity and florid qualities that led most nineteenth-century theorists to condemn the style.

lively and fertile contact with its English and French counterparts, with a richer understanding of the style as the product of cultural, social and religious forces.

Because of its prolonged period of construction, from 1840 to 1880, Cologne Cathedral dominated the course of the German Gothic Revival. It gave it a strongly conservative character, unlike England, for example, where the most important Gothic Revival works were new buildings, like the Houses of Parliament. Cologne's example was widely imitated in Germany and the Austro-Hungarian Empire, most importantly at St Vitus's Cathedral in Prague, the principal work of the celebrated Peter Parler (1333?–99). Parler was an innovator of net-vaults, which dissolve the visual boundaries between each vaulted bay, creating the spatial continuity that distinguished the Late Gothic, of which St Vitus's was an essential monument. When its construction was abandoned at the end of the Middle Ages, only the choir, transepts and the lower stages of the massive south tower had been finished. In 1861, inspired by the example of Cologne, work was taken up again. In this a considerable role was played by nascent Czech nationalism, one of many movements burgeoning throughout the unstable Austro-Hungarian empire. The project was entrusted to Joseph Kranner (1801–71) who followed the policy of Reichensperger at Cologne: scrupulous copyism where

original elements survived and intelligent but cautious speculation where they did not. The result is a triumph of the German Gothic Revival, on the order of Zwirner's bold north transept for Cologne. Kranner showed that the sensitive completion of a medieval building, far from being a routine exercize in copyism, is an artistic challenge of the highest order.

Awakening nationalism helped bring about the completion of medieval buildings in other countries, particularly Italy. Like Germany, Italy was not united until the second half of the nineteenth century although here the architectural problem was different. It is a peculiarity of Italian architecture to build churches and to use them for centuries without ever giving them a facade. This is made possible by building in rough, unfinished masonry, which can then be revetted in slabs of fine coloured marble – or not. Milan Cathedral was the first to receive a neo-Gothic facade, predating even the initiative to complete Cologne. In 1806, following his conquest of Italy, Napoleon demanded that the fourteenth-century cathedral was given a new facade – one of the few instances of his art patronage extending to a medieval

68 Milan Cathedral, with its facade as completed in 1806–13. The confused national currents of the Gothic Revival swirl around it: a French emperor commanding the completion in Italy of a German Gothic cathedral.

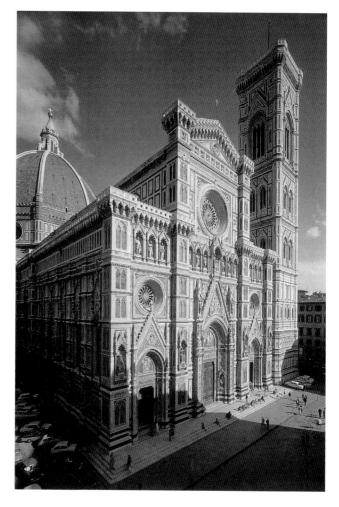

69 The facade of Florence Cathedral, 1867–87, by Emilio de Fabris. Rather than imitating a contemporary medieval facade, such as that of Siena or Orvieto, de Fabris made a grand summary of the architectural ideas surrounding it, particularly the bulky machicolated cornice of Giotto's adjacent campanile.

monument. A Gothic facade and gable was accordingly fitted above Milan's already existing lower storey, which consisted of three strictly classical portals. No more incongruous juxtaposition of styles appeared in the course of the Gothic Revival, and yet the effect is not as jarring as one might think, perhaps because the consistent bright marble construction reduces the discordance. By the 1880s, as taste turned to the more rigorously archaeological, the facade was regarded as an embarrassment and an ambitious competition for a replacement was held. In the end the prudent decision was taken to leave the building alone.

The course of action at Milan was repeated throughout the century. Santa Croce in Florence (1857–63) and the cathedrals of

Florence (1867–87) and of Naples (1877–1905) were all given historicizing facades, growing ever more scholarly in character. Of these Florence Cathedral was the jewel, its unfinished facade having vexed architects since the Renaissance. Here, as with Cologne Cathedral, the deadlock was broken by a king anxious to please and flatter his newly won subjects. This was Vittorio Emanuele II, under whom the modern nation-state of Italy was formed in 1861. It took the new king a decade to win the city of Rome to his realm, during which time he resided in Florence, the cultural heritage of which he saw as a building block of Italian national unity. He personally took the initiative to complete the cathedral, contributing privately – like Friedrich Wilhelm IV of Prussia – a substantial amount of the necessary funds. After three rather inept competitions between 1861 and 1867, the commission was given to the architect Emilio de Fabris (1808–83). Mindful that the intention was a Florentine rather than a Gothic monument, de Fabris made a boisterous urban set-piece, relating his design to the existing cathedral but also to Giotto's adjoining campanile and to the richly polychromatic baptistery across the piazza.

Similar forces were in play in Portugal. Here the Napoleonic wars and the depredations of the French occupation galvanized nationalism, which King John VI encouraged, hoping to court the support of liberals. As in Prussia and Italy, the restoration of national monuments became a conscious instrument of state policy. This led to a revival of the Manueline Style, a supremely decorative style which had flourished during the prosperous reign of King Emanuel I (1495–1521), and whose forms were a curious mixture of late Gothic ornament and maritime imagery. While the forms were altogether unlike the High Gothic of Cologne or Milan, the Manueline Revival performed precisely the same cultural and political function as did the Gothic Revival elsewhere in Europe.

Despite these popular movements, the Gothic Revival never took on the urgent sense of mission it did in England and Germany, countries where strong Catholic–protestant tensions ran high. Despite numerous neo-Gothic and neo-Romanesque buildings during the second half of the century, no organized movement came into being in Italy, nor in Spain, France or any other predominantly Catholic country. But where religious minorities within divided populations sought to proclaim their identity, the Gothic could helped assert difference – and confidence. In Montreal, a predominantly French Catholic city within

English protestant Canada, one of North America's largest cathedrals, Notre Dame, was built in 1823–29. The architect was James O'Donnel, an Irishman and himself a member of a Catholic minority. His design was somewhat crude – an immense barn of a nave, enormous in capacity, with two superimposed galleries – but it was an attempt to make a Gothic space rather than mere Gothic ornament. The building was by far the largest neo-Gothic church yet raised, showing the growing self-assurance of Catholics under British rule, just on the eve of the passing of the Act of Emancipation.

Notre Dame also shows the limits of the doctrine of Gothic associationism. As a principle, associational theory made amusing pavilions and houses, and even poignant monuments which unleashed the power of their viewers' historical imagination. Nonetheless, it was hardly the basis for the making of serious and complicated buildings. These raised an endless barrage of questions – concerning materials, planning, decoration, the proper handling of details and ornament, the nature of originality and the role of the craftsman – which the casual stage-scenery principles of associationism could not pretend to resolve. Against this background the solitary figure of A. W. N. Pugin, the most important figure in the history of the Gothic Revival, strode forth.

70 Notre Dame Cathedral, Montreal, 1823–29. Throughout the nineteenth century, American and Canadian Catholics oscillated between medieval and Renaissance models – associating themselves either with medieval piety or with allegiance to Rome. Usually the impulse to make a visual distinction with the local protestant architecture was decisive. Notre Dame remained the most important Gothic cathedral until the building of St Patrick's, New York.

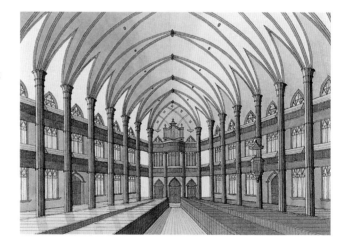

Chapter 4: Truth

There is nothing worth living for but Christian architecture and a boat.
A. W. N. Pugin

71 Holy Trinity, Cloudesley Square, Islington, London, 1826. Although a classicist, Charles Barry was able to design a Gothic church when necessary. His Holy Trinity gives an idea of his medievalism without the benefit of Pugin's counsel. Like many classically trained architects, Barry found it easier to design a convincing Gothic wall than a ceiling.

On the evening of 16 October 1834, fire blazed through the Palace of Westminster, home of English Parliament since the Middle Ages. The flames rising over the Thames suggested to Turner a hellish vision, and so he painted them, but to another Londoner they were perversely enjoyable. This was A. W. N. Pugin, who despised all sham Gothic but particularly that of James Wyatt, who had remodelled the palace with his customary low-cost contrivances. Now the destruction of 'Wyatt's heresies' amused Pugin mightily: 'Oh it was a glorious sight to see his composition mullions and cement pinnacles and battlements flying and cracking while his 2.6 [two shillings and sixpence] turrets were smoking like so many manufacturing chimneys till the heat shivered them into a thousand pieces.'

This disaster ultimately drew Pugin into the design of the new Houses of Parliament (1836–68), which inaugurated the mature Gothic Revival and gave the style the authority and prestige of a major building of state. No more would it be the garden sport of dilettantes like Beckford. There was never any question that the new Houses of Parliament must be Gothic: Parliament was itself a medieval institution, its Gothic associations not romantic affectation but literally true. Moreover, two genuine Gothic fragments survived, Westminster Hall and St Stephen's Chapel, which might set the stylistic key of the new complex. The ensuing competition stipulated 'either Gothic or Elizabethan' designs and produced ninety-seven entries, varying widely in quality. Among these antiquarian performances and collations of cathedral fronts, the design of Charles Barry (1795–1860) stood out by virtue of its startling artistic intelligence.

Barry specialized in the design of genteel London clubs, a reasonable preparation for designing Parliament – itself something of a great club – where comfort and ease of circulation were paramount. He was no Goth but a classicist, and was thus inoculated against the exhibitionistic medievalism that distracted his com-

81

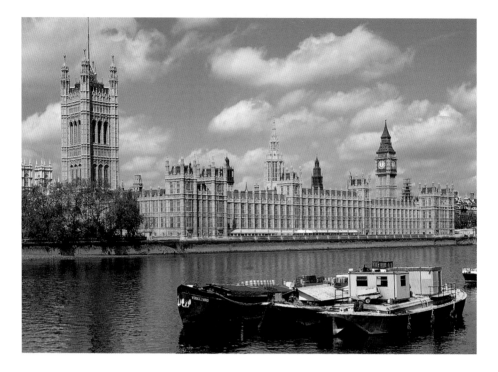

72 'All Grecian, Sir; Tudor details on a classic body.' So ran Pugin's famous dismissal of Barry's symmetrical facade, made to a friend while sailing along the Thames. The remark came to haunt Pugin's admirers, who took extraordinary measures to escape similar criticism, contorting their designs into conspicuous irregularity.

petitors. Superb classical discipline distinguished his design, as well as a scrupulous sense of scale. Barry recognized the threat of monotony in an 800-foot-long symmetrical facade and he broke it into shorter sections with a series of turreted pavilions, paired at either end. Any more variety would have compromised the sense of monumentality of the magnificent flank along the Thames. His only asymmetrical gesture was the pair of picturesque towers – the massive Victoria tower to the west and the slender clock tower to the right – that accented the periphery rather than the centre, which good classical practice would have preferred.

73 With a simple and lucid arrangement of two intersecting axes, Barry's plan for the Houses of Parliament organized a vast array of functions. A long spine running parallel to the Thames contained the House of Lords and House of Commons, poised at either side of a central lobby, where the cross axis also terminated. This served as the public corridor, which began at Westminster Hall, now reused as an entrance.

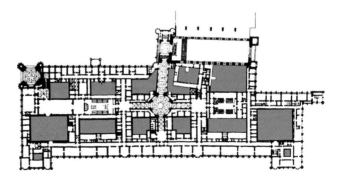

If Barry's Perpendicular-cum-Tudor facade was an exercize in political nostalgia, the building's construction was another matter. The invisible structure – foundations, construction, ventilation, heating, fireproof construction and the iron framing of its towers – was a triumph of industrial technology, making it the world's first large modern building, where the architect was forced to consider the mechanical systems as a central part of his task. Indeed, it was precisely these technical demands that compelled Barry to delegate the decorative aspects to Pugin. Pugin transformed the building – and the Gothic Revival.

Augustus Welby Northmore Pugin (1812–52) accomplished more than any other architect of the revival. Taught by his father, a refugee from revolutionary France who had worked in the office of John Nash, Pugin was a prodigy as a draftsman. At the age of twelve he was already helping prepare the plates for his father's *Specimens of Gothic Architecture* (1821–23). He seemed to possess an inexhaustible ability to supply intricate and elegant ornament, which he could draw by the yard, often while sailing alone in the North Sea on his small boat. It is easy to see why Barry, with acres of walls to panel and ceilings to decorate, turned to him. Between 1836 and 1837 and again from 1844 to his death, Pugin embell-

74 While the House of Commons was bombed during the Second World War, the House of Lords still retains most of Pugin's sumptuous decoration and fittings.

ished Barry's preliminary sketches with Gothic wainscoting, sculpture and tracery. This division of creative labour peculiarly suited to the two architects, each of whom felt he had designed the building – Barry, because he had devised the plan and composition, Pugin, because he had drawn every window, desk and inkwell, in short, most of the visible fabric of the building.

Pugin's facility with the pencil was incidental to his greatest achievement, which was to subject architecture to moral analysis. He had no terror of controversy, having already converted publicly to Catholicism in 1835, a career-damaging move in protestant England. The following year he produced a slim volume with a massive title, *Contrasts: or, a parallel between the noble edifices of the fourteenth and fifteenth centuries, and similar buildings of the present day; shewing the present decay of taste.* Its sixteen copper engravings juxtaposed the artistic creations of medieval

75 A. W. N. Pugin's *Contrasts* (1836) contrasted two types of 'residences for the poor,' a medieval almonry and a modern workhouse of the Panopticon type. Here the parallel was almost grotesquely overwrought – particularly the contrast between the burial of the medieval pauper, to the singing of monks, and his modern counterpart, crated for dissection. Nonetheless, Pugin was responding to the most pressing moral issue of the Industrial Revolution, providing the architectural equivalent of Dickens's *David Copperfield*, which also drew freely on caricature and comic distortion to make its moral case.

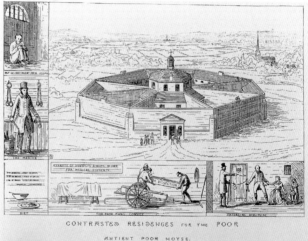

76, 77 In the 1841 edition of *Contrasts*, Pugin looked beyond the design of individual buildings to show how the moral health of a society as a whole was reflected in its physical form. Here a gentle landscape of church spires and abbeys was replaced by the remorseless geometry of smokestacks, gasworks and the lunatic asylum.

England with their modern equivalents, shaming the latter by comparison. *Contrasts* turned on a single insight: that architecture can not be judged apart from the society that produced it, a doctrine that instantly and permanently changed the terms of architectural debate. The revised edition of 1841 added several even more ferocious contrasts, a shocking indictment of Industrial Revolution England whose physical repulsiveness was claimed to be of a piece with its moral degradation. This was a world familiar to readers of Charles Dickens, who was born in the same year as Pugin.

Pugin's *Contrasts* was one of the nineteenth century's most heartfelt and anguished responses to the Industrial Revolution and it confronted the same shocks and ruptures as did another

78 Pugin's *True Principles of Pointed or Christian Architecture* observed that small and irregular individual stones produced a richer effect than larger, regular blocks, which tended to compete with the lines of the architecture. This concern for texture and surface effect was Pugin's great strength as an artist but also something of a weakness.

nineteenth-century thinker, Karl Marx. And, as is so often the case in revolutionary times, each found his model for reform in the age before the present. Pugin yearned for the humane and cohesive society of the Middle Ages, when a common faith and not capitalism was the organizing principle. Marx had no use for religion but his appreciation of medieval society and its communal and cooperative aspects resembled Pugin's, as did his horror at the dehumanizing nature of modern labour.

Confronted with an architecture and a social order equally vicious, Pugin sought to reform the former. The result was *True Principles of Pointed or Christian Architecture* (1841), his brilliant attempt to justify Gothic architecture on the basis of objective principles, easily one of the most influential architectural books of all time. Its doctrine was proclaimed in the very first paragraph: 'First, that there should be no features about a building which are not necessary for convenience, construction or propriety; second, that all ornament should consist of enrichment of the essential construction of the building.' Such principles seem in the nature of self-evident truisms – hardly revolutionary – but with them Pugin upended the whole apparatus of classical architecture (and most neo-Gothic architecture, for that matter). Every single element of classical architecture – from pilasters and entablatures to triglyphs and acanthus leaves – could be dismissed by his principles as 'constructed decoration', while Gothic buttresses or archivolts were celebrated as the 'essential construction' of a building, and hence worthy of decorative elaboration. Rather than prescribing a set of ideal proportions, as treatises on the classical orders did, *True Principles* stressed that forms were dependent on the physical properties of the materials used. Here again Pugin elevated a platitude into a radiant principle, 'truth in materials', a rallying cry that long outlived the revival.

With these heady principles, Pugin effortlessly took apart the frail doctrine of associationism. Gothic architecture was superior, not because of the accidental mental turbulence it might conjure up in spectators, but because of its intrinsic qualities – or so Pugin trumpeted. So dazzling was the promise of *True Principles* that Pugin's own architecture could scarcely live up to it. He produced a torrent of churches for Catholic (and occasionally Anglican) congregations, unsurpassed in their archaeological plausibility, artistic sense of ensemble and sheer quantity of historical knowledge. But rarely did he have a budget and client to match his ambition. When one appeared, such as the Earl of

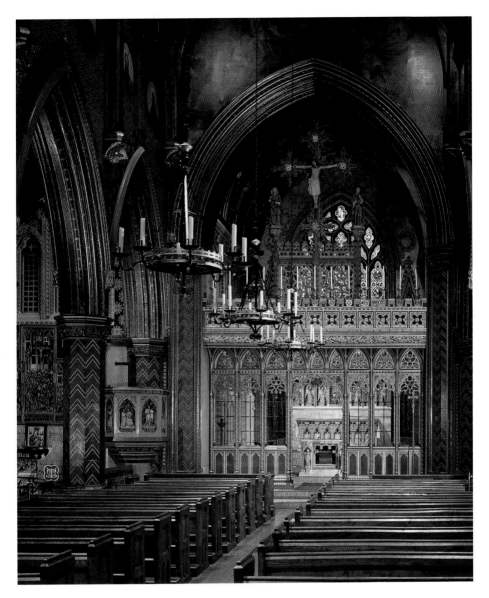

79 St Giles, Cheadle (1841–46) – 'Perfect Cheadle,' Pugin called it,
'my consolation in all my afflictions' – showed the architect at his
happiest. Its interior was a symphony in red and gold in which every
visible surface was enriched with painting, gilding, carving or the
coloured light that filtered through the stained glass. This was the
total sensory experience that Walpole and Beckford sought in
architecture and literature, but here disciplined and yoked in the
service of religious reverie. The composition was handled with
panache; a triumphant tower, as lofty as the church was long, lifted
joyously over the pinnacled dormers to terminate in a slender spire.

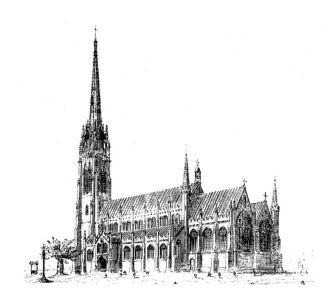

79

80, 81 The ideal church shown in Pugin's *True Principles* served as the model for Trinity Church, New York, built 1839–46 by Richard Upjohn. At a time when most American churches were rendered as white Greek temples, its brownstone walls were startling. The plaster vaults of the high nave required no flying buttresses, which accounts for the row of rather bewildered finials.

Shrewsbury, Pugin might produce something as splendid as the soaring church of St Giles at Cheadle. But his churches were generally stiff and boxy, and his Gothic remained that of a draftsman, linear and graphic, the ineradicable consequence of his early training. He never became the sculptor of volumes and masses that his successors would be, although he envisaged the Middle Ages with painful clarity, as a kind of dream just out of reach.

Pugin's doctrines spread swiftly. His influence was already apparent in Trinity Church, New York, the first masterpiece of Richard Upjohn (1802–78). Gothic churches were not unknown in America – in fact, Trinity itself replaced a 1788 building in the Wren-Gibbs Gothic mode – but these tended to be flimsy contrivances, in which pointed windows and spiky wooden finials at the corners were applied to buildings of meeting house character. Upjohn's own first design, prepared in 1839, was not terribly different from this type. But within months of its publication he evidently acquired a copy of *True Principles* for he revised his design to follow Pugin's design for an ideal Gothic basilica in the Perpendicular style. Instantly Upjohn catapulted the American revival from Walpole's Gothic to Pugin's. At the same time he deviated from the model in telling ways. At this early date there was no prospect of building genuine rib-vaulting in America, which lacked medieval precedents to drawn upon. The only choices were an exposed timber truss or a faux vault of plaster on lath; Upjohn chose the latter – heresy to Pugin, although he did it

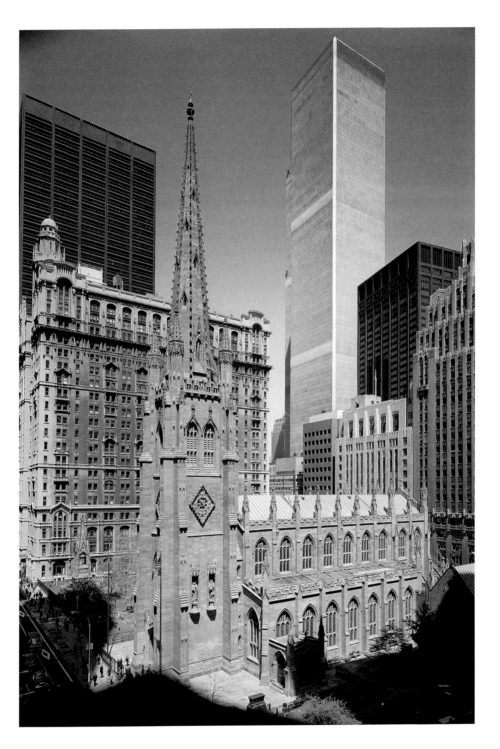

rather well. He also reduced the roof pitch of Pugin's design, and de-emphasized the chancel. Such adjustments would persist through the course of the revival as architects perforce modified English models in accordance with American taste and custom. These changes were invariably in the direction of simplification, a pardonable pattern in a country with a wood-building culture, which instinctively flattened its forms – or which received them pre-flattened, in the form of the patternbook illustrations that often provided the only acquaintance American architects had with real Gothic work.

Pugin was a jolly figure, working 'with no tools but a rule and rough pencil, amidst a continual rattle of marvellous stories and shouts of laughter'. But while he enjoyed great stature abroad, as a Catholic in a protestant country he could never win full acceptance as a reformer of religious architecture. Not until he himself was personally disassociated from his doctrine could the Church of England embrace it. This feat was the accomplishment of the Ecclesiological Society. During the 1830s the Church of England was engaged in the turbulent process of renewal. Three centuries after the protestant reformation, many felt the Church had become remote and spiritually unfulfilling. It had systematically eliminated all the vestiges of Catholic ritual and ceremony, insulating itself from Rome but it had also estranged itself from the livelier currents of protestant worship. The great evangelical revivals of the eighteenth century had made it wary of excessive emotionalism – the 'enthusiasm' dreaded by polite Georgian society – and in reaction against it, it had become even more stately and detached. Between these two poles of superstition and enthusiasm the Church languished; Kenneth Clark summed it up as 'cautious sermons in bleak churches'. Beginning in 1833, the first critical tracts were published, urging a revival of traditional forms of worship. No longer should worship concentrate solely on the spoken word of the sermon, but the sacred, sacramental rites should be revived, restoring the solemnity and mystery of pre-reformation worship. These tracts signalled the emergence of the Tractarian or Oxford Movement.

The Tractarian Movement arose during an age of fashionable antiquarianism, when architectural tourists would pause – Britton or Milner in hand – to admire a fine bit of Decorated tracery or a handsome Early English capital. Increasingly well informed, they would also notice how seriously the Reformation had altered these medieval fabrics, stripping their altars, walling up chancels, pulling down rood screens and even selling off the

lead from the roofs. Most of these depredations occurred long ago (chiefly during the 1550s, not during the later Puritan commonwealth, as is sometimes believed) but antiquarian knowledge had suddenly made them distressingly visible. Given the state of the Anglican Church and of English architecture, one could only lament this – at least until 1839. In that year the architectural thought of Pugin recoiled against the theology of the Tractarian Movement to produce that invincible alloy of architecture and moralism, Ecclesiology.

The Ecclesiological Society (called at first the Cambridge Camden Society) was formed by several Cambridge undergraduates, chief of whom were two future Anglican ministers, John Mason Neale (1818–66) and Benjamin Webb (1819–85), and a future Member of Parliament, A. J. Beresford Hope (1820–87). Their original goals were modestly antiquarian: to gather drawings and descriptions of medieval churches and to campaign for church restoration, reestablishing chancels and the altars within them. In this they resembled other antiquarian societies, such as the Oxford Society for Promoting the Study of Gothic Architecture, which attracted young John Ruskin as a

82 The Grange, Pugin's house at Ramsgate (1841), was attached to St Augustine's (1846), forming a kind of monastic enclave – recreating with poignant fidelity the vanished medieval world that Pugin brooded over in his *Contrasts*.

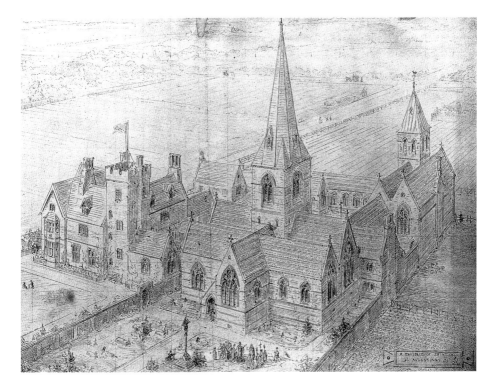

member. But in November 1841 they began to publish a monthly journal, the *Ecclesiologist*, and turned activist, taking church-building in its widest sense as their calling. The effect of their doctrines was instantly felt in every corner of England and the English-speaking world. Even granting the influential connections and wealth of their members, it is astonishing that such an influence was exerted by a group whose founders were just over twenty years old.

Like Pugin, whom they privately admired, the Ecclesiologists despised the faux Gothic churches of the previous generation, which they viewed as mere preaching boxes, glorified auditoriums in which galleries huddled around the pulpit to provide clear lines of sight and sound. Seeking to restore the concept of the church as a sacred vessel, they published *A Few Words For Churchbuilders* (1841) with its rigid strictures: first, the church was to be oriented to the East, as in the Middle Ages, pointing to the rising sun as a symbol of redemption; it must also be divided into two clearly demarcated precincts – a worldly and a sacred – reflected in the division between the nave and the chancel. This separation was to be emphasized – within by a prominent chancel arch and rood screen, without by differing height and treatment of the volumes. Further rules governed the placement of the baptismal font, the three steps leading to the altar, the custom of the southern porch and even the role of galleries (there were to be none). For the Ecclesiologists, these requirements were theological, not aesthetic. It so happened that they were consistently fulfilled only in the Gothic style.

The *Ecclesiologist* had one instrument at its disposal – and this was a bludgeon: the bracing review of new church designs that jolted every issue. The forty-year run of these reviews forms the most sustained corpus of intelligent and savage architectural criticism in English literature. None of the professional courtesy that usually restrains architectural criticism was at play here, for the critics were not architects but clerics, with no tolerance for architectural sins. A church was instantly condemned 'as bad as anything can be' or mocked as 'an odious structure rendered at once offensive by pretence, and ridiculous by failure'. Minor features such as window shape, moulding profiles and the arrangement of steps in the chancel were put to the question, and pronounced as orthodox or heretical. Even architects themselves were divided into goats and lambs, with Butterfield, Richard Carpenter and Benjamin Ferry marked as 'approved' while poor Charles Barry was placed on the 'condemned' roster.

83 At St Michael's, Long Stanton, Cambridgeshire, all the cardinal Ecclesiological elements were present in their most condensed form: the detached chancel oriented to the east, the south porch, and the compact nave and aisles, measuring a diminutive forty-nine by fourteen feet. The most useful feature was the elegant bellcote that crowned its western gable, a far more satisfying solution than the cramped and niggardly tower usually attached to small churches.

At first the *Ecclesiologist* had no confidence in modern Gothic and urged readers not to invent but 'to be content to copy acknowledged perfection'. By 1843 it decided that this perfection was to be found in the Early Middle Pointed style (or, to use Rickman's terminology, the early Decorated). Earlier styles were imperfect, later ones corrupt, but the architecture to either side of 1300 was perfection itself. The following year the *Ecclesiologist* began selecting models, measuring them and distributing scaled drawings to places where medieval examples were not at hand, such as Australia and the United States. St Mary's, Arnold, Nottinghamshire and All Saints, Teversham, Cambridgeshire were measured and drawn, the latter by Butterfield. For smaller, rural churches, the society recommended St Michael's, Long Stanton, in Cambridgeshire, an exceptionally pure example of a rural parish church.

With its advocacy of St Michael's, the *Ecclesiologist* discredited a practice that had bedevilled the Gothic Revival since the days of Batty Langley – the use of the heroic forms of cathedrals on buildings that were not cathedrals. It advocated the small parish church type, a modest affair of a simple gabled mass, relieved only by a bellcote and gabled porch. The essential fitness of the scheme was obvious, and copies and variants of St Michael's can be found throughout Britain and the United States, where they are occasionally of wood. Even Germany noticed, after Reichensperger visited England in 1846, returning with drawings and photographs of English examples.

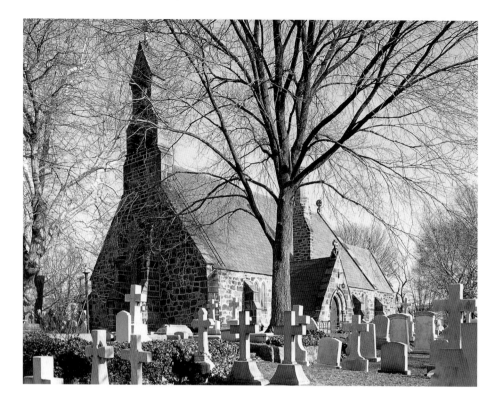

But the United States, where a tight web of personal and institutional connections bound the Episcopal to the Anglican Church, was even more hospitable to Ecclesiology. George Washington Doane, Bishop of New Jersey, became a patron member of the society in 1841, and set in motion a campaign of Gothic building based on approved Ecclesiological models. His church of St Mary's, Burlington (1846–48) was a gorgeously refined version of St John the Baptist, Shottesbrooke, Berkshire, with an emphatically cruciform plan and a soaring crossing tower, both novelties in America. The architect was Richard Upjohn, who now knew better than to build a plaster vault and who instead exposed his dramatic wooden roof truss. By now other architects were producing work of equal quality and corresponding with the Ecclesiological Society. One of these was the Philadelphia architect John Notman – a Scottish emigré who, like Upjohn, began as a classicist – who designed St Mark's, an early American church to receive a review in the *Ecclesiologist*.

In 1848 the New York Ecclesiological Society was established, along with its house organ, *New York Ecclesiologist*, as acerbic as

88

84, 85 St James the Less scrupulously reproduced St Michael's, Long Stanton (although it was extended by one bay and a vestry to the north of the chancel) in a suburb of Philadelphia. Intended to cost about $3,000 it eventually cost ten times that as Robert Ralston, the principal patron, outfitted it according to the *Instrumenta Ecclesiastica* (1847/56), the Ecclesiologists' manual of church furnishings and fixtures. It is zenith of the archaeological Gothic.

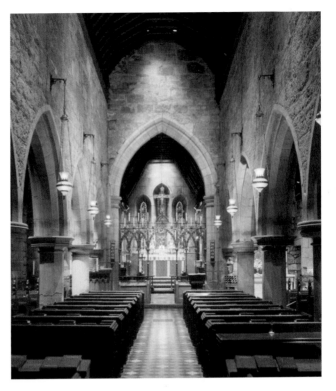

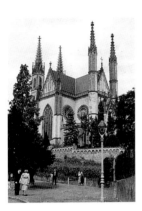

86, 87 The Apollonariskirche at Remagen, 1840–48 (above), and the Marienkapelle at Nippes, Cologne, 1847–49. The former was a classical box sprinkled with cast iron details, designed by Ernst Zwirner, who was simultaneously completing Cologne Cathedral, which contributed many of the details. The Marienkapelle was the work of Vincenz Statz, a stonemason from the cathedral's building lodge, and shows a builder's understanding of the Gothic. The influence of the Ecclesiological Society is unmistakable, while Zwirner's building shows the highly rational 'corrected' Gothic of his mentor, Schinkel.

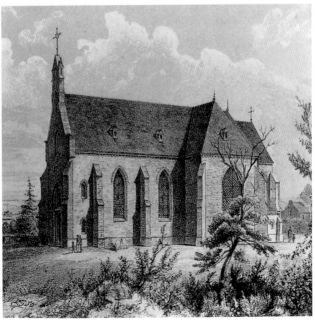

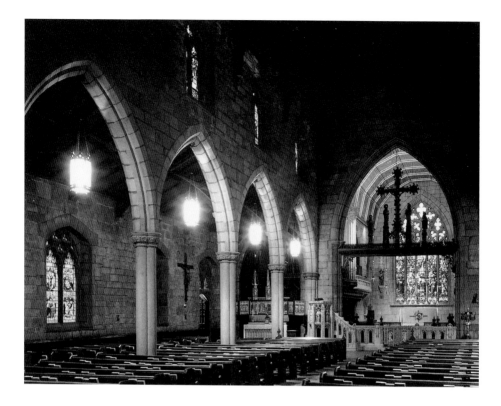

88 St Mark's Episcopal Church, Philadelphia, 1847–48, by John Notman, represented a striking advance over New York's Trinity Church, both in its open roof truss and the unplastered and hammer-dressed stone walls of the interior.

its English counterpart. With a steady stream of immigrant architects from England, New York became the movement's nerve center. Frank Wills and Gervase Wheeler arrived in 1848; Calvert Vaux in 1850; Henry Dudley in 1851, F. C. Withers and Jacob Wray Mould in 1852. All were Goths of conviction and skill, and their mutual competition lifted the standards of American practice nearly to English levels. Viewed as a whole, their work was provincial in character, the diminished reflection of English developments, and this was particularly true of their largest buildings. But their more modest projects, where they were forced to address the realities of American wood construction, were often more original. Upjohn's many board and batten churches frankly depicted their framing within and without, relying on the eloquent geometry of their faceted wood planes to create their character. In terms of Pugin's principles, they were more truly Gothic than his sham vault at Trinity Church, New York.

Upjohn imbibed the religious as well as architectural preju-dices of the Ecclesiological Society and on one celebrated

occasion he refused to design a Unitarian church because he did not want to support a 'heretical sect'. The feeling was mutual, though, for there was vehement resistance to the rising tide of Ecclesiology, caused by America's distinctive religious character. The Episcopal church – the American version of Anglicanism – represented an influential slice of the population, but a tiny one. The great majority of protestant Americans belonged to other denominations: Congregationalists, Presbyterians, Methodists, Baptists, Lutherans, and so forth. Many of these were dissenting denominations, historically hostile to state-established faiths and deeply suspicious of the Anglican tilt toward Catholic ritual and symbolism. Nonetheless, although the United States was ultra-protestant, it was also profoundly middle class in its values, and quite conscious of the demands of status and appearance. Prestigious new church buildings routinely induced a wave of imitators among other denominations. And while Low Church congregations might scorn the tenets of Ecclesiology, they could not resist the tug of fashion. Medievalism spread among them although some token resistance was offered, as when Gothic churches were built without 'Papist' spires or when the pews were planted in the middle of the nave, with passages to either side, to avoid the central processional axis of a Catholic church.

In this search for a fashionable medievalism, capable of romantic and picturesque effects but free of any taint of Catholic ritualism, the Romanesque offered a fitting alternative. The style was effective on several levels: it permitted identification with the recent round-arch (or *Rundbogenstil*) churches built in Germany, then an influential theological centre for American protestants. It also made a satisfying theological point, linking the congregation to the simpler forms of primitive Christianity rather than the corruption of the late Middle Ages. As a result, with the exception of the Episcopal church, American religious architecture in the 1850s was invariably round-arched. This was the careful minuet of styles during this period, when the most subtle symbolic nuances were given as much reflection as the practical considerations of construction and capacity. A trip through any older American town confirms this. Low Church Episcopalians used the Norman style, heralding their Englishness even as they avoided the Gothic. Lutheran churches were invariably Germanic in character, often in a sober brick Rundbogenstil of Berlin and Munich, with plain walls articulated by pilaster strips and corbel tables. And Congregationalists, descended from the Puritans of seventeenth-century New England, applied

89 *A Book of Plans for Churches and Parsonages* (1853) was the response of the American Congregationalist Church to the *Ecclesiologist*. The descendants of New England's Puritans, the Congregationalists endorsed the Romanesque on grounds of symbolism and economy although their designs were often Gothic in every respect – massing, verticality, asymmetry – except the shape of their windows, creating a kind of sublimated Gothic Revival.

Romanesque walls to buildings that were essentially still meeting houses, designed for preaching rather than ritual.

In England there were proportionately fewer dissenters but they, too, gravitated to the Romanesque, much to the disgust of the *Ecclesiologist*. Even ambivalent Anglican congregations, Low Church by sentiment, might hedge their stylistic bets and prefer the Romanesque over Tractarian Gothic. Christ Church, Streatham, by the team of James Wild and Owen Jones, was an electrifying example, an essay in the brick Lombard architecture of northern Italy with a freestanding campanile. The *Ecclesiologist* went to considerable theoretical lengths to explain why the Romanesque, like the Gothic equally an outgrowth of the Christian Middle Ages, should be forbidden. To them the Romanesque was the style of 'austerity', appropriate to the church in its centuries of poverty and trial, but superseded by the triumphant Gothic. English architects such as E. A. Freeman and Edmund Sharpe, who had been to Germany and had been impressed with the quality and sophistication of Rundbogenstil churches, spoke up in vain. For the *Ecclesiologist* the style – not to mention its advocates – was 'almost pagan'.

The calculus of denomination and style was just as contentious in Germany. For their part, many German protestants viewed the Gothic as dangerously Catholic and sectarian tensions increased as German states became less religiously monolithic. The round-arched Rundbogenstil, vaguely patriotic but not sectarian, remained popular. Nevertheless the nationalist imagery conjured up by the Napoleonic wars resounded in the German mind, and sympathy for the Gothic was widespread and deep. As is often the case, it took an outside impulse to set things in motion – in this case, an impulse from England. Just as the doctrine of the Ecclesiologists was applied to Catholic churches, an English architect built protestant Germany's most opulent Gothic church, the Nikolaikirche in Hamburg (1845–63). George Gilbert Scott won the commission with a brilliant distillation of elements from throughout Germany, bringing together an open work spire like that at Freiburg, polygonal apses of the northern German type, and various details from Cologne. Here he created an imaginative pan-Germanic Gothic of a type unknown to the Middle Ages. The building established Scott as an international figure and had a decisive effect on German practice, confirming to Germans that a historically sophisticated Gothic was possible, might be adapted to protestant worship, and was likely to be extremely popular.

90 The jury for the Nikolaikirche competition originally chose the Byzantine design of Gottfried Semper, but popular outrage caused the formation of a second jury composed of pro-Gothic Ernst Zwirner and Sulpiz Boisserée. They awarded the commission to George Gilbert Scott, who built the church from 1845–63. All but the tower was destroyed during the Second World War.

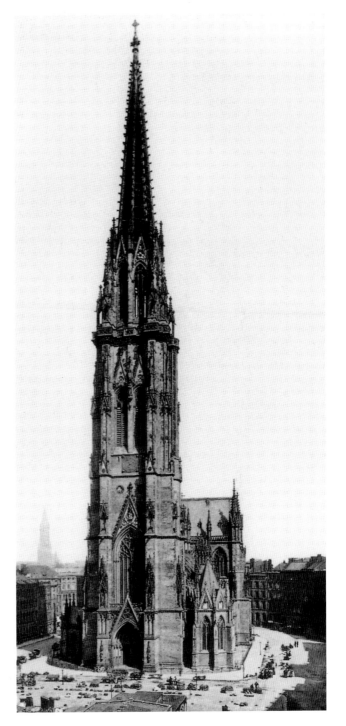

The success vaulted Scott to the forefront of the English profession. His attitude toward religion was not as dogmatic as his Ecclesiological colleagues (after all, he was willing to work for German Lutherans) and he radiated a reassuring sobriety. This brought a frantic rush of work. Much was competent rather than imaginative, but with a good budget and adequate time for study, his work was often quite good. His church of All Souls, Halifax (1855–59) certainly was: a solid and substantial basilica with a full complement of nave and aisles, transepts, south porch, chancel and a glorious corner spire: 'on the whole, my best church,' Scott boasted.

By the middle of the 1840s, England was decisively the international leader of the Gothic Revival. England contributed its most important monuments and its most potent ideas – the moral critique of architecture, the avoidance of both early and late Gothic, 'truth in materials' and so forth. But there now developed quite suddenly and dramatically a Gothic Revival in France, which had previously been rather indifferent to the movement. The religious movement in the Anglican Church that gave impetus to the Gothic Revival had no counterpart in France, nor were there the political preoccupations of Germany. In France, with its highly centralized political and artistic culture, architecture was classical by custom and by national policy. New tastes and fashions might develop in England through the patronage of landed aristocrats, but French taste was dominated by the royal court, its building bureaucracy and its academy. These, with a few notable exceptions, were implacably hostile to medieval architecture.

During the eighteenth century, the French attitude tolerated the Gothic just as Wren had, resorting to it whenever a medieval complex was to be repaired or enlarged. The Cathedral at Noyon, for example, was partially rebuilt in the mid-eighteenth century in a Gothic style that was no worse than Wren's at Westminster Abbey. As in England, French theorists and architects were curious about the style. Marc-Antoine Laugier, the abbot and architectural critic, together with the architect Soufflot, admired it for the astonishing lightness in construction. Nonetheless, this admiration was limited to the effects achieved by Gothic architecture, not the forms themselves.

The situation quickened in the 1830s. In 1831–32 Victor Hugo published his *Notre-Dame de Paris*, in which the cathedral itself is as much the principal character as the hunchback Quasimodo, and which like him contains a heroic soul under what outwardly appears to be deformity. In 1833 Charles-René

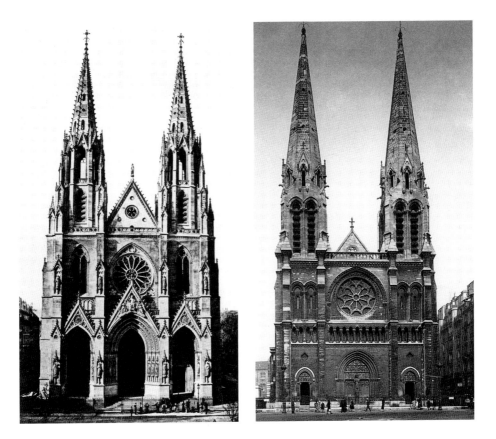

91 Sainte-Clotilde, Paris was not completed until 1857, under the direction of Théodore Ballu, although designs were begun by Franz Christian Gau in 1839. Like Zwirner, another classicist dabbling at the Gothic, Gau was happy to use cast iron, as he did here in his spires.

92 Lassus provided an architectural rebuttal to Ste. Clotilde with his more correct Saint-Jean-Baptiste de Belleville, Paris, of 1854–59. A restrained essay in twelfth-century Gothic, it is rendered with almost skeletal abstraction, the facade reduced to a simple, taut screen against which the active elements, the buttresses, step forth boldly to do their work.

Montalambert attacked the government's policy towards its medieval monuments as 'official vandalism'. In response, the Commission des Monuments Historiques was formed, charged with the protection and restoration of national monuments, particularly cathedrals looted and defiled during the French Revolution. Not until 1844 did these inchoate impulses find a voice. In that year the cosmopolitan Adolphe-Napoléon Didron (1806–67) founded the journal *Annales archéologiques*, the purview of which extended to anything pertaining to medieval art and architecture, including the neo-Gothic.

Didron served as secretary of the Comité Historique des Arts where he had established friendly terms with the leaders of the English and German movements. (He and Reichensperger, for example, both attended the consecration of Pugin's St Giles in 1846.) Through these connections the Gothic Revival now advanced as a coordinated international effort, as motifs, drawings and the names of architects themselves were passed along

private channels of communication. Didron agreed with his English and German friends that the burning question was how to place religious architecture on a basis of rules and laws. His answer was similar: modern architecture should return to the moment when the Gothic had just cast off its last vestiges of Romanesque awkwardness to emerge in its fully formed youthful vigour, which it did most stunningly in the great cathedrals of northwestern France. The cathedral – as both a symbol and a storehouse of forms – came to play a central role in the French revival, unlike England, which stressed the parish church. Didron's *Annales archéologiques* presented a model cathedral in its first number, in which the elements of Chartres, Reims and Amiens were distilled and purified into ideal form – the sort of thought exercize that became popular during this dogmatic phase of the revival.

With this Gothic ideal before him, Didron zealously policed new churches for archaeological correctness, much like his comrades at the *Ecclesiologist*. It was not sufficient that a church merely be Gothic in its decorative forms, as he showed by his attack on Sainte-Clotilde in Paris, the largest and most conspicuous new Gothic church in France. The work of Franz Christian Gau (1790–1853), a German who trained in Paris, the church was a deflated cathedral, a miniature of Gau's native Cologne. By any yardstick Sainte-Clotilde was a scholarly and confident performance, as good as anything Pugin ever did. And yet to Didron it lacked 'austerity'. Indeed, the building might have leapt soaring from one of Schinkel's ravishing paintings. Perhaps Didron sensed that Gau, a trained classicist, viewed the Gothic only as an ornamental language, and did not appreciate it as a structural system, whose outward forms were rooted in the logic of the plan and the geometry of its vaulting.

Instead, Didron promoted a circle of young architects who learned the language of Gothic cathedrals at first hand – by measuring, repairing and replacing their weathered stones. These included the talented trio responsible for the restoration of the cathedral of Notre-Dame in Paris, Jean-Baptiste Lassus (1807–57) and Eugène-Emmanuel Viollet-le-Duc (1814–79), and their job captain Paul Abadie (1812–84). Because these architects were generally self-taught and worked for the church rather than the state, they were often disparaged as mere *diocésains*, i.e. architects of the Catholic diocese. But if they stood outside of the French architectural establishment, with its long tradition of classicism and persistent hostility to things medieval, they were

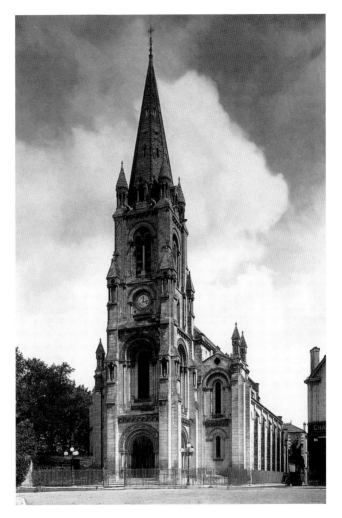

93 Unlike American protestant denominations who used a stringent form of the Romanesque for reasons of theology, Paul Abadie used it as a marker of regional identity. There was nothing at all puritanical about Saint-Martial d'Angoulême (1849–56), his first Romanesque experiment. A lively array of spires and colonettes cascade from its central tower, a typically joyful gesture by Abadie, who lacked the high-minded intellectualism of Lassus or Viollet-le-Duc, and who had a more jovial sense of design.

nonetheless influenced by it. Both Lassus and Abadie had studied at the Ecole des Beaux-Arts, absorbing its tenets, its disciplined planning and rational construction. France had raised the practice of stereotomy, the cutting of stone, to a high art, and from the beginning French neo-Gothic buildings were vaulted in consummate stone masonry. If these churches never developed the striking personal originality and idiosyncrasy of England, their unparalleled structural logic and intellectual discipline offered much compensation.

Inevitably, the original designs of these architects were informed by the historical restorations they conducted. Lassus began in 1836 to work on Chartres, a kind of incubator for his

hardy personal style. His churches of Saint-Nicolas at Nantes (1844–69) and Saint-Jean-Baptiste de Belleville in Paris (1854–59) were in the Chartres mode, muscularly buttressed and robust to the point of severity. Abadie, conversely, practised in southwestern France where he restored about forty churches, including the cathedrals of Saint-Front de Périgueux and Saint-Pierre d'Angoulême. Many of these buildings were Romanesque – or Byzantine – which set the key for his own work. If Gothic architecture was fundamentally 'true', such Romanesque churches would be unacceptable to militant revivalists, but Abadie was no militant. In fact, he could argue that his churches expressed a truth of an entirely different sort: regional truth, that is, the respectful continuation of well developed regional building practices. In France too, therefore, the Romanesque became an auxiliary branch of the revival, an acceptable alternative mode under certain local circumstances.

Thus by the middle of the 1840s, England, France and Germany had each developed a characteristic Gothic Revival. Between these centres ideas exchanged rapidly and continuously along a net of personal connections. Reichensperger, for example, was the German correspondent for both the *Ecclesiologist* and the *Annales archéologiques*. From these countries Gothic doctrine spread outwards, exercizing more or less influence according to geographic and religious closeness. Protestant Scandinavia drew from England and Germany, Catholic Spain and Belgium from France, and cosmopolitan Holland from all three. In the space of a decade the Gothic had cast off the last vestiges of Georgian frivolity and had emerged to rival classicism for the architectural stylistic leadership of Europe – matching it in theoretical and structural achievement and, in the sweep and audacity of its social vision, surpassing it.

Chapter 5 : Development

I should like to draw all St Mark's and all this Verona stone by stone, to eat it all up in my mind, touch by touch.

John Ruskin

In the 1840s, the ideal of making a building that could not be distinguished from genuine Gothic architecture exercized an irresistible attraction over the minds of young architects. Presenting them with a clearly defined goal, it gave urgency and direction to their architectural studies, and acted as a healthy tonic on the whole Gothic Revival movement. It certainly cannot be said to have destroyed anyone's powers of imagination for out of the ranks of the most successful copyists later emerged the revival's most original architects, such as Butterfield and Street. But at bottom the impulse to create a convincing Gothic illusion is not architectural but theatrical, and once the illusion was perfectly realized, it no longer seemed quite so tantalizing.

Pedantic imitation was not necessarily wrong. When a modern building functioned precisely as did its medieval prototype, it made sense. A rural parish church, for example, required no significant updating, other than the occasional exchange of an organ loft for the medieval sacristy – a space not needed in a protestant

94 G. E. Street's St Peter, Treverbyn, Cornwall, 1848–50, is as perfect a recreation of a rural church in the Decorated style as can be imagined, with no hint of the mechanical rigidity that the precise copying of medieval models sometimes produced.

church. But anything larger involved matters of circulation, ventilation, heating and fire-proofing that tested the limits of archaeological copyism. The simplest of churches in a modern factory neighbourhood – requiring the architect to squeeze large congregations onto a constricted lot in an environment of exceptional visual brutality – posed questions that no thirteenth-century model could answer.

The Ecclesiological Society felt these pressures in a way that a purely architectural society never would have. Most of the founding Ecclesiologists were trained to be ministers and groomed for a church with an international missionary program, which forced them to test their tenets in other cultures and climates. Beresford Hope pointed out in 1847 that 'Great Britain reigns over the torrid and hyperborean zone, that she will soon have to rear temples of the True Faith in Benares and Labrador, Newfoundland and Cathay.' Obviously mission churches in these tropical and subarctic locales could not all be served by a rigid programme of stylistically correct Middle Pointed architecture. A more dynamic and more comprehensive understanding of Gothic architecture was required, and this was provided by that quintessentially nineteenth-century doctrine, *development*.

The Ecclesiological Society viewed Gothic architecture as the product of a prolonged process of historical evolution, which achieved perfection at the end of the thirteenth century, remaining at that peak for a time and slowly degenerating thereafter. It had always sought a return to that crystalline high point, although once that point was reached it was not entirely clear what would happen next. Would the modern world stay there, perpetually suspended in a Golden Age of the Early Middle Pointed? Gradually it was recognized that the notion of an eternally fixed and unchanging Golden Age was a chimera, and that literalism led to stagnation. The Ecclesiologists' obsessive concern with historical accuracy became something of a joke, and Scott mocked the dangers of using a moulding half an hour too late. Furthermore, the temperament of the times stood against such a static world view. A new dynamic understanding of history as process was in the air, which stamps much of the thought of the mid-nineteenth century. Charles Darwin's doctrine of evolution applied it to natural history while Karl Marx applied it to economic history.

The doctrine of development was not an English invention. It had been in circulation much longer in Germany, where it came to be associated with the Rundbogenstil of the 1830s and 1840s.

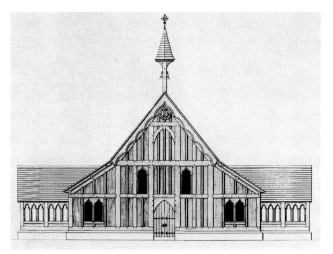

95 In 1851 the Ecclesiologists' architect R. C. Carpenter designed a wooden church for Tristan da Cunha, a lonely volcanic island in the far South Atlantic, whose population numbered about eighty-five. Taking into account the island's poverty and isolation, Carpenter designed a roughly framed church under a low sheltering roof. Although intended for a site below the equator, the traditional position of a sacristy to the north and the baptismal font to the south followed Ecclesiological orthodoxy.

This round-arched style resembled Romanesque architecture in many respects, though it was never treated as an archaeological exercise. Instead it was treated from the first as a synthetic style, open-ended and progressive, which might be a way station to the style of the future, the *Zukunftstil*. So Gottfried Semper argued when he competed against Scott for the Nikolaikirche in Hamburg. The Romanesque 'has not outlived itself, as the Gothic has,' Semper argued; it was 'capable of further development'.

This progressive doctrine went against the theological grain of the Ecclesiological Society, which saw its mission as restoration rather than revolution. Nonetheless it was backed into the position, as it were, by the problem of the mission church. Often built in rugged, remote settings, these needed to be as simple in character and construction as possible, with little or no ornament. In such cases the Ecclesiological Society accepted the Norman style as an acceptable, though inferior substitute. It was sufficiently simple and massive to withstand crudity in execution, and it also had a certain metaphorical fitness for use in the colonies. After all, the Norman style itself was an instance of a conquering civilization that bestowed its culture upon its conquered subjects, having been introduced in England in 1066 in the wake of the Norman Conquest. Even its primitiveness would serve an educational function; in colonial New Zealand, 'its rudeness and massiveness, and the grotesque character of its sculpture, will probably render it easier to be understood and appreciated' by the indigenous Maoris, argued the *Ecclesiologist* in 1841.

Although this stylistic licence was a makeshift measure for the colonies, it set in motion a comprehensive re-examination of Gothic theory. By sanctioning styles other than the Middle Pointed, if only for distant mission churches, the Ecclesiological Society eventually surrendered the idea of a single moment of Gothic perfection. Such an idea was not difficult to renounce. After all, it was derivative, borrowed from Greek art with its dream of a Periclean golden age, and was alien to the spirit of the Gothic Revival. Pugin had shown in his *Contrasts* that art and architecture are intimately connected with the life of society. To copy its forms and motifs – even the best of them – without reference to the society that produced and sustained them would be nothing more than a shuffling of bones. A true and healthy Gothic Revival must permit the style to evolve further, bending to the demands placed upon it and making use of the material means available. Street expressed the idea in his 1852 lecture on 'The True Principles of Architecture and the Possibilities of Development'. This liberating insight produced the High Victorian Gothic, one of the most vital movements in all of architectural history, as an energetic body of architects and patrons was released in a sudden spasm from a position of the most docile antiquarianism to one of dazzling and limitless originality.

The break with archaeological copyism took place in 1849. For several years the Ecclesiological Society had been looking to build a model church in England that would serve as a summation of ecclesiological doctrine, both artistic and liturgical. The society agreed to fund the church, so long as it might control every aspect of its design, furnishing and decoration. When a suitable candidate was found in the St Marylebone district of London, oversight of the project was given to Beresford Hope, who helped fund it and chose its architect, William Butterfield. The result of this collaboration was All Saints, Margaret Street, one of the 96–98 most innovative buildings of the nineteenth century.

The church would not have been so good if the site had not been so bad. Butterfield was handed a mere speck of a lot, built in on three sides, making impossible the traditional free-standing basilica. Instead he wedged the church to the rear, up to the property line, and brought forward the rector's residence and school; these three volumes huddled about a small courtyard. At the corner where church met school, he set a tall tower that marked the church entrance and gave focus to the rambling compound. The visitor, having slipped through the constricted courtyard and

crossing this tight entrance porch, would find himself in a space of surprising generosity. A broad basilica beckoned, whose roof rose to an unusual height, lifting the clerestory clear of the neighbouring buildings. The space was a glittering vessel, a high-keyed chromatic symphony in which Butterfield laid jewel-like colour on whatever he could touch. Pugin had attained a similar chromatic intensity at St Giles, Cheadle, but where he used paint and gilding Butterfield painted with the materials themselves: polished green and red marbles, tinted brick, alabaster, and the brightly coloured tiles that paved the floors and mottled the arcade walls.

79

This structural polychromy – the creation of colour through construction – was just as sensational on the exterior. Previously brick had been regarded as a humble material, an inferior surrogate for stone, but Butterfield used it defiantly, letting loose a riot of stripes, zig-zags and diaper work. Colour and pattern alone provided the ornamental effect, with no carved decoration apart from the single oversized finial of the courtyard. Varicoloured brick architecture was not unknown (northern Italy and the Hanseatic cities of Germany offered ample precedent) but there was a justification closer in time – and closer to home. Urban pollution was wreaking havoc on stone architecture, particularly marble, which swiftly blackened in modern London's corrosive air. Brick had no pristine patina to lose; its strong textures could stand up to a rain of soot, which could only emphasize the strong lines of the building. It also related the building to its unlovely industrial environs.

Butterfield's taut, gaunt walls and agitated details had a mechanistic quality that was absent in Pugin or the picturesque rustic churches of the 1840s. The new sensibility was particularly evident in the iron work, which was cut into slender straps, bent and twisted to make foliated forms for his screens, an innovation which was widely imitated. In an age where the concentrated power of steam replaced horse power as the increment of applied energy, Butterfield's forms had the directional intensity of mechanical force. The stubby colonettes of his pulpit and baptismal font look as if they might have been made by machine – extruded and rolled in mills, then cut by steam-powered saws. This gave his work a quality of crisp, hard-edged newness that startled contemporaries, either enchanting or maddening them. The consequences were profound. No longer was it the highest praise an architect might receive to have his work mistaken for a thirteenth-century building.

97 After elimination of the brick tax in 1849 made the material affordable for All Saints, Margaret Street, Butterfield exploited its expressive possibilities. He articulated the walls in parallel bands and stripes, showing that the process of masonry construction is a horizontal one. These stripes also suggest the geological strata visible in an eroded cliff, recalling that the church was built at a time when geology was the most progressive of the sciences.

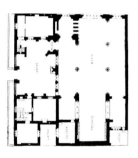

96 The plan of William Butterfield's church of All Saints, Margaret Street, London (1849–59) is a diagram of efficiency. Three tiny light courts are judiciously arranged so that almost the entire cramped lot is utilized, while every space is provided with light and air.

98 The brilliantly coloured interior of All Saints, Margaret Street, London, shocked even Butterfield's client, Beresford Hope, who privately lamented its 'clown's dress, so spotty and spidery and flimsy.' He complained in vain, for Butterfield's speckled interior set the tone for every colour essay that followed for the next three decades.

The flirting with continental forms in All Saints, Margaret Street, was a sign of the broadening horizons of the Gothic Revival. England's long afternoon of insularity, which began during the decades of war with France, was now at an end. Architects once scoured the English landscape with their sketchpads; now the steamboat and the railroad brought most cities of the continent comfortably within the range of a two-week trip. High Victorian architecture shows the restlessness and eclecticism of an architectural culture that was as conversant with the buildings of Paris and Venice as with those at home. The Great Exhibition of 1851, the first world's fair, proclaimed this new international outlook. It confirmed that London was the great metropolis of the age, a clearing house through which all the products, ideas and impulses of the modern world would pass. This idea was unprecedented, and so was the building that gave it tangible form: the Crystal Palace, the world's first monumental structure of iron and glass. The Crystal Palace was the very

incarnation of development, solving the demands of the present with specifically Gothic means, frankly displaying its construction with a filigree lightness that surpassed even the airiest of Gothic cathedrals. The structure was a rebuke to the servile copyism of the Ecclesiological Society, daring it to develop Gothic forms appropriate for iron construction, forms more adventurous than Butterfield's decorative screens. It would be some years before the challenge would be answered, and for the moment the Crystal Palace served only to showcase the achievements of the Gothic Revival, not to inspire new ones.

The Crystal Palace was an abomination to the man who succeeded Pugin as the principal theorist of the Gothic Revival, John Ruskin (1819–1900). Ruskin was an evangelical who stood outside England's established Church and, like Pugin, he criticized English architecture from without. Unlike Pugin, however, he was a critic, not an architect, and his influence was entirely polemical. He was also one of the finest English prose stylists. He had the ability to present subtle and complex ideas in striking aphorisms, and to orchestrate them into a majestic cadence that fell naturally into thumping iambic pentameter. In his two works of architectural theory, *The Seven Lamps of Architecture* (1849) and *The Stones of Venice* (1851/53), Ruskin created the theoretical

99 Pugin's Medieval Court at the Crystal Palace was crammed with decorative art objects produced by his collaborators, including J. G. Crace (carpets), John Hardman (painting), Herbert Minton (tiles) and George Myers (sculpture). The Medieval Court should have been Pugin's crowning achievement but it ended his career in a Gothic delirium. Shortly after its completion he was confined to an asylum, dying in 1852. Only forty years old, he seemed to many to have already lived several lifetimes.

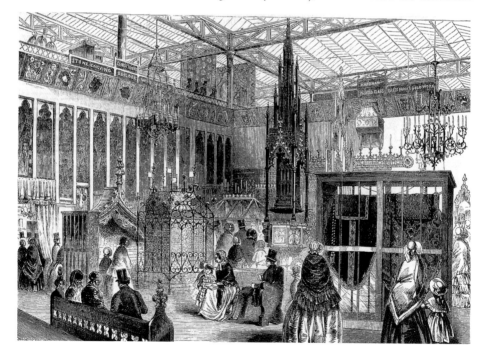

100 For John Ruskin, the most eloquent components of a building were decorative details such as mouldings, capitals and carved ornament. These represented 'sacrifice', the costly and time-consuming embellishment of the structural torso that elevated mere construction to architecture. His 1841 pencil and wash drawing of the Casa Contarini-Fasan in Venice, turned so as to maximize the projection of balconies and cornices, shows his exquisite concern for these sculptural elements.

basis for High Victorian architecture. This basis was neither comprehensive nor coherent – the majority of his architectural criticism consisted of microscopic and furiously opinionated examinations of parts of buildings, justified by frequent appeals to nature – but it was astonishingly persuasive. Like Pugin, his verbal authority came from presenting aesthetic judgments on a moral basis. That basis comprised his 'seven lamps' (Sacrifice, Truth, Power, Beauty, Life, Memory, Obedience), abstract principles that were meant to underlie all great architecture. These seven criteria overturned the classical triad of utility, firmness and delight, but they also supplanted Pugin's True Principles.

Ruskin's *Seven Lamps* seemed to cast light into every aspect of architecture but in fact they were selective in their focus. Planning, construction and the orchestration of spatial sequences interested him little. He was interested primarily in the qualities at the surface of a building – no one looked more

closely at the lines, shades, cuttings, wrinkles, shifts in tone over the face of a wall. This is not surprising in the author of *Modern Painters*, a man who began his career as a critic of paintings. For Ruskin it was the elements that were added to the surface of a building that elevated it to the status of architecture. These non-essential elements, such as sculpture, painting or rich materials, constituted the Lamp of Sacrifice. Without them, there could be no architecture, only building.

Ruskin's architectural theory concentrated on the skin of buildings and his architectural ideal was the city with the most exquisite surfaces of all – Venice, with her tradition of coloured stone revetments and vividly contrasting marble and brick. Such decorative facing violated Pugin's strictures, because it masked construction, but Ruskin pointed to nature to show that lively colour needed no structural rationale: 'The stripes of a zebra do not follow the lines of its body or limbs, still less the spots of a leopard.' For Ruskin, there was only one firm rule for architectural colour: 'let it be visibly independent of form.'

Ruskin was scarcely able to admire a building without making it a pivot of world history. In *The Stones of Venice*, he portrayed the Ducal Palace as the architectural embodiment of Venice, poised between northern Europe with its Gothic achievement and the Italian peninsula with its Classical legacy, and uniquely qualified to distil the best of both. This cosmopolitan mixture was leavened by a certain Eastern influence, brought about by Venice's active trading ties to the East, and to Islam. This made Venice the point of intersection of three great architectural traditions, a concept which Ruskin expounded in the celebrated chapter in *The Stones of Venice* on 'The Nature of Gothic':

Opposite in their character and mission, alike in their magnificence of energy, they came from the North and from the South, the glacier torrent and the lava stream they met and contended over the wreck of the Roman empire and the very centre of the struggle, the point of pause of both, the dead water of the opposite eddies, charged with embayed fragments of the Roman wreck, is VENICE. The Ducal palace of Venice contains the three elements in exactly equal proportions – the Roman, Lombard, and Arab. It is the central building of the world.

Ruskin's praise of Venice had nothing at all to do with her picturesqueness, which was generally what critics had found admirable about the city. Instead, her dynamic whirlpool of influences seemed quintessentially modern, foreshadowing contemporary London.

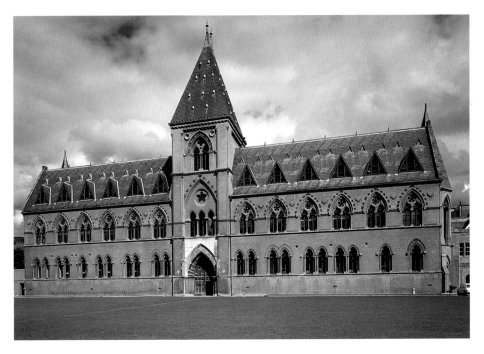

101 Deane and Woodward,
University Museum, Oxford,
1854–60.

Ruskin, like Pugin (and Marx), was troubled by the degrada-
tion of human labour in the modern world. He believed that
physical labour had a nobility and spiritual dimension, which the
Industrial Revolution had despoiled, condemning the factory
worker to mindless repetitive action. This hatred of machine pro-
duction, and his equally passionate loves of medieval architecture
and ornamental surfaces, collided to produce his most attractive
and enduring idea: the notion that human labour has intrinsic
worth because it is human, and while machine production can
parody its qualities, it cannot duplicate it. Medieval work was
superior because it commanded the full range of human faculties,
the sculptor using his mind as well as his hands – designing as
well as executing. The picture Ruskin painted was infinitely
alluring: a medieval sculptor picking wildflowers from a field,
arranging them on his sturdy table until the pattern pleased him
and then taking up the chisel to immortalize them in stone. There
could be no starker contrast to the plight of the modern factory
labourer, producing vapid cast iron ornament through a process
of mechanical reproduction, in whose design he played no part. It
also stood in vivid contrast to the Greek sculptor, likewise com-
pelled to produce rigidly conventional ornament by rote. In this
romantic vision was the origin of the Arts and Crafts movement.

102 James O'Shea, shown here in 1860 sculpting the museum's 'cat window', disliked working from measured drawings and instead he and his brother took potted plants from the botanical garden every morning to use as models. Ruskin liked the idea but not the execution: 'When I said that the workman should be left free to design his work as he went on, I never meant that you could secure a great national monument of art by letting loose the first lively Irishman you could get hold of to do what he liked in it.'

These sentiments made Ruskin an implacable foe of architectural restoration, which he called 'the most total destruction which a building can suffer: a destruction accompanied with false description of the thing destroyed'. He loathed the massive restoration campaign which the Ecclesiological Society had helped unleash, and which was vigorously cleaning, scraping and recarving the walls of England's medieval churches. To him, this was nothing less than the destruction of the most valuable and eloquent aspect of a building, the chisel marks and tooled surfaces. Even worse was the replacement of damaged elements by accurate modern copies. 'What copying can there be,' he demanded, 'of surfaces that have been worn half an inch down?' Instead, Ruskin urged a process of dignified decay, letting a building gradually sink into senescence.

Although Ruskin's influence was prodigious, he despised virtually everything built in his name and had little direct involvement with actual building. The critical exception was Oxford University Museum (1854–60), the great test case of his *101–3* theory. At first blush, the purpose of the museum – science, chemistry and natural history – does not immediately call to mind the Gothic. A style associated with the melancholy of ruins or the austerity of a fortress was ill-suited for buildings of science or learning. There was also serious doubt about the fitness of the Gothic for public architecture. The great proliferation of specialized building types that distinguished the modern city – not only museums but also libraries, opera houses, banks and railway stations – had all arisen after the seventeenth century, after the Gothic had been extinguished. For their design there was no medieval precedent. But this lack of formal precedent was itself a kind of advantage. Classical architecture suggested permanence and authority, and the passing on of static knowledge. But nineteenth-century science was shaking apart, the store of knowledge changing in every field. Here the Gothic had a decided symbolic advantage: its open forms suggested infinity, making it a fitting emblem of progress and development, in which constant change was required rather than fixed perfection.

An architectural competition for the Oxford Museum was held in 1854, requiring a three-sided building with an enclosed glass-roofed court, the fourth side to be treated loosely so that it might be expanded in future. Separate facilities for dissection and chemistry were mandated. The entrants were soon winnowed down to two, a Palladian design by Sir Charles Barry's son, Edward, and a Gothic scheme by the Irish architects Deane and

Woodward. In the end function carried the day. Barry's rectangular building, once completed, admitted no additions. And the detached facilities necessary for security against odour, infection and explosion were difficult to marshal into Palladian regularity. The Gothic of Deane and Woodward permitted a loose monastic treatment, with the dissecting room and the perilous chemistry laboratory both held at arm's length, the latter cloaked in the form of the fourteenth-century Abbot's Kitchen at Glastonbury.

Woodward's building (he was the imaginative lobe of the firm) was strongly Italian in character: horizontal in composition, brightly coloured and cubical in massing. Also Italian was the use of coloured marble and such details as the first-storey windows, divided by marble colonettes. This was clearly the mark of Ruskin, to whose judgment Woodward continually subordinated himself until Ruskin himself was annoyed ('I've told Woodward fifty times that I'm busy at present and yet they keep at me'). But his role was less ghostwriter than editor and critic. His great passion, as usual, was for surfaces and ornament. He imagined carved capitals and mouldings that would faithfully represent the bounty of nature, depicting the natural history contained within. Ruskin enthused: 'I shall get all the pre-Raphaelites to design one each an archivolt – and some capitals – and we will have all the plants in England and all the monsters in the museum.' Although a window was built to Ruskin's design (the second pair of windows to the right of the entrance, on the ground storey), only a fragment of this ambitious scheme was realized.

The most forward-looking aspect of the Oxford museum, its interior, was less interesting to Ruskin. When he first heard that it might copy the skeletal architecture of the Crystal Palace, he was aghast: 'You don't want your museum of *glass*– do you? If you do – I will have nothing to do with it.' Ruskin was simply ignored and the museum court was built as intended, roofed in glass and carried on slender iron columns. In its construction it owed a considerable debt to the Crystal Palace but its spatial sense was that of a late Gothic hall church, where aisles of equal height helped create a sense of undivided spatial continuity. This was not yet an iron Gothic, however – that would come later – for this forward-looking construction was embedded deep within the building and not permitted to show on the facade.

Drawing its forms from Venice and its arguments from Ruskin, the Gothic Revival now entered into its Italian phase. For the next decade, vibrant colour, Italian horizontality and delicate

103 The great hall of the Oxford Museum is a gothicized version of the Crystal Palace, its iron and glass architecture treated explicitly as medieval vaulting. The pointed arches are made from riveted iron plates and angles while the columns are bundles of hollow cast iron tubes. Hammered and cut wrought iron was bolted to the columns to form the capitals, thus forming 'applied ornament' in violation of Pugin's stricture that ornament should derive from the construction itself.

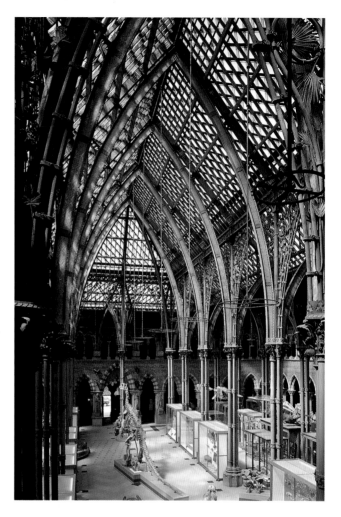

window colonettes were in fashion. The new style spread swiftly to the continent, where George Gilbert Scott won the 1854 competition for the Hamburg Rathaus (town hall). This was a clever and original essay, a translation of the celebrated medieval Wool Guild Hall in Ypres, Belgium, into an Italian idiom. Scott also borrowed from the Oxford Museum but its glass-roofed hall was published too late to inspire his design. Rather than revising his drawings, the resourceful architect simply changed his captions, adding a note that the main courtyard would 'probably' be roofed in glass! In the United States, where Ruskin's highly moralizing prose struck a chord, the new Italian mode was embraced, even by low church congregations that had resisted Ecclesiology. The

most literal Ruskinian building, however, was in New York, where the National Academy of Design was built in 1862. 106 Designed by Peter Bonnet Wight, it intelligently paraphrased the Ducal Palace ('the central building in the world') which made sense as a model, its blank upper walls suiting painting galleries lit from above. Wight clearly admired the botanical realism of the Oxford Museum facade, which he imitated in the carved capitals about the entrance, the luxuriant naturalistic foliage proclaiming the building to be a container of nature's truth. The symbolism was appropriate in more ways than one. It showed that English pre-Raphaelite taste reigned supreme among the painters of the academy, their highest artistic law being fidelity to nature.

The Venetian Gothic mode was not universally popular, however. Many found it garish and outlandish; during the mid-1850s its supporters and adversaries squared off in a parliamentary debate known as the Battle of the Styles, the most comprehensive public airing of the respective merits of the Gothic and the Classical. The occasion was a joint competition for two large government office buildings, a War Office and Foreign Office. Not since the competition for the Houses of Parliament had there been such a lucrative project, and it drew an avalanche of 218

104 George Gilbert Scott had met Ruskin in Venice in 1851 and had become convinced that the north Italian Gothic offered the best model for a modern public building, its regularity and simple geometry giving it a dignity befitting civic or state authority. This was the origin of his design for the Hamburg Rathaus, with its emphatically horizontal character and sprightly arches, whose voussoirs alternated in colour. Despite its success, local opposition prevented its construction.

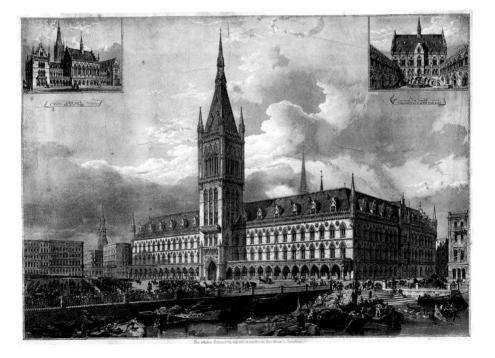

105 'I'm hell on colour,' Jacob Wray Mould bragged, an understandable remark for a pupil of England's great colourist and decorative artist, Owen Jones. Mould was one of the first to bring the taste for Ruskinian theory and Venetian colour to the United States. His chief work is All Souls' Unitarian Church, New York, 1853–55, a synthesis of Byzantine, Venetian and Rundbogenstil motifs, ablaze with structural colour, although its planned campanile was never built.

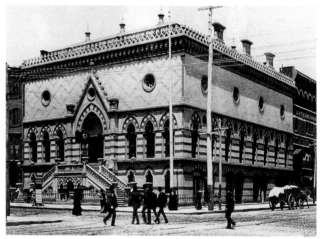

106 Peter Bonnet Wight, National Academy of Design, New York, 1862–63 (demolished). Under the sway of Ruskin, many architects paid tribute to the Doges' Palace in Venice but never as logically as Wight. Here the richly patterned walls of the upper storey make sense for galleries for the display of art, where windows are to be avoided in favour of skylights.

entries (only 19 of which were Gothic). Scott was placed second in both competitions and the parliamentary committee elected to entrust him with the entire complex. His design was a revision of his Hamburg project, augmented by considerable figural sculpture and bits of Woodward's Oxford Museum. Challenged by the Prime Minister, Lord Palmerston, a tireless foe of the Gothic, Scott defended the style as a rational, logical and flexible system. He published *Remarks on Secular and Domestic Architecture, Present and Future* (1858) to elaborate the case, the most cogent statement of the High Victorian belief that a free and flexible Gothic was the suitable style for the modern industrial world.

107 George Gilbert Scott, competition design for the Foreign Office, 1856. 'There is a noble design by an architect named Scott which [Benjamin Woodward] admits beats him to chalks.' So a friend of Woodward's reported his reaction to the public exhibition of the competition entries.

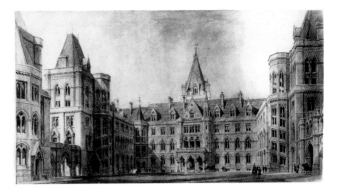

108 Thomas Fuller and Chilion Jones designed the Canadian Houses of Parliament in Ottawa in 1857–66. They produced a fully Gothic version of the English Houses of Parliament, not merely a coating of Tudor details. A picturesque complex of several buildings, with towered rooflines and rough rubble masonry, the Canadian parliament strikes a note of robust vitality, befitting a young country with a rugged natural landscape.

Scott won the commission but lost the stylistic battle. He was forced to build in sixteenth-century Italian style, applying Renaissance facades to his unchanged floor plans, much to the disgust of his colleagues. But he won a kind of moral victory, bringing welcome publicity for the Gothic cause. His original design, with its four-square solidity and lack of medieval mysticism, was widely published and widely imitated. E. W. Godwin's Northampton Town Hall borrowed its Venetian colours and even the canopied statues along the second storey. As far away as Canada, Scott's polychromatic picturesque mode was used for the

109

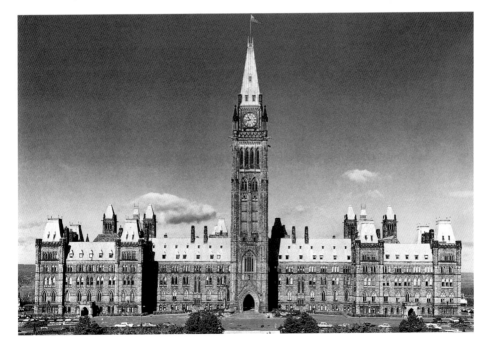

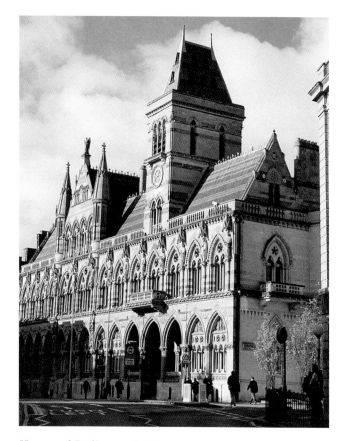

109 E. W. Godwin's Northampton Town Hall, 1860–64, showed that Ruskin's *Stones of Venice* did not necessarily inhibit artistic creativity. To heighten the sculptural presence of the building's single facade, Godwin thrust a stout tower above the cavernous opening of the arcade, a volumetric approach to design that he called 'the careful adjustment of solids and voids.' The polychrome stonework of the facade is of exceptional richness.

Houses of Parliament in Ottawa, rather than the classicizing 108 Gothic of Barry's Parliament.

The chief innovations of 1850s architecture – the ideas of Ruskin, Venice and development – worked their way grudgingly into civic architecture. But in religious architecture, where one had only to convince a pastor and a few parishioners, rather than a whole nation, there came a lush flowering of originality. The most talented figure was George Edmund Street, a veteran of Scott's genial office and an assiduous architectural theorist. Street was also widely travelled and he published important accounts of the Gothic architecture of Spain and Germany. His *Brick and Marble in the Middle Ages* (1855) was a practising architect's version of Ruskin's *Stones of Venice*, cleared of tirades and rhapsodic sermons, and focused squarely on the problem of improving contemporary design. Street cheerfully acknowledged his eclecticism, which sought to combine the 'verticality of Pointed with the Repose of Classic architecture', which can be

taken as the motto for much of the eclectic architecture of the ensuing decades, in Britain and beyond.

Two churches from 1859 show Street's range: one a picturesque collegiate enclave, the other a mission church in a seedy industrial slum of London. The former, the church of St Philip and St James at Oxford, is a compact basilica with transepts and polygonal apse, a muscular tower emerging from the crossing, the whole drawn together by a few broad bands of colour. In a strange and lovely touch, absolutely unprecedented, the final bay of the nave visibly cants inward before dying into the chancel wall; at the same time the deeply laminated clerestory windows stubbornly refuse to follow the rhythm of the arcade below, as if they had been carelessly added by another hand at a later date. These subtle violations of rectilinearity enlivened what would otherwise be a regular box of space; they recall the countless structural irregularities that contribute to the liveliness of a true medieval building, a quality that Ruskin repeatedly contrasted with the dry and lifeless geometry produced by modern construction.

110 G. E. Street's church of St Philip and St James, Oxford, should be compared with All Saints, Margaret Street. Although Street also uses colour contrast, he reduces their intensity and volume, and concentrates on the rich textures produced by broad areas of simple stone masonry.

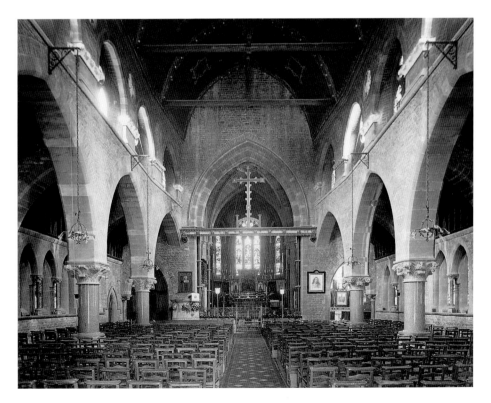

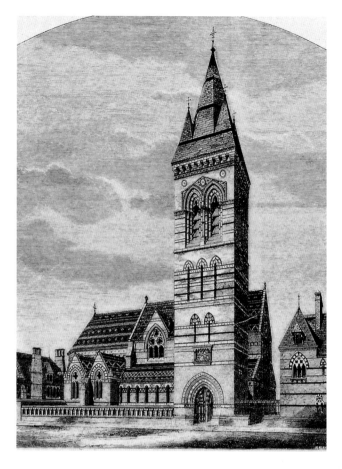

111 St James-the-Less, Westminster, London (1859–61), seems to have been Street's way of curing by shock therapy the Englishman's 'insane hatred of bright colours.' Wildly colourful inside and out, it shows his characteristic synthesis of Italian, French and English Gothic forms.

By contrast, St James-the-Less, in Westminster, announced its presence in its grim urban surroundings with a haughty Italian campanile and polychrome interior. But it too was muscular in its sculptural jumble of volumes and its thickly buttressed polygonal apse. It set the stage for countless Gothic churches in London's working-class neighbourhoods, designed by contemporaries of Street, each of whom cultivated a highly individualistic manner. These included such thoughtful ecclesiologists as J. L. Pearson, James Brooks and William White as well as a stable of 'rogue architects', those who embraced the eccentricity of Butterfield without his structural logic. These included such wayward figures as E. B. Lamb, E. Bassett Keeling and S. S. Teulon. But both groups made the lively depiction of structural processes a central aspect of design. St Peter's, Vauxhall, by Pearson, shows the impulse to make a structural idea the central

episode of a facade: a vignette of a single buttress clutching the nave gable wall like a clamp. In these works, at once original and scholarly, we see the summit of High Victorian swagger and confidence. That an architecture of such intense inventiveness, underpinned by sweeping encyclopedic learning, should have arisen so rapidly after the doctrine of development was formulated, is simply astonishing.

Street was influenced not only by Venetian architecture, with its active surfaces and blazing colours, but by the Early French Gothic, with which he began to experiment in the mid-1850s. The Early French was a robust and highly plastic style, which treated its walls as sculpture rather than as a colourful mosaic. It was as monochromatic as bone, and like a skeleton it was a display of visible engineering. Its detail derived from the early Gothic cathedrals of Chartres and Laon, in which a certain residual heaviness from the Romanesque still persisted. In fact it was much the same style that Lassus had long been practising in France, that mode which contemporaries called *muscularity*. The term became one of high praise, in part because it suggested Muscular Christianity, that attitude of combative and forthright religiosity that the Anglican Church adopted during the Victorian era. And

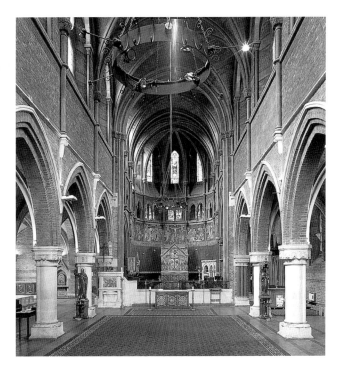

112 Stone vaulting was unusual in the English Gothic Revival, except for the occasional chancel, and timber roofs were the rule. The first major vaulted church was J. L. Pearson's St Peter's, Vauxhall, London (1863–65). Although the Ecclesiologists had shunned the use of upper galleries as recalling protestant meeting houses, Beresford Hope praised this church. Its broad proportions were an intimation of developments to come.

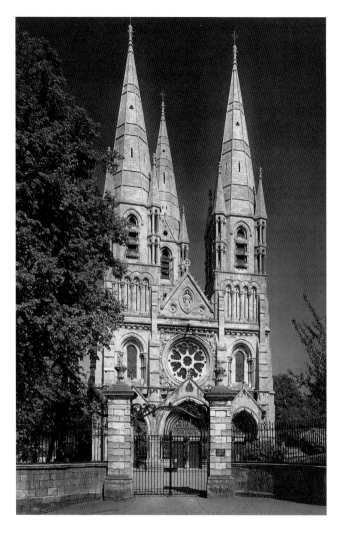

113 Burges's 1863 design for Cork Cathedral was the zenith of Early French muscularity, celebrating the precise moment when the active components the Gothic liberated themselves from Romanesque rigidity. Burges's example was especially influential in the United States, where he designed Trinity College in Hartford, Connecticut, a secular counterpart to Cork Cathedral, and where photographs of his buildings and drawings were widely circulated.

certainly the Early French Gothic seemed to be brimming with primitive power – what Street called 'nervous manliness'.

The fad coincided with the launch of Viollet-le-Duc's *Dictionnaire de l'architecture française* (1854–68), a comprehensive compendium of Gothic forms and details that exceeded anything ever produced in England, and that made available a wealth of meticulously drafted French Gothic details. Thus armed, the new taste spread rapidly, making bold stripes and coloured marbles obsolete. With the change in style nearly every aspect of a church, inside and out, was affected, as Charles Eastlake catalogued in his 1872 *History of the Gothic Revival*:

The small and intricately carved foliage of capitals which had hitherto
been in vogue gave place to bolder and simpler forms of leaf ornament.
The round abacus was superseded by the square. In place of compound or
clustered pillars, plain cylindrical shafts were employed. Arch mould-
ings grew less complex. Crockets and ball-flower enrichments were
reduced to a minimum.

Other changes consisted of the substitution of plate tracery
for bar tracery, and the banding of columns with shaft rings. Even
more strongly than Street, the architect William Burges became
identified with the French mode. Burges emerged publically with
the winning of two important international competitions, for the
cathedral of Lille, France (1855) and for the Crimean Memorial
Church in Constantinople (1856–57). Although eventually
cheated out of both (Street built the Crimean church), Burges
came to design Cork Cathedral, Ireland (1863–1904), the finest
cathedral designed under the influence of Ecclesiology. Burges
was an artist of unusual sweep, and he leavened the structural
'reality' of the Early French Gothic with a sprightly and highly
graphic style in his decoration, and a love of architectural sculp-
ture. No one since Pugin had the same flair for pictorial
decoration, and yet no one since Lassus had the same feeling for
the hefty language of stone. It may be that his business and per-
sonal talents did not match his architectural gifts, for Burges only
built a fraction of Street's restless production. But like Street he
showed that Ecclesiology did not make every architect into a
prim theologian but from time to time might turn out an artist of
originality and power.

On the continent developments paralleled those of English
High Victorian architecture, prompted by the same forces: new
materials, increasing international contacts and an intellectual
climate that tolerated stylistic experimentation. Illustrative of
the growing cosmopolitanism was P. J. H. Cuypers (1827–1921),
a Catholic architect working in protestant Holland. Cuypers was
in contact with Viollet-le-Duc and the building lodge of Cologne
Cathedral, and he adapted their ideas to Dutch conditions and
forms. He built a series of fine Gothic churches, invariably vaulted
in brick and distinguished by that array of high spindly towers
that instantly marked them as Netherlandish. His finest was the
Our Lady of the Immaculate Conception (Posthoorn Kerk) in
Amsterdam which – like Butterfield's All Saints, Margaret Street
– stood in a working-class neighbourhood and needed to accom-
modate large congregations. Cuypers achieved this by placing

114

two tiers of galleries, one above the other, flanking the lofty nave. It was a clever stroke, achieving the large capacity of an auditorium space without relinquishing the verticality and processional axis of an ecclesiological plan.

Just as cosmopolitan was Belgium, where, for example, Baron Jean-Baptiste Bethune (1821–94) regularly met Pugin, Reichensperger and Montalambert. One of the revival's genuine mavericks, Bethune was a trained lawyer who met Pugin and was overwhelmed, thereafter pledging himself to the Gothic cause. He studied painting and sculpture, and finally, after 1856, architecture as well (with E. W. Pugin). Bethune single-handedly raised the level of the Belgian revival, through his own enormous decorative output but also by his uncommon generosity in promoting pro-Gothic artists and throwing commissions their way. Wherever he practised, first in Bruges and then in Ghent, he organized artists into collaborative teams, an effort that culminated in the establishment of the St Luke School in Ghent. It is a pity that no great national commission came his way. He deserved a chance at the church of Notre-Dame de Laeken, Brussels, intended to serve as the royal mausoleum and the most conspicuous neo-Gothic monument in Belgium. But this fell to Joseph Poelaert, a fine classicist but a fumbling gothicist, whose overwrought play of spires hovers uncertainly between medieval archaeology and the pastry shop. It is impossible to believe that Bethune could not have done better.

In Germany, High Victorian originality was a far more constrained affair. The doctrine of development was viewed with suspicion by Gothic Revivalists, for it was still a hallmark of the Rundbogenstil. To August Reichensperger, Germany's principal theorist, it was a licence for the worst wilful and frantic novelty. There was also a political context. He noted that the vocabulary of 'progress' and 'development' was the same used by his foes on the political left to describe their campaign for a new German political order, based on a written constitution. Reichensperger commingled these artistic and political quests, seeing both as a futile attempt to replace living medieval organisms with abstract paper inventions. His distaste for experimentation made him a lifelong champion of thirteenth-century Gothic orthodoxy. Although he travelled regularly to England, was a close friend of Scott and knew Burges, he never accepted the highest flights of High Victorian idiosyncrasy.

Reichensperger was able to enforce Gothic orthodoxy through persuasion. He enjoyed a remarkably prolific journalis-

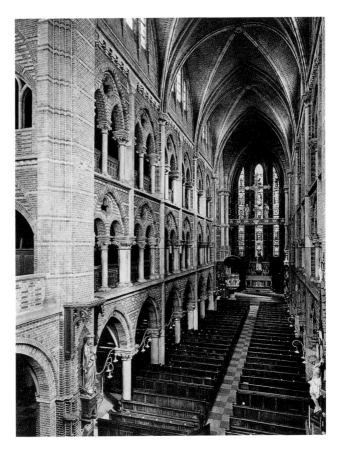

114 P. J. H. Cuypers, Posthoorn Kerk, Amsterdam, 1860–63. It was often the case that an architect's early restoration provided a storehouse of motifs for his original designs. Here the cloverleaf apse, the twin-towered westwork and the thick bundled shafts of the nave arcade were all borrowed from the Minster at Roermond, which Cuypers restored in 1850.

tic career, writing *Fingerzeige auf dem Gebiet der kirchlichen Kunst* (Hints on Religious Art, 1854) and *Vermischte Schriften über christliche Kunst* (Collected Essays on Christian Art, 1856), among others. But he also had an uncanny ability to find architects willing to follow his strictures. Two of them came out of the cathedral building lodge, Vincenz Statz (1818–98) and Friedrich von Schmidt (1825–91). These were quite different figures from Street or Butterfield, their churches typically substantial and serious, without shows of idiosyncratic personality. Trained as masons and not as architects, they embodied Reichensperger's dream of reviving the building lodges of the great cathedrals, and who contrasted the healthy arts of 'building, chiselling, carving' with the effete pursuits of 'collecting, preserving, drawing, and explaining'. Their works were rigorously consistent: an axial western tower, an orthodox arrangement of nave and aisles terminating in a polygonal apse, masonry vaulting and historically

accurate thirteenth-century detail. Deviations from this strenuous formula were permitted only under the pressure of outside circumstance, as when Schmidt designed an octagonal, twin-towered church to fit an irregular site in Vienna. (The result, Maria vom Siege, Fünfhaus, built 1864–75, is one of his happiest and freest performances).

Reichensperger's misgivings about architectural originality were rooted in his understanding of the nature of the Gothic. Unlike England, Germany possessed a relatively large number of late medieval architectural plans. These drawings (and the tell-tale compass pinpricks in them) suggested that Gothic forms were derived from precise geometric rules. A few medieval treatises survived, including Matthias Roritzer's *Büchlein von der*

115 Friedrich Hoffstadt's *Gothisches A.B.C.-Buch* (1840), a practical manual for artisans, was the first attempt to codify the 'underlying laws of geometric development' in Gothic architecture. Simple geometric forms such as squares and circles were inscribed within one another, generating secondary shapes and intersections that could be manipulated to determine the proportions of every element of a building, from the most minute ornament to the overall floor plan itself.

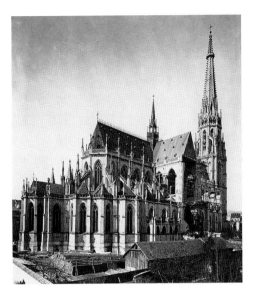
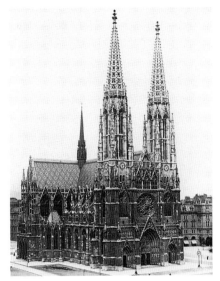

116 Vincenz Statz, Linz Cathedral, Austria, 1857–1922. A comparison of Street with Statz, his German contemporary, shows the difference between the English and German revivals. Through Reichensperger's support, Statz became diocesan architect in Cologne in 1854, in which capacity he designed over one hundred churches throughout the Rhineland – vaulted in stone, orthodox in plan and thirteenth-century in character. His most important work is the cathedral in Linz, Austria, the only modern cathedral built by the German Gothic Revival.

117 Heinrich von Ferstel, Votivkirche, Ringstrasse, Vienna, 1857–79. The Votivkirche was built to commemorate the deliverance of the Austrian emperor from a botched assassination attempt. Among the competition entries were several handsome and original medieval essays but von Ferstel's more derivative design was chosen by the honorary judge of the competition, King Ludwig of Bavaria, whose taste tended to the literal and obvious.

Fialen Gerechtigkeit (1486), a treatise on the design of finials which Reichensperger republished in 1845. Such bits of evidence persuaded him of the existence of a lost code of Gothic geometry; modern architects, instead of fruitlessly pursuing originality for its own sake, ought to recapture that lost code. This is not to say that Reichensperger favoured mindless copyism. It grieved him when the Votivkirche (1854–79) was built in Vienna as a diminutive scale model of Cologne Cathedral when it was not a cathedral at all – i.e., the seat of a bishop – but a kind of parish church. Medieval forms must be used according to medieval principles, he argued; otherwise they were meaningless.

Among German protestants the situation was different. There the vigorous tradition of central planning, with concentric rings of galleries encircling the all-important pulpit, flourished. Gottfried Semper's unrealized plan for the Hamburg Nikolaikirche was of this type; a brick Gothic variant of it was built in Oslo by Semper's colleague Alexis de Châteauneuf. But Scott's winning Nikolaikirche aroused great interest in more historically accurate Gothic churches. Reichensperger helped sway protestant Germany to proper ecclesiology, although this he accomplished by proxy. In the late 1850s he came into contact with Conrad Wilhelm Hase (1818–1902), professor of architecture at the Polytechnical School of Hanover. There Hase.was designing the Christuskirche, a handsome thirteenth-century hall church with transepts, a design that clearly shows

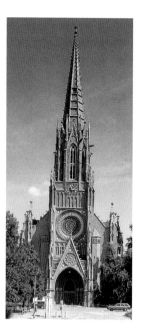

Reichensperger's influence – who may have helped arrange for the Cologne sculptor Peter Fuchs to carve the jamb figures. In 1861 Hase was appointed to serve on the three-man commission to draft rules for building Lutheran churches, the so-called Eisenach Regulativ. Reichensperger himself might have drafted the rules; they mandated the use of the style as a specifically Christian and German style, a traditional orientation of the church to the east, a nave of longitudinal form and a projecting chancel, strict masonry vaulting, even the use of transepts – a longstanding protestant bugbear. With the Eisenach Regulativ, Catholic and protestant church design, after three centuries of religious schism, came to an end.

This stylistic truce even reached beyond Christianity, for a time. Germany's most important designer of synagogues was Hanover architect Edwin Oppler, a pupil of Hase who had spent time in Paris with Viollet-le-Duc. Oppler was an assimiliationist, at least in architectural terms. Since Jews had lived in Germany since the Middle Ages, he argued, Gothic and Romanesque forms were appropriate for a German synagogue, an idea which he carried out in his synagogues in Hanover and Breslau.

Oppler's buildings, like all those of the Hanover School, were of brick, the characteristic material of northern Europe. For this Hase had devised a stylistic language of great rigour and consis-

118 Christuskirche, Hanover, 1860. Wilhelm Hase taught that every element of a building be conceived in terms of brick and permitted no use of terra cotta trim and cut stone details. As a result, the richly modelled and energetic surfaces of Hanover School buildings are created entirely by manipulating the brick bond itself through corbelling, geometric patterning and the use of moulded brick. His Christuskirche established the new style, although he later rejected its sparing use of sandstone elements.

119 Edwin Oppler's round-arched synagogue (1864–70) in Hanover is an earnest conflation of the medieval synagogue at Worms and the Catholic cathedral in that city. It was destroyed by the Nazis in 1938, a revival of one medieval pattern never intended by the Gothic Revival, which in Germany – under Reichensperger's leadership – had been strictly philosemitic.

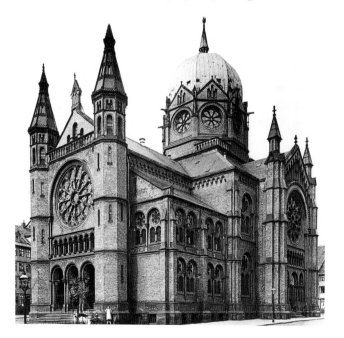

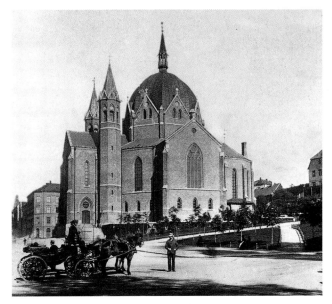

tency, worked out in terms of the module of each masonry course. He regularly took his students to study first-hand the buildings of Lübeck, Rostock and Lüneburg, those once prosperous and architecturally intact Hanseatic cities, where he demonstrated the extraordinary expressive range of brick construction. His students were also taught the importance of utility, which showed in the informal and functionally irregular floor plans that became a hallmark of the Hanover School. Grounded in materials and construction rather than superficial style, and stressing flexibility in plan and composition, this school proved exceptionally adaptable and its influence reached beyond Germany throughout Scandinavia and northern Europe.

Hase was but one of many protestants to follow Reichensperger's leadership. Equally loyal and far more eccentric was Georg Gottlob Ungewitter (1820–64), professor of architecture at Kassel and a tireless publisher of Gothic pattern books (who worked himself to death in the process). He too regularly sent his designs for review to Reichensperger, who brought him and Statz together to publish a joint Gothic pattern book, an unusual protestant–Catholic collaboration. No German Gothic architect rivalled Ungewitter in the toughness of his early Gothic, which mixed English muscularity and the influence of Lassus. His real genius was revealed in his pattern books, however, which paraded a whimsical assortment of weirdly top-heavy

houses in half-timber – a kind of overflow valve for the excess imagination that was otherwise held in check by the strict thirteenth-century orthodoxy of the German Gothic Revival.

Ungewitter's uninhibited house designs were an exception to the rule. Otherwise, Germany lagged behind, as if exhausted by the heroic mobilization of resources needed to complete Cologne Cathedral. Despite its lively political currents and despite the superb scholarship of the French movement, leadership of the Gothic Revival remained firmly centred in England where it reached an apogee of sophistication during the 1850s and 1860s. There the Gothic faction dominated the architectural profession. Indeed, there was scarcely one aspect of architecture – planning, construction or new building types – on which the Gothic faction did not lavish its originality and sheer intellectual energy. To its proponents, it seemed as if the Gothic Revival was now about to engage all of Europe in a wholehearted return to medievalism. It was a tantalizing vision, and it would cast a rich golden glow throughout the 1860s.

122 Ungewitter's churches, such as that at Hundelshausen, dutifully followed Reichensperger's beloved early Gothic, but the thirteenth century offered few useful models for domestic architecture. Instead Ungewitter looked to the late Gothic of his native Hessia for his wildly imaginative houses, which were as unruly and undisciplined as his churches were sober. He published his designs as *Entwürfe zu Stadt- und Landhäusern* (1856–58), which became a favourite source for architects in the United States.

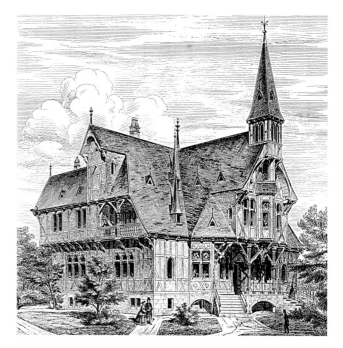

Chapter 6: Iron

Iron and masonry make poor bedfellows.
Viollet-le-Duc, in a letter to the *Encyclopédie d'Architecture*, 1855

Can [masonry] be combined with iron construction? Certainly it can.
Viollet-le-Duc, *Entretiens*, II, 1872

Gothic Revival doctrine was so brash and exhilarating that it long masked certain theoretical weaknesses. Its moral conviction was an undoubted strength, for it drew converts and made them intensely aware of architectural principles, compelling them to take seriously every aspect of design and decoration. Its obsessive insistence on archaeological accuracy, however, could be a weakness, particularly when it came to new materials such as iron, which acutely discomfited Gothic Revival theorists. When in 1851 the Crystal Palace showed an architecture of unprecedented lightness and delicacy, such prominent arbiters as Ruskin and Reichensperger disparaged it as 'a fortified greenhouse', and denied that it had any lessons to offer.

This suspicion of modern materials was actually new for the Gothic Revival, which for most of its early history had been tolerant. Its medieval structural traditions having been lost, it welcomed innovation in building materials and construction practices. Walpole exploited this at Strawberry Hill with an unerring opposition, according to Kenneth Clark, 'to anything made of its right material'. Wyatt relied too enthusiastically on compo-cement at Fonthill Abbey, which contributed to its first collapse, after which he shifted to stone. Iron was used creatively from the beginning. Rickman, as noted in Chapter 2, habitually used cast iron columns, not only for cheapness but to help achieve clear open spans. In France, an iron roof truss was installed in Chartres Cathedral between 1836 and 1841, following the burning of the medieval wood roof. Prussia, which built Schinkel's iron Kreuzberg monument, was even more adventurous. In 1825 the state building administration erected a remarkable foundry at Sayn, by Bendorf near the River Rhine. The building was a kind of advertisement for itself, not only manufacturing iron goods

123 For the Prussian iron foundry at Sayn, Karl Ludwig Althans imaginatively adapted the form of a Gothic basilica, using its nave and flanking aisles as a logical way of lighting and ventilating a broad hall. Later in the century, the basilica would be a common model for factories, but here its ecclesiastical origin was frankly confessed, especially in the traceried windows that relieved the facade.

but doing so in a structure of iron, a remarkable union of modern technology and Gothic imagery far ahead of its day.

In the 1840s, however, the mania for archaeological accuracy brought the material into disrepute. Iron seemed to embody the very worst features of the 'Gothick': cheapness, flimsiness and indifference to historical precedent. Throughout the decade the *Ecclesiologist* and the *Annales archéologiques* railed against its use. Opposition was typically dogmatic in Germany. There Reichensperger campaigned furiously (and in vain) against Zwirner's plan to roof Cologne Cathedral with an enormous iron truss, even though the feature would be completely invisible. This reflexive hostility was embarrassed by the triumph of the Crystal Palace. The structure seemed to embody Gothic principles in their most rarified and elegant form: reduction of the piers to their skeletal minimum and dematerialization of the wall into glass and light. To praise these qualities in Gothic buildings while excluding the Crystal Palace would require considerable ingenuity indeed.

The narrow arguments against iron soon collapsed. Deane and Woodward's iron museum gallery at Oxford won begrudging acceptance, even from Ruskin. Around the same time, in 1856, the Ecclesiological Society recanted its ferrophobia and sanctioned a design for an iron church in the second volume of the

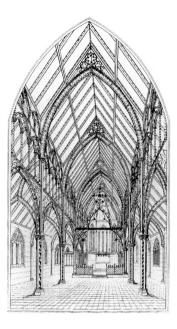

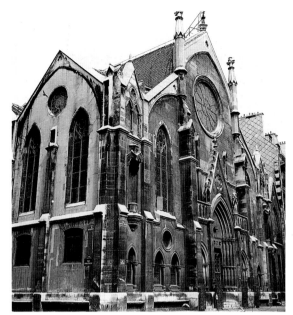

124 William Slater's 1856 design in the *Instrumenta Ecclesiastica* translated the pre-fabricated system of the Crystal Palace into Gothic terms. It was only a partial success. The piers are ingenious – rolled iron columns braced together, suggesting the form of medieval grouped shafts – but the pointed arches reproduce a form that only has structural sense in stone.

125, 126 Louis-Auguste Boileau's Saint-Eugène, Paris, 1854–55, was to show the potential of an iron Gothic architecture. In fact, its boxiness and two-dimensional character suggested wood as much as iron, reflecting its designer's early education as a joiner. His proposed iron chapel for Saint-Denis (at bottom), of the same date, was an eclectic mishmash, closer to Russian orthodox churches than to the French Gothic.

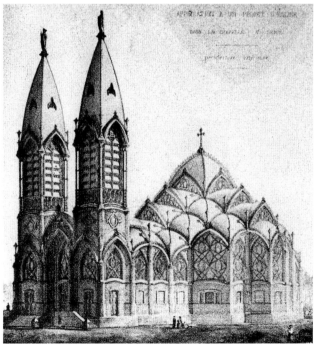

127 Eugène-Emmanuel Viollet-le-Duc's illustrations from his *Dictionnaire de l'architecture française* (1854–68) depicted Gothic forms as they had never been shown before, in cut-away views that suggested anatomical diagrams, making legible the direct relationship between function and form. Here he shows how the ribs of a vault converge on the capital of a shaft, and how the individual stones are shaped and cut. This rigorously rational critique of Gothic construction was the antithesis of Goethe's Romantic vision.

Instrumenta Ecclesiastica, its handbook of medieval designs. Once again, the problem of the mission church pushed the society toward innovation. Obviously the building of stone churches in cultures without a stone-building tradition was absurd. But in the United States, iron had been used since 1849 in commercial architecture, forming both skeleton and sheathing. Such iron components could be pre-fabricated, shipped overseas and fitted together – all without trained craftsmen on site. So William Slater's church was conceived.

The Ecclesiological Society conceded that the church was a makeshift, 'a stone church built in iron' and not one designed on 'purely metallic principles'. Not that 'metallic principles' were themselves a guarantee of beauty – or even of solidity. In 1854 Louis-Auguste Boileau (1812–96), a joiner turned architect, designed Saint-Eugène in Paris, a hybrid structure with an iron 125–26 frame whose interstices he filled with masonry, a system very much like medieval half-timbering. The church prompted a furious exchange of letters between its designer and Viollet-le-Duc, who warned that the tendency of iron to expand and contract with temperature change would soon loosen and dislodge its joints with the masonry. He also chided Boileau for treating iron as if it were stone – not heeding architectural reality – and reminded him that 'a change in material should involve a change in form'. But when Boileau set out to think in ferrous terms, the results were no better. He designed an ambitious 'synthetic cathedral' and an odd design for a chapel at Saint-Denis, where a cage of spindly iron columns hoisted aloft a cascade of high springy vaults. If they were admired it was not for their aesthetic properties.

Although Viollet-le-Duc scorned Boileau's efforts, he seems to have been unsettled. Although he insisted in 1855 that 'iron and masonry make poor bedfellows', he began to brood over the question. A decade later he responded to Boileau's challenge with a set of visionary designs for iron and masonry buildings, a manifesto for the proper use of architectural materials. These were some of the most radical and intellectually rigorous works of the whole Gothic Revival, in which the whole apparatus of the masonry vault was re-examined. Most astounding was his design for a market hall, which was arranged so as to leave the ground floor as unencumbered as possible for merchants' stalls. Viollet-le-Duc had already formulated his rational critique of Gothic architecture, describing how each form of a medieval building was shaped according to its structural role, each helping

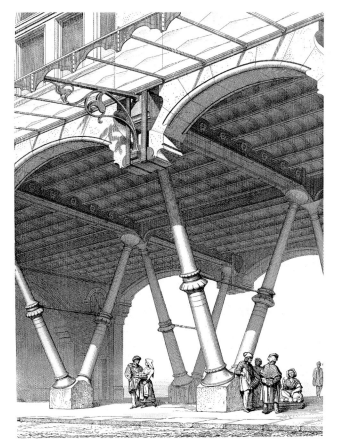

128 Eugène Emmanuel Viollet-le-Duc's design for a market hall, from his *Entretiens* (1872). Viollet-le-Duc's market hall, a reduced version of the facade of his unbuilt Paris Opera, is sometimes seen as an aesthetic failure. Nonetheless, it challenged such admirers as Hector Guimard, Antonio Gaudí and Frank Furness to find an architectural form appropriate to its daring structural exhibitionism.

to discharge the mighty thrust of the vaults through stone buttresses, channelling the weight safely to the ground; the entire system relied on the compressive strength of stone. So he depicted Gothic forms, organisms that were as suited to their physical function as human bones were to theirs. His treatment of iron was similarly rational. Unlike stone, iron is a tensile material and behaves better when stretched than when squeezed; to support a load with iron suggests a form more like a truss than a buttress. Accordingly he placed his angled struts on tough stone plinths and laced them together with slender iron tie rods, which acted to resist the tendency of the struts to spread apart under the load of the masonry above them. Cast iron, with its higher compressive strength, was specified for the struts and wrought iron, better under tension, for the tie rods. This ingenious system could have been concealed in the thickness of the wall, but

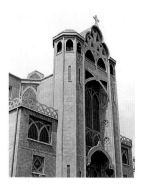

129 Anatole de Baudot (1834–1915) adapted Viollet-le-Duc's structural materialism to reinforced concrete in the church of Saint-Jean de Montmartre, Paris (1894–1901). Concerned that a simple concrete shell might have an unpleasant boxy quality, Baudot layered his facade in depth and screened it with cascades of swirling tracery, showing his effort to find ornamental forms appropriate to concrete.

Viollet-le-Duc could not resist the opportunity to make visible the engineering. For him these squat struts and their filigree ties were objects of stirring drama – the poetic limbs of the building, modern descendants of the buttress, and as such they deserved celebration.

Viollet-le-Duc's iron and masonry projects had tremendous inspirational force, influencing such diverse figures as Hector Guimard, Frank Furness and Antonio Gaudí. They reflect in dazzling form his profound materialism, the notion that the physical properties of materials, and the dynamic laws that govern their interaction, constitute the essence of architecture. Nonetheless, the designs remained abstract theoretical exercizes, confined to paper. The French architectural establishment remained stalwartly classical and conservative, and a generation would pass before the seeds he planted bore fruit. By then, however, concrete and not metal represented the most innovative technology. According to Viollet-le-Duc's theory, this would require acknowledging the plastic nature of the material, which is poured, rather than assembled skeletally as is iron. In 1894, his ardent disciple Anatole de Baudot did this, building the first reinforced concrete church, Saint-Jean de Montmartre, Paris, in 1894. By then, the Arts Nouveau movement was in full swing, and these stylistic experiments would quickly stray from Gothic territory.

Viollet-le-Duc's materialism and his structural rationalism was not limited to abstract projects but played an active role in his restoration practice. He was France's greatest restoration architect, picking up the work of Lassus, and he is better remembered for his restorations than for his original architecture. He reconstructed many of France's most important monuments – the church at Vézelay, the Château de Pierrefonds, the fortified town of Carcassonne – in effect creating the medieval France we see today. Ruskin believed that it was the tangible marks of human labour that ennobled a building, any restoration that involved scraping or replacing old work must be destructive. Viollet-le-Duc, who viewed architecture as rational construction and as the product of human ingenuity, had no such inhibitions. Such scraping and replacement of damaged stone was to give back to a building 'through prudent repairs the richness and brightness of which it has been robbed'. But he envisioned something far more sweeping than a good scrub. Restoration of a building, for Viollet-le-Duc, 'is not to preserve it, to repair it, or rebuild it; it is to reinstate it in a condition of completeness that could never

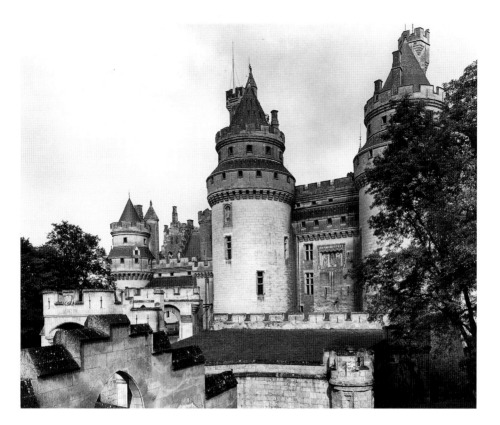

130 Viollet-le-Duc won the personal favour of Emperor Napoleon III and the Empress Eugenie, who called him 'my sweet violet'. In 1857 they chose him to restore the Château de Pierrefonds, built by the Duke of Orléans in the late fourteenth century. Its principal interior space was the 'Hall of the Valiant Knights', an extraordinary 165-foot (50-metre) chamber in which the Emperor installed his collection of armour.

have existed at any time.' That is, the architect had to comprehend the building as a functioning mechanical system as well as a historical artifact, treating it as both machine and work of art. A skilful restoration needed to negotiate among several competing benefits: the original state of a building, which may have been structurally imperfect; subsequent alterations, which might have improved its physical functioning; valuable works of art from a later date, such as stained glass or altars. Rather than repeating a formulaic approach, Viollet-le-Duc brought a high degree of flexibility to his restorations. In the Romanesque church of the Madeleine at Vézelay, his first project, he completely rebuilt the vaulting but left two bays intact to show the state prior to reconstruction. At the Château de Pierrefonds his restoration ran the gamut from forensic investigation in the reconstruction of the existing fragments and the archaeologically correct chapel, to speculative recreation of the missing keep, to complete fantasy in the opulent interiors. These works show Viollet-le-Duc at his best, acting simultaneously

as scholar and creative artist. In contrast to these, his fully original works are somewhat less interesting, despite their artistic intelligence.

Viollet-le-Duc's structural achievements were theoretical and the greatest tangible accomplishments in the use of iron in the Gothic Revival came about in commercial architecture. Here the constraints of theology or scholarship did little to inhibit originality, while the need to make vivid, eye-catching images spurred architects to invent freely. This was especially the case with railway stations, whose design and symbolism was a characteristic dilemma of the Industrial Revolution. At first, railway stations were designed in the prevailing classical mode, but while they presented a pleasing classical fiction on the street, their serene volumes and marble porticoes expressed nothing of the violent energy of train travel. They certainly did not indicate that at the rear was a gaping aperture through which smoke and cinders belched, and thundering locomotives emerged. By the 1840s came the first tentative attempts to make stations in the Gothic, whose active imagery and capacious arches suited it to the problem of the train shed.

The first Gothic stations were still polite essays, using the picturesque forms of the romantically landscaped garden, but in the High Victorian era their character grew more assertive. The hulking St Pancras Station and its attached Midland Grand Hotel was designed by G. G. Scott, who for once was not shackled

131 Nuremberg was proud of its Gothic heritage and began at an early date to make its public buildings Gothic. The municipal railway station, shown here in an 1850 view, is an early attempt to find a monumental form for the train shed – an ecclesiastical nave attached to the castellated block of the station itself.

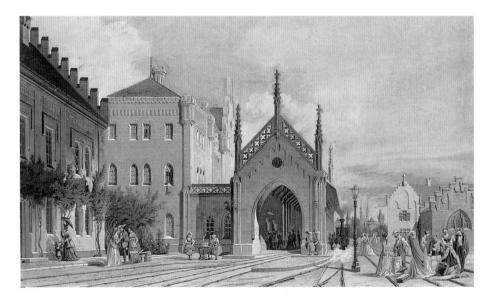

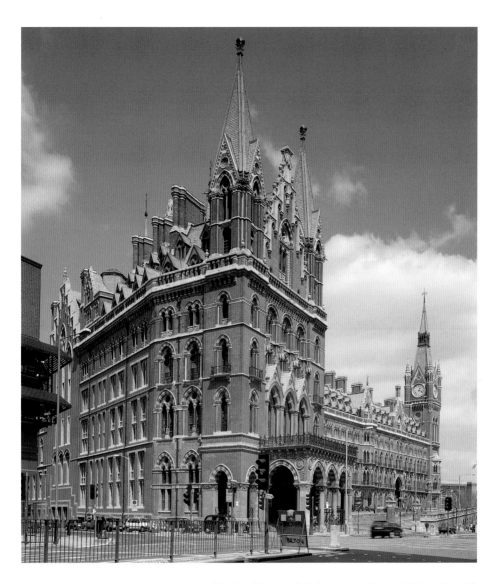

132 George Gilbert Scott, Midland Grand Hotel, St Pancras Station, London, 1868–77. In the Middle Ages, the vaults of the great urban cathedrals tested the physical limits of stone construction. In the nineteenth centuries, the sheds of the great railroad stations did the same with iron. His structural daring is celebrated in Scott's exuberant, tower-broken roofline.

by a Gothic foe like Lord Palmerston. Instead his industrial clients had no wish to mask the nature of train travel by a show of picturesqueness. Scott's theme was urgent tempo and physical energy, expressed by the irregular crouched silhouette of the hotel and the gigantic metal train shed, designed by the engineer Barlow, that swallowed the arriving passengers. Even after they stepped off the platform and into the luxury of the hotel, the frankly industrial vocabulary continued in the intricate iron stairs of the interior.

133, 134 A pair of modern Gothic warehouses by 'muscular' Burges and 'rogue' R. L. Romieu: Skilbeck's warehouse (1865–66) by Burges is a simple and practical loft of the medieval type, its newness announced only by the exposed iron lintel over the ground floor. Romieu's vinegar warehouse in Eastcheap (1868) is an agitated screen of Gothic canopies, creating the alarming top-heaviness that Victorians interpreted as commercial vigour.

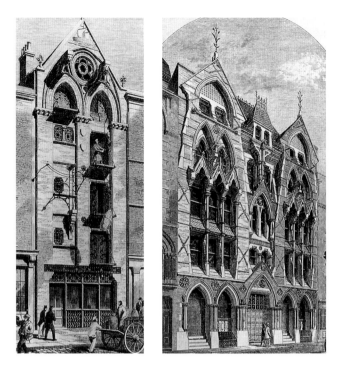

St Pancras Station was a very different Gothic from that of the early nineteenth century, which had been cultivated by dreamy romantics and amateur scholars. The wealthy, self-promoting classes served by Scott were less likely to feel the bounds of tradition and the agrarian past; moving by steamboat and rail, communicating by telegraph and canal packet, their restlessness and commercial energy was transmitted to their architecture. Rather than inducing a private romantic reverie, association was harnessed to the selling of wares and the communication of corporate values. Predictably Ruskin resented the application of Gothic forms to these vulgar purposes. He especially disliked the ornamentation of train stations, which he viewed as purely utilitarian structures. 'You would not put rings,' he pronounced, 'on the fingers of a smith at his anvil.'

In storefronts and other commercial buildings, iron was accepted as a matter of course. The need for maximizing light and air on a narrow urban lot was the sort of architectural problem for which iron construction and Gothic forms were splendidly suited. Gothic verticality and skeletal structure made it possible to treat a building as a simple Gothic bay or two, consisting of slender piers that enframed broad expanses of glazed openings,

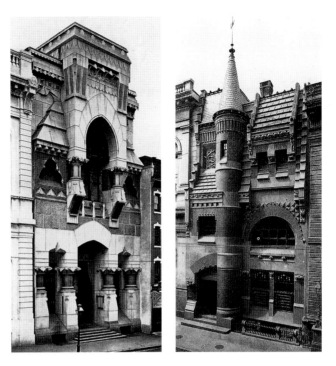

136, 137 For two competing institutions only a block apart from each other, Furness provided two different variations on the theme of the fortified portal. In the Provident Life and Trust Company (1876–79), the arched portal is guarded by the monstrous Gothic aedicule above, held aloft by dramatically compacted columns. In the National Bank of the Republic (1883–86) the bank is treated as a miniature Crusader's castle, with a turreted tower and an incongruous half-arch over the entrance.

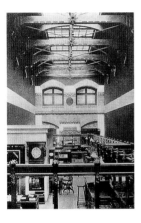

135 Frank Furness's iron roof truss for the National Bank of the Republic was medieval in spirit, if not in form. The bulky compressive members were clearly distinguished from the wiry tie-rods beneath them, demonstrating close study of Viollet-le-Duc's imaginative iron and masonry projects.

which were often capped by a bluntly exposed iron lintel. Some of these were astonishingly eccentric, but for all their High Victorian pyrotechnics, their medievalism had a core of authenticity. The modern commercial warehouse was itself medieval in origin, a direct descendant of the narrow, high gabled houses of Germany's Hanseatic cities, with their living quarters below and storage lofts above. This gave an aspect of plausibility to the best of modern commercial buildings, particularly in Germany.

In the United States, commercial architecture was far more freewheeling, or even vulgar. The social constraints and professional institutions that inhibited architectural excess in England and on the Continent were either absent or much weaker. Commercial forces poured into architecture without restraint. If a building used extravagant forms to try to draw attention to itself and to outshout its neighbours, so be it: such was the Darwinian jungle of commercial competition. Of the architectural competitors the fiercest was Frank Furness (1839–1912), who designed a dozen banks in his native Philadelphia with aggressive vigour, all for rival institutions in fierce competition with one another. Furness recognized that narrow commercial buildings tended to recede into the continuous plane of the

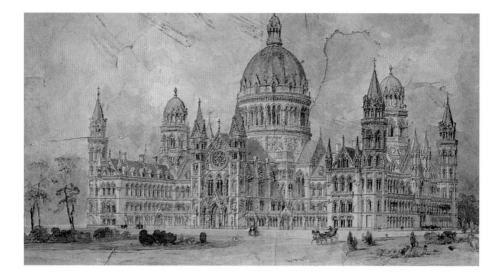

streetfront and he assembled his facades out of a few oversized Gothic components, rendering them in the broad strokes of caricature. His interiors, however, were invariably functional: open wells of light, rising to generous skylights and dramatically exposed iron roof trusses.

By the 1860s the resistance against using the Gothic for civic buildings seemed to collapse throughout Europe all at once. Previously Gothic town halls had been designed for Hamburg (1854) and Berlin (1859) but not built. Now major Gothic town halls rose in Munich (1864), Manchester (1868) and Vienna (1869), the latter by Reichensperger's protegé, Friedrich von Schmidt. The Viennese *Rathaus*, or town hall, displayed a disci- *141–42* plined, symmetrical design whose sweeping horizontals in its cornices and arcades precisely balanced the emphatic verticals of its tower and pavilions. Schmidt confined his exuberance to the spirited roofline and programme of decorative sculpture, avoiding the additive composition and raucous colour of the English High Victorian movement. Within was a grand arcaded courtyard, sober to the point of dryness, although relieved by exquisite proportions and detailing. This was the most important work of secular Gothic in German-speaking Europe, and gave hope that there might be a German Gothic parliament to match that of England.

This became possible after 1871, when Germany was united in the wake of the Franco-Prussian war and a competition was

139 Richard M. Upjohn was the son of Richard Upjohn, and took his father's practice in a High Victorian direction; the Connecticut State Capitol in Hartford, Connecticut (1872–78) is his principal work. It shows how much the character of Victorian Gothic depended on the choice of materials, for its glistening white marble construction gave it a far more frosty and puritanical character than if it had been built in the warm stones of contrasting colour that its forms seem to suggest.

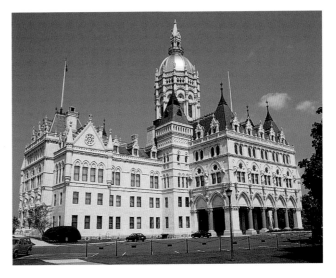

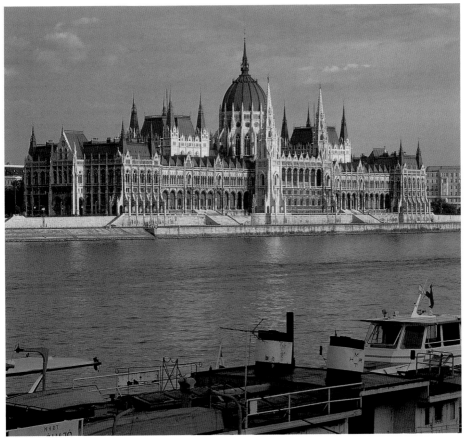

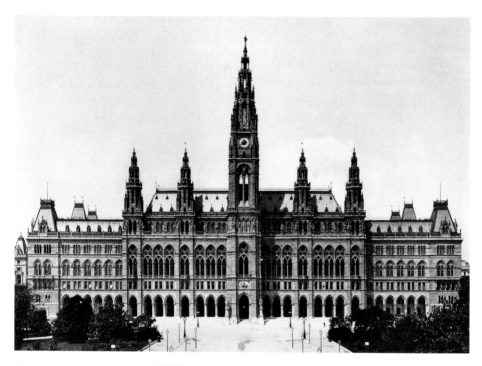

141, 142 Friedrich von
Schmidt's Vienna Rathaus
(1869–82). In its judicious
restraint and overall sense of
historical plausibility, it shows
Schmidt's years of work as a stone
mason on Cologne Cathedral.

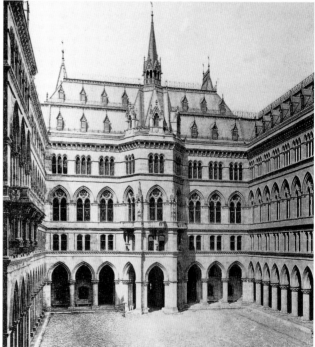

organized for a Reichstag building. Reichensperger helped supervise the competition in his capacity as a delegate to the Reichstag, and he worked assiduously to select a Gothic design, believing that the Middle Ages offered an appropriate model for the newly formed German nation: democratic and decentralized, and opposed to the absolutism that Baroque or Imperial Roman architecture evoked. Unfortunately, decision-making was now centred in Berlin, the German city least touched by the Gothic Revival, with an architectural establishment that was resolutely eclectic in the manner of Schinkel. Neither the Kaiser, nor Bismarck, nor the Bauakademie – Prussia's school of architecture – had any use for a style associated with Cologne Cathedral, and with Roman Catholicism. The competition turned into a fiasco for the Gothic camp, partly because Reichensperger had packed the jury with his friends Schmidt and Statz, thereby preventing them from competing. Only G. G. Scott turned in a sumptuous *138* Gothic entry. The competition failed to choose an architect and in the second competition of 1882 the few Gothic entries were ignored, indicating that German taste as well was turning to other models.

Scott's Reichstag design, despite its rejection, had stylistic progeny, including the State Capitol in Hartford, Connecticut. It also influenced the only Gothic Revival house of Parliament to be built outside of England, that of Hungary (1883–1904). The site *140* was the most spectacular in Budapest, a superb stretch of the banks of the Danube, and the architect Imre Steindl exploited it extravagantly. The result shows careful study of G. G. Scott's project, which is recalled in the central cupola, now held aloft by a corona of flying buttresses, but also of Barry's Houses of Parliament in London and even the Viennese Rathaus – not surprising, since Steindl was a pupil of Schmidt The interior was a decorative confection, crammed with paintings and statuary on nationalist themes. It thumpingly asserted Hungarian national identity at a time when the country was still submerged in the Austro-Hungarian Empire.

While Central Europe struggled with the nationalist symbolism of the Gothic, England tried once again to build a major Gothic monument in London. In 1866 a competition was held for the Law Courts, capturing the English Gothic Revival at the peak of its confidence and authority. With eleven architects invited, including Scott, Street, Burges and Waterhouse – the cream of the profession – the competition proceeded in stately pageantry. The invitees were handsomely paid so that they might refine

144 'Too much opium', William Burges complained to his diary in 1865; at Cardiff Castle (1869–76) his rich style reached its climax of narcotic fantasy. Not since Strawberry Hill had so much thought, care and love gone into the making of a vast Gothic playhouse, including the summit of Lord Bute's towered eyrie, his Summer Smoking Room.

143 William Burges's competition design for the Law Courts, 1866–67, was a medieval fantasy of a walled city, early French Gothic in detail and inspired by the fortified town of Carcassonne. Its architectural climax was not the central portal but the magnificent corner tower, doubly effective as a fireproof records tower and a glorious piece of stage scenery.

their designs to a much higher degree of development than the usual standard. This was no luxury for the programme was one of baffling complexity: twenty-four court rooms were required and barristers, defendants, witnesses and spectators needed to pass between them without colliding inappropriately. Here was an open test of the proudest and loudest boast made by the Goths, that their style, by virtue of its freedom from static symmetry, offered the most functional planning.

The drawings were exhibited to the public in 1867 in a specially built gallery, forming the century's greatest assembly of Gothic talent under one roof, an *omnium gatherum* of the living titans of the Revival. While the exhibition was a sensation, thoughtful critics would have noticed signs of strain. The free agglutinative planning that worked so well in a collegiate complex or a monastery could not be replicated on such a monumental scale without tumbling into incoherence. Throughout the entries were flashes of genuine brilliance but in none of them could the exterior be said to fit organically on its contrived plan. As logical as the plans might be, they seldom had any meaningful connection with the strenuous towers that erupted from the rooflines. The feature of most interest was the central circulatory spine, which lent itself to treatment in iron

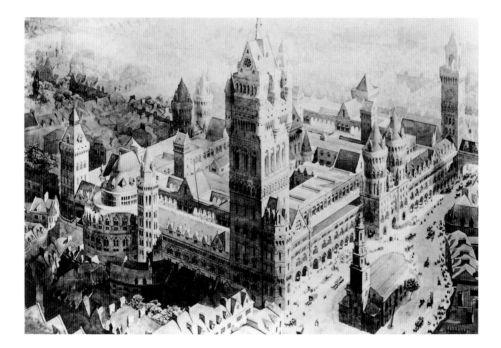

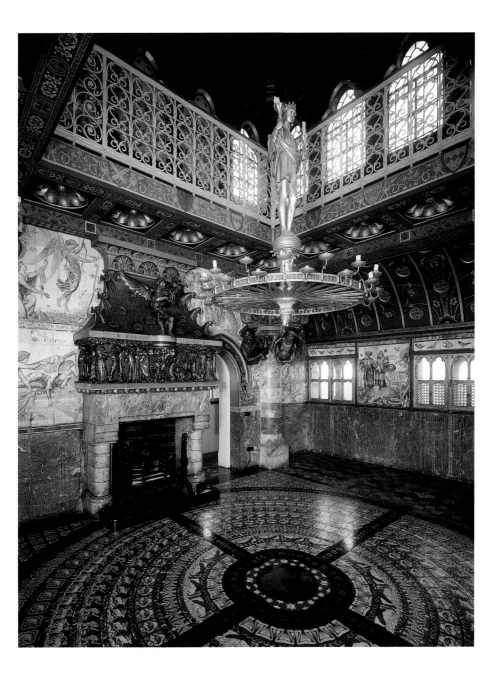

146

143

145 Alfred Waterhouse, competition design for the Law Courts, 1866–67. Waterhouse developed the most ingenious system for segregating litigants from the general public: the former moved along a wide internal boulevard, vaulted in iron and glass, which passed directly above the transverse passage used by the latter. Their point of intersection was an event of high spatial drama, compared by John Summerson to 'a railway cutting between two tunnels, crossed by a footbridge'.

and glass. That of Waterhouse was the most ingenious: litigants moved along a wide internal boulevard, under a transparent roof, which passed directly above the transverse passage used by the general public. Their point of intersection was an event of high spatial drama, compared by John Summerson to 'a railway cutting between two tunnels, crossed by a footbridge'.

Street won the prize but his hulking Courts were pared down in the execution between 1874 and 1882. Even so, his building is a marvellously picturesque congregation of forms – polygonal bays, festive tourelles and stout saddlebacked towers – whose additive and informal accretion of parts was not a bad metaphor for English law. Unlike continental law with its imperial decrees or abstract constructs like the Code Napoléon, English law was the collective body of precedent and custom that formed Common Law, constantly developing and growing. Its living organic quality comported happily with Street's rambling empirical composition. A relentlessly rational architecture, of the sort used for the contemporary Palais de Justice in Paris, France, would have been markedly out of place.

Although Street won the Law Courts competition, the future of the Revival was shown by another competitor. This was William Burges, the popular favourite of the competition, whose staggering aerial perspective exhilarated the public; no one else achieved such a moody play of shadows nor dared to elevate the mundane business of lawsuits and legal quarrels to such poetic heights. At thirty-eight, Burges was one of the youngest competitors, and his exhilarating design was an indication that the coming generation was thinking in graphic terms, concentrating on the artistic coordination of the whole ensemble. The Revival had advanced so far that it was now returning to where it was at the start of the nineteenth century: a pictorial rather than a moral enterprise, and – the intervening leap in scholarship notwithstanding – more akin to dreamy Wyatt than pious Pugin. This was not the only sign of coming change. The stalwart morality of Pugin, or that of a celibate bachelor like Butterfield, was now looking rather stodgy. More in keeping with the spirit of the day was Burges's friendship was the libertine E. W. Godwin, who lived openly with the actress Ellen Terry and fathered a child by her. As architects grew less rigid in their personal morality, it is telling that their architectural morality became comparably lax.

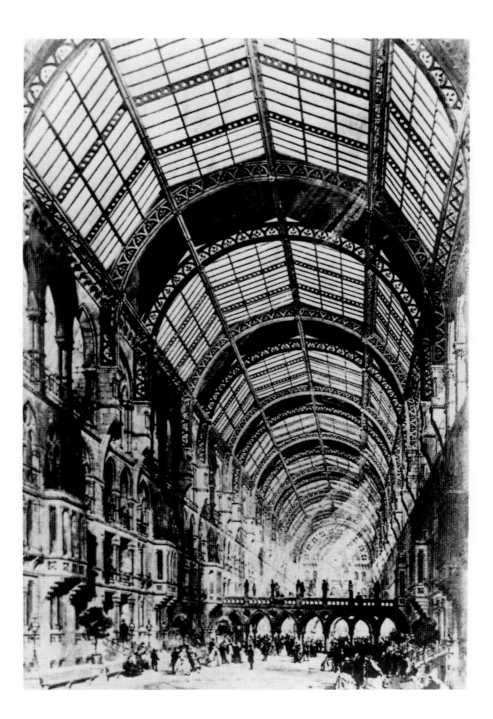

146 G. E. Street, Law Courts, London, 1866–82. In his final work Street turned his back on his Italian sources in favour of the Early English to represent an essentially English institution. Only on the rear elevations does the building burst forth in the 'streaky bacon' style of red brick and white marble stripes.

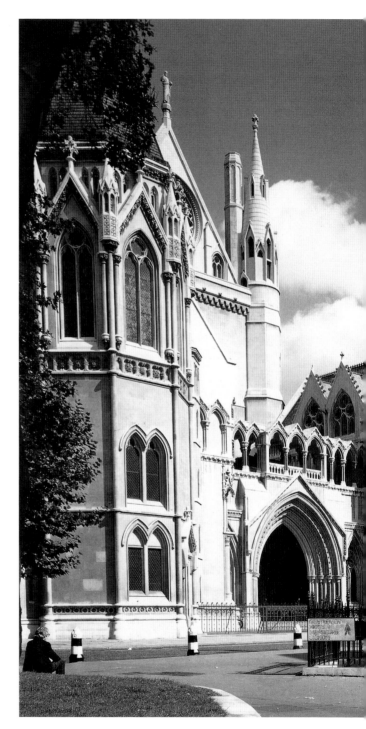

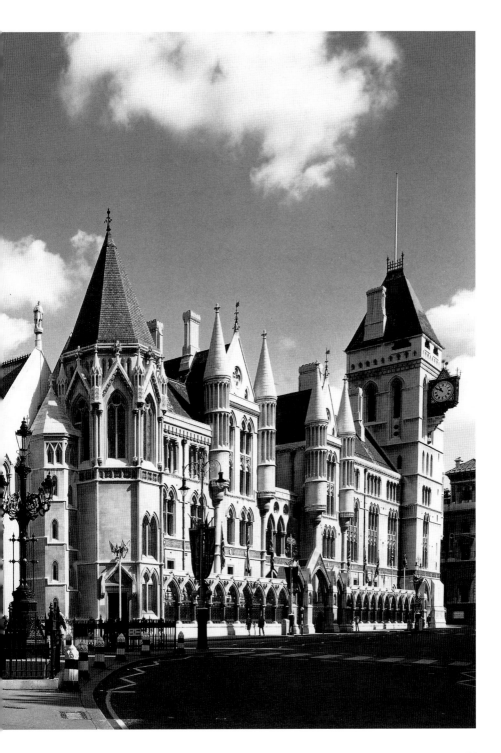

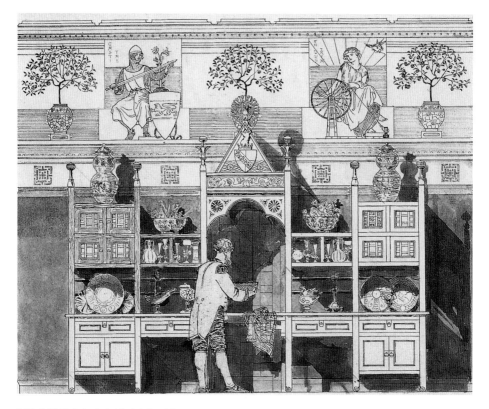

147 E. W. Godwin, design for interior of Dromore
Castle, County Limerick, including a dining-room
sideboard, *c.* 1869. Godwin's vernacular medievalism
was sufficiently abstract for him to absorb new stylistic
impulses, particularly from Japan, forming the basis for
the later Aesthetic Movement.

Chapter 7: Beauty

Keep it quiet. Richard Norman Shaw's advice to his pupils

By the 1860s the angry tone of moral indignation that had fired the architectural criticism of Pugin, Ruskin and the *Ecclesiologist* sounded old-fashioned and overwrought. Public opinion at last rendered its verdict on the Gothic Revival, neatly distinguishing between insights that were eminently pragmatic – such as truth in materials – and those which were merely matters of taste – such as the hatred of Perpendicular Gothic. Proclamations that had been radical when first uttered by Pugin were now enshrined as platitudes, or else forgotten; in either case they were no longer controversial. Gradually the polemical edge of the Gothic Revival was blunted.

As the movement waned in moral fervour, it diminished in intellectual rigour. High Victorian doctrine was eclectic and synthetic, the architectural language of a worldwide colonial empire. Opening ever wider to new geographical and historical knowledge, and lacking stylistic commissars to police its content, it lost its sense of opponents and opposition. In seeking to embrace everything, its boundaries became blurry. High Victorian architecture sprawled into a fashionable vernacular, cosmopolitan and colourful, but hardly revolutionary. In 1862 Queen Victoria, herself no great architectural innovator, deemed it acceptable for a monument to be built to Albert, the late Prince Consort. The result was the masterpiece of George Gilbert Scott, who 148 designed it and developed its lavish decorative programme. This was allegory at its most encyclopaedic, with the world's great artists and poets milling about under representations of the Four Continents and their peoples. Over all this presided the statue of the seated prince himself, sheltered beneath a lofty baldachino that was like nothing so much as a colossal reliquary, graced by all the decorative richness that statuary, mosaic and metal work could muster. Although the language was Gothic, the theme was confidence and bravura at the magnitude of Imperial Rome. By comparison, Kemp's rather Georgian monument to Walter Scott 42 in Edinburgh (1840–46) looked provincial and mincing.

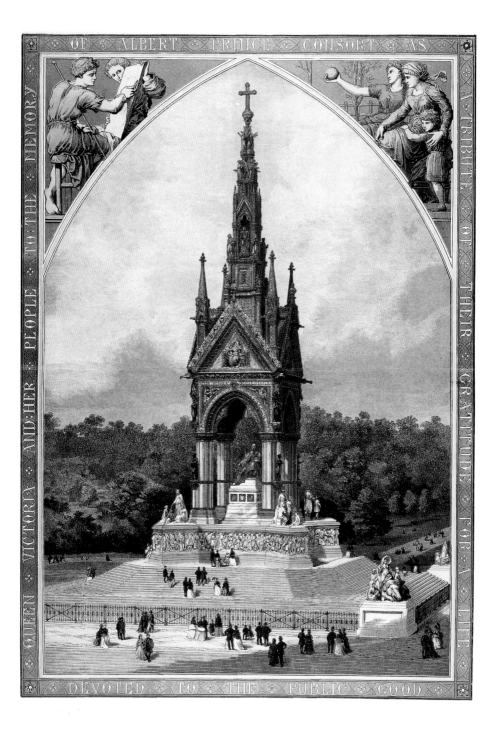

OF · ALBERT · PRINCE · CONSORT · AS · A · TRIBUTE · OF · THEIR · GRATITUDE · FOR · A · LIFE · DEVOTED · TO · THE · PUBLIC · GOOD · QUEEN · VICTORIA · AND · HER · PEOPLE · TO · THE · MEMORY

High Victorian eclecticism reached its acme in the United States, where architects were by necessity borrowers and compilers. Here no ancient architectural tradition inhibited the reception of foreign ideas, as impulses from England, France, Germany and beyond intermingled freely. For example, Leopold Eidlitz, a German-speaking émigré from Prague, devised New York's most raucous High Victorian church, Trinity Church, English in its assertive colouring but Germanic in its towers and roof forms. Even more idiosyncratic was the Philadelphia architect Frank Furness, who was educated on the French Beaux-Arts model but drew his inspiration from England's High Victorian architecture. His Pennsylvania Academy of the Fine Arts shows the collision of those sources, as Gothic arches, French Renaissance pavilions, an abstracted Islamic portico and even Greek triglyphs and metopes jostled in a stylistic jubilee. For a museum with an eclectic art collection such a melange was not unreasonable. And yet Furness revelled in the surfeit of styles, as if determined to test the limits of how much architectural history a single building could carry.

Eclecticism flourished because it satisfied the acute symbolic needs of Victorian society. It possessed a vitality appropriate to an age of railways, steam power and the telegraph – and a compositional flexibility appropriate to new building types at home and

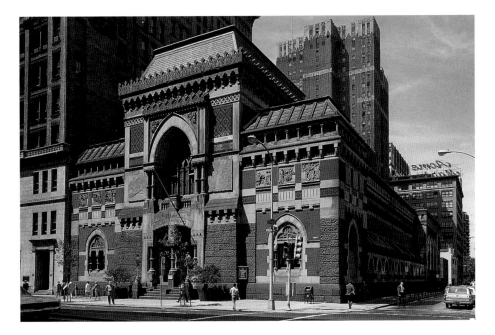

in the colonies. But as it fulfilled these expressive demands, it unravelled one of the cardinal doctrines of the Gothic Revival. Since Pugin's day, the organic union of form and construction was seen as the fundamental goal of architecture. Only in Gothic architecture, it was argued, was appearance identical with reality. High Victorian eclecticism challenged this unity. If multiple styles could be slathered onto a building like so many coats of whitewash, style could no longer be said to be an essential quality; it became mere arbitrary costume. Inevitably, a countervailing movement arose, seeking to purge these decorative veneers, eliminating the clutter of period styles to achieve genuine style. The key figure was William Morris, and the key building was the sturdy Red House he built for himself at Bexleyheath in 1859. 151

Morris (1834–96) wanted to be an architect and he toiled for a time in George Street's office. There he met Philip Webb, a fellow draughtsman and a kindred spirit. After Morris decided to abandon architecture as a profession in 1859, the two friends piloted a small boat along the Seine from Paris to the sea, during the course of which the Red House was conceived. As designed by Webb, it was a rambling brick affair, L-shaped in plan, with the oddity of its principal rooms facing north. Despite the connection to Street, there was little display of personal idiosyncrasy here. Its novelty was that it was not novel at all, looking as if it had always been there. There was none of the aggressive, hard-edged newness so cherished by High Victorian architects, nor the fiction of thirteenth-century perfection required by the pedants of the *Ecclesiologist*. Its sense of history was general rather than specific, deriving from the vernacular tradition of the countryside, where building was carried out unselfconsciously by anonymous carpenters and masons, and where the same local materials and building practices prevailed over the centuries because they were reasonable and appropriate. Style here was the outcome of sound construction and problem-solving, and not of self-conscious artistic invention. Webb, his pupils testified, 'thought more of stone than of style'.

A similar attitude reigned in Morris's workshop. In 1861, the year his house was completed, he founded the firm Morris, Marshall, Faulkner & Co., to produce furniture, wallpaper and decorative objects. Rather than merely reproducing approved medieval models, Morris and his designers worked freely and inventively, responding to the physical properties of wood, leather and fabric. Medieval principle, not medieval form, was the watchword. But Morris's mind ranged beyond good workman-

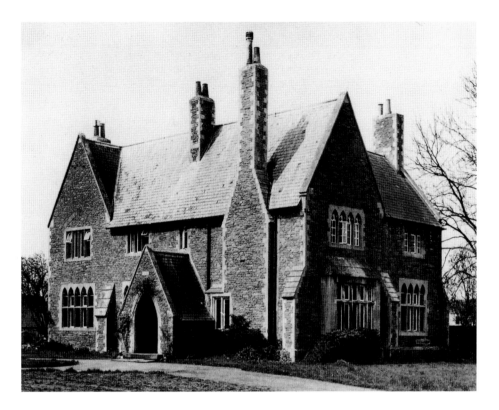

150 Philip Webb inherited his appreciation for vernacular construction from his teacher, William Butterfield, whose rural parish houses strictly deferred to local materials and tradition. Butterfield's vicarage for St Mary's at Coalpit Heath, near Bristol, 1845, is virtually unornamented, its character deriving from its rough rubble walls and the arrangement of bold gabled volumes.

ship to the philosophy of work itself. His mentor was Ruskin, who taught that human labour was a thing of sacred dignity which had been demeaned by the Industrial Revolution, condemning the labourer to mindless repetitive action. Perhaps Morris thought of Street's office, where draughtsmen were not permitted to design so much as a keyhole. Seeking to restore the dignity of labour, and to make it humane once more, he exalted the idea of the medieval workshop, in which all the arts were practised cooperatively and joyously, unlike the modern factory with its deadening routine. His medievalism was scarcely distinguishable from socialism, as his visionary novel *News from Nowhere* (1890) showed. Brilliantly conflating Pugin's *Contrasts* with Marx's *Das Kapital*, Morris depicted a twenty-first century Utopia that had abolished property, schools and mass production, even as it restored the vernacular architecture of the late Middle Ages. *News from Nowhere* was influential and was a major inspiration to the Garden City movement. Ironically, despite Morris's avid socialism, his honest, workmanlike products became coveted luxury goods in a capitalist society.

The movement that Morris set in motion unfolded so swiftly and with such urgent force that it is impossible to give it a precise name. If one looks at its underlying premises and the artistic problems it sought to remedy, then it should be called the Reform Gothic. But if one looks forward, it is the start of the Arts and Crafts movement. Between the two labels no strict line can be drawn, for while Morris began by seeking to reform the Gothic Revival he soon came to eliminate everything about it that was literally Gothic. Here he exposed the internal contradiction in Pugin's theory, which assumed that the doctrine of truth in materials was uniquely fulfilled by Gothic architecture. So long as the alternative to medieval architecture consisted of variants of the classical orders, this was a tenable position. But by justifying the pointed arch and the ribbed vault in terms of abstract principle, Pugin opened the door to any other style that expressed construction directly and boldly, regardless of its symbolic associations or historical origins.

151 Built at the height of the High Victorian era, William Morris's Red House, Bexleyheath, 1859–61, was revolutionary in its deliberate suppression of style and personality. The goal of its architect, Philip Webb, seems to have been the timeless rather than the fashionable.

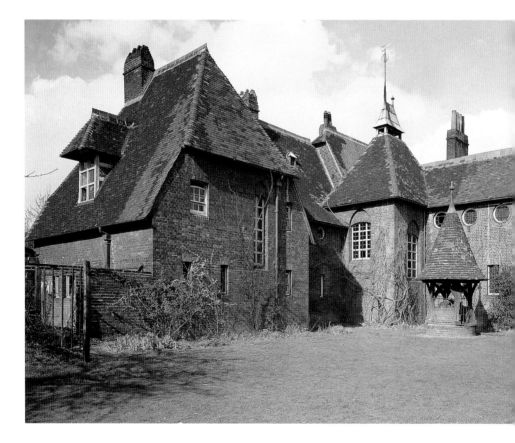

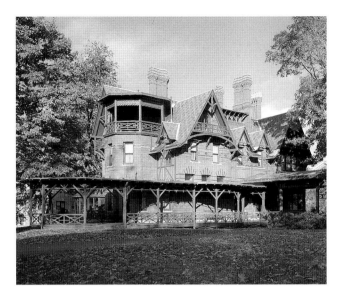

152 The Mark Twain House, Hartford, Connecticut, 1873. Here architect Edward Tuckerman Potter used High Victorian eccentricity to convey Twain's vitality and flamboyance. The stylistic sources are English and Continental, although the sleek verandas and machine-like sense of the composition is rather American. Potter and his brother William prospered under yet another brother, an influential Episcopalian bishop, who secured them commissions throughout the country, which they rendered in strenuous Anglophilic style, largely derived from Street and Butterfield.

In 1862 such a style seemed to appear. The International Exhibition in London presented the first comprehensive display of Japanese furnishings and furniture ever shown in the west. William Burges marvelled, writing that if anyone 'wishes to see the real Middle Ages, he must visit the Japanese Court'. Burges's enthusiasm for Japanese art was passed on to his friend and collaborator, the eccentric E. W. Godwin (1833–86). Previously, Godwin had been an obedient Ruskinian, having designed Northampton Town Hall, the most sprightly and imaginative of Venetian-style town halls. But he had grown disenchanted with the whole business of choosing a style and a century to work in, and, like Morris, had come to praise the vernacular: 'Nothing but the vernacular, the builder's work, naked of ornament, void of style, and answering only to one name – Utility.' Having shifted his criteria from style to utility, Godwin was able to assimilate the lessons of Japanese art with exceptional speed. He especially admired the way that Japanese art juxtaposed discrete passages of ornament against flat, unadorned planes – areas of 'spatial silence', in the words of Alan Colquhoun – just as Japanese calligraphy exploited the empty space of the page. From Japanese art he learned that the display of construction need not be an overwrought drama of force and counterforce, and that it might be graceful, even lyrical. Applying these lessons indiscriminately to his architecture, textiles and furniture, he developed an abstract style of exquisite restraint and delicacy.

147

Godwin's understated work was a withering rebuke to High Victorian architecture. Its razor-sharp edges, slashes of electric colour and aggressive swaggering had once conveyed energy and originality; compared to Godwin's mature work they seemed merely nervous and contrived. Quiet repose and simplicity began to look startlingly fresh, bringing about a general lowering of expressive intensity, especially in domestic architecture. There emerged a bewildering variety of styles – the Queen Anne and Old English in Britain, the Shingle Style and Colonial Revival in the United States – but all shared a common root: an impulse to reconcile Gothic freedom with classical values, to 'discipline the picturesque'.

In this process, explicitly Gothic features were the first to go. Nonetheless, Gothic habits of planning and massing continued undiminished, even achieving a kind of apogee, as country houses

153 Richard Norman Shaw, Leyswood, near Withyham, Sussex, 1868. Three decades of structural truth were elegantly repudiated by charming, picturesque Leyswood, a warning sign that the moralistic interpretation of architecture was toppling.

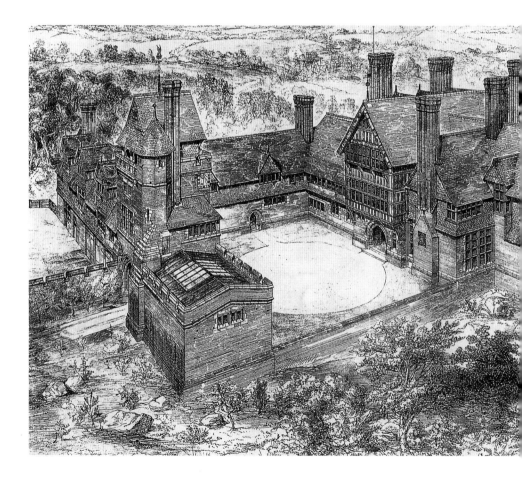

shook off the last vestiges of Georgian symmetry. This was in large measure the achievement of Richard Norman Shaw (1831–1912), the pioneer of the Old English style. His Leyswood, near Withyham, Sussex, of 1868, a lovely essay in the poetry of timber and brick, crystallized the new mode. Like Webb, he was a veteran of Street's office and he also forsook early French muscularity for the charms of late medieval vernacular architecture. His chief compositional tool was the roof, and he loved to subordinate gables, dormers and chimneys to its lazy, gently straggling line. Shaw was a skilled pen-and-ink artist who excelled at aerial perspective, a form of draughtsmanship peculiarly well suited to rambling informality.

Shaw's renderings were widely imitated in Britain and America, itself a sign of an upheaval in values. During the dogmatic phase of the revival, the making of architectural drawings was never seen as an end in itself. An architect was pre-eminently a builder, like his medieval counterpart, and not a maker of pretty pictures. Structural reality and utility was everything; if pictorial effects resulted, these were but the secondary consequences of functional design. To make the form of a building defer to pictorial requirements would be to design backwards. This crucial distinction led Philip Webb to divide the architects of the revival into two categories, which he termed Softs and Hards. The Softs were those who exhibited regularly, who made luscious renderings and whose conception of architecture was essentially visual; the Hards were men who thought in terms of construction and materials, and approached the act of design as a hard-headed, practical problem-solving. (Webb's less poetically minded contemporaries distinguished between those whose chimneys drew and those whose did not.) The generation of the 1850s and 1860s tended to be Hards, such as Butterfield, who once dismissed Webb as an apprentice because he had participated in a student exhibition. In the more tolerant atmosphere of the 1870s the Softs prospered. Improvements in photo-reproduction technology played a part in this, now permitting the architectural journals to reproduce pen and ink drawings such as Shaw's, with their expressively quivering lines, instead of the hard-edged woodcuts that were so well suited to High Victorian muscularity. Pre-Raphaelite painters also contributed to the revival of interest in medieval drawing technique. The firebrands of the new generation, such as Beresford Pite, exploited these graphic tools to treat the Gothic in the mystic terms of a dream. Measured against such delirious visions architectural 'reality', that

154 If Burges's Law Courts entry hinted at the return of purely pictorial values, Arthur Beresford Pite completed the process. His 1882 drawing for a West End Club House, submitted in the Soane Medallion Competition, shows a hulking behemoth in modern London – an ogre's stronghold rendered in the style of a fifteenth-century German wood engraver.

favourite term of High Victorian praise, was hopelessly stodgy – as stodgy as Wyatt had looked to Pugin.

In the United States, Shaw's example was swiftly copied, although interpreted in the light of indigenous colonial architecture. This was the counterpart to Shaw's Old English sources, a historical style midway between medievalism and classicism, admitting elements of both. H. H. Richardson's celebrated William Watts Sherman House in Newport, Rhode Island (1873) was the first of these, a robust affair of half-timbering and shingles whose plan centred on the great living hall within. In the work of Richardson's pupils, Charles F. McKim and Stanford White, these sources were blended even more completely until their stylistic pedigree was no longer recognizable. The result was that boldly abstract mode now known as the Shingle Style, based on the structural properties of the humble wood shingle. Seldom was a building material more suited to the aesthetic values of an age. Used as sheathing over a wood frame, shingles undulated freely around bays and dormers. Instead of the additive juxtaposition of volumes that High Victorian architects preferred, walls and roofs could now be treated as a seamless membrane, achieving a degree of linear continuity beyond what even Shaw could realize. Design now became a matter of expressive line. The Shingle Style achieved a splendid clarity in the work of the society architect Bruce Price (1845–1903) at Tuxedo Park, New York.

If the Gothic means only a repertoire of buttresses, tracery and finials, such buildings were not Gothic at all in the strict stylistic sense. But in every other respect – in their picturesque informality, delight in materials and construction, and the functional freedom of the open plan – these buildings were fundamentally Gothic, the direct offspring of Pugin's principles. The unquestioned success of these same principles now meant that they were no longer the exclusive property of Gothic architects. Even the most bigoted Renaissance architect could no more think away functional planning than he could iron lintels, coal furnaces and gas lighting: they were part of the common architectural culture.

Abstraction and simplification was not the only way of checking High Victorian excess. Another was to insist on the correct use of style. This was academic historicism, the second great strand to appear out of the debris of the dogmatic Gothic Revival. Instead of trying to eliminate stylistic incoherence by eliminating style itself, it sought to discipline style by a process of

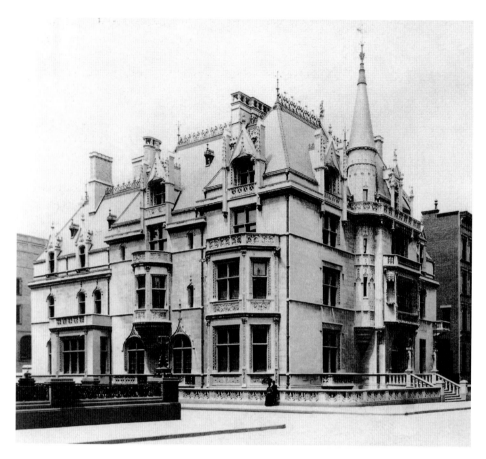

155 The William K. Vanderbilt House, New York, built by Richard Morris Hunt (1877–82), launched a fad among America's Gilded Age plutocrats for building tastefully historicizing mansions. Hunt built many of these for the extended Vanderbilt family, including the massive Biltmore, at Asheville, North Carolina, the greatest of the neo-Gothic châteaux.

scrupulous scholarship and study. After a generation of unrestricted freedom, the artist was once again subjected to the yoke of antiquarianism. By way of consolation, this was no longer the narrow stylistic range permitted by the *Ecclesiologist*; now taste began tiptoeing back toward the long-reviled English perpendicular. Even Tudor Gothic, scorned since the day of Pugin, again won acceptance, as did the sixteenth-century châteaux of the Loire valley. Such explicit copyism fulfilled a client's representational needs in a way that the symbolically mute vernacular could not. For example, Richard Morris Hunt's townhouse for William K. Vanderbilt was a clever response to the problem of how a modern railroad tycoon should live (i.e., like a medieval French duke). Both as social symbolism and architectural scholarship the Vanderbilt house was impeccable, although analyzed in terms of theory it marked a return to the stage-scenery Gothic of James Wyatt.

Academic historicism was strongest in the field of religious architecture, where symbolism was literally a sacred matter. In the 1870s two distinct movements arose, taking their inspiration from opposite ends of the Middle Ages, equally distant from the prescribed thirteenth century. In short order, the Romanesque was rehabilitated, in all its primitive vigour, as was the lush architecture of the late Gothic. Radically different in ornament and expression, these two styles nonetheless shared certain formal values. Each had classical qualities, suggesting dignity and solidity, values very far removed from the nervous, colour-drenched churches of the High Victorian era. Here again Richardson played a decisive role. Trained in Paris as a classicist, he adapted to the High Victorian architecture demanded in the United States, and struggled to find a middle way between classicism and medievalism. His 1873 perspective drawing for Trinity Church, 157 Boston (1872–76), peeled away to reveal the facts of its physical assembly, captures this struggle. Although the style was nominally Romanesque, its electric colours and structural exhibitionism remained defiantly High Victorian. In the final design, 156 Richardson brought his details into harmony with the style. His walls became mural, broad and flat areas to be painted, establishing the generous scale and bold simplicity that is the hallmark of his mature work. During this heroic bout of design revision, he consolidated the forms of the exterior, compacting them and subordinating them to the strong pyramidal lines of the roof. The building was a sensation, and almost singlehandedly marked the end of the High Victorian Gothic movement in the United States. Within a few years its Romanesque style swept the nation, its round-arched arcades, low gables and ground-hugging silhouettes dislodging the spiky, vertical forms of the Victorian Gothic.

Although he worked in the Romanesque, Richardson is one of the great figures of the Gothic Revival. He represents the culmination of the longstanding interest in Gothic primitivism and the ultimate sources of Gothic power, a tradition that extends through William Burges and the fad for muscularity, reaching to the late eighteenth-century preoccupation with the origins of Gothic architecture. Of course the most articulate exponent of the 'lamp of power' was John Ruskin, and Richardson must be counted as his most attentive reader. Ruskinian architecture is generally taken to indicate tight paraphrases of the Doge's Palace in Venice, but Ruskin never demanded a moulding-for-moulding reproduction of the buildings of Venice. His architectural prescriptions were metaphorical and impressionistic, not specific.

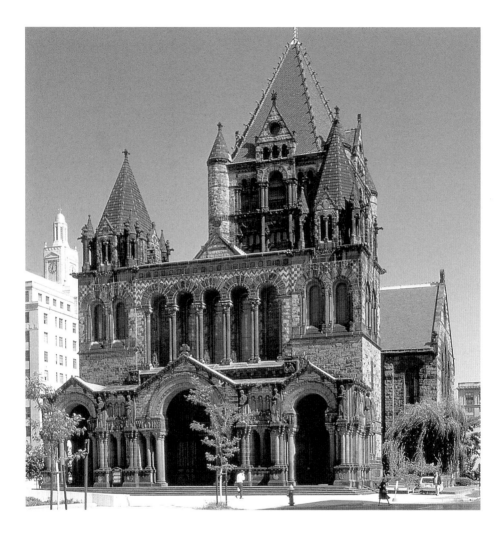

156 H. H. Richardson, Trinity Church, Boston (1872–76). After the completion of Trinity Church in 1876, the Romanesque was no longer an apologetic and half-hearted alternative to the Gothic. Now a full-fledged stylistic movement in its own right, it was a lively generator of architectural ideas and forms into the early twentieth century, particularly in northern Europe.

He called for an architecture that aspired to the state of nature herself, with the fierce dignity of a cliff face, or the swelling sense of a geological upheaval. No other architect came closer to fulfilling these demands than Richardson. The presence of nature was a constant theme in his geologically oriented work, which evoked the epic scale of the American continent but also the ravages of the Industrial Revolution. In his work runs a thread of sublime melancholy, a quality present in no other neo-Romanesque architecture. Here the Gothic Revival reached the limits of what style itself could express.

Richardson's heroic primitivism found little direct echo in Europe, although there was a parallel revival of the Romanesque.

In France it was especially popular. Clerics appreciated its Christian pedigree and medieval symbolism, while the classically minded students of the Ecole des Beaux-Arts valued its formal qualities of repose and clarity. Since the Ecole trained many architects of the Service des Edifices Diocésans (the building office of the Catholic church in France) there was a persistent tendency to classicize its medieval sources. This is apparent in the career of Emile Vaudremer (1829–1914), a distinguished Prix de Rome winner who dominated the work of the office after 1870. He practised a learned and eclectic medievalism, swirling together Romanesque, Lombard and Early Christian motifs for his Church of Saint-Pierre-de-Montrouge, Paris (1864–70). Unlike Richardson, it was not the archaic power of the Romanesque which attracted him, but its flexibility, which suited a cosmopolitan age. Encyclopaedic cosmopolitanism was also the theme of the dramatic cathedral at Marseilles, a brightly striped Byzantine essay that dominates the modern harbour below. It was the work of Léon Vaudoyer, another student of the Ecole who had no use for the thirteenth-century orthodoxy of Viollet-le-Duc.

157 H. H. Richardson's 1873 perspective of Trinity Church, Boston, is in the characteristic cut-away style of Viollet-le-Duc, peeling away walls and piers to show the interrelationship of construction and materials. Richardson surely attended the French architect's lectures while studying in Paris but it is likely that the drawing was made by Charles McKim or Stanford White, then training in Richardson's office.

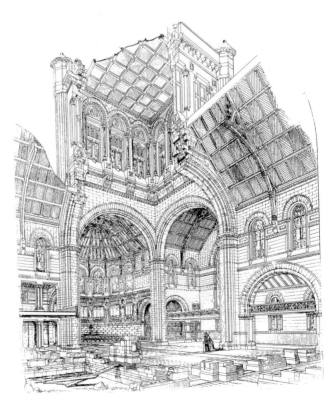

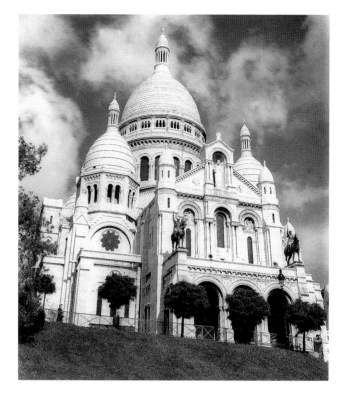

The most celebrated Romanesque work – and certainly the most conspicuous monument of the French revival – was the Sacré-Coeur, Montmartre, Paris. This was the design of Paul Abadie, who had restored and rebuilt the cathedral of Saint-Front de Périgueux, which gave him the idea of a church composed of domed bays, rising to a dominant central dome. When Abadie first dabbled in the Romanesque and Byzantine in the 1850s, he was working within the historical tradition of the Poitiers region. But the glistening marble domes of Sacré-Coeur were an exotic novelty, having nothing to do with Parisian tradition. The result was thrilling, and a sign that Didron's Gothic orthodoxy – always hostile to the use of archaeological forms simply for effect – had collapsed.

In England, High Victorian architecture met a different fate. Here the Gothic turned towards taste and reticence, and a growing tendency to give church interiors a sense of spatial unity. The first churches to show the new tendency were those of that genteel genius, G. L. F. Bodley, who was blessed with a rare aesthetic sensibility. By birth and training, he belonged to the rollicking

generation of the 1850s. He was a veteran of Scott's office, like Street and Webb, his earliest works bared the same tense muscularity. But Bodley's artistic disposition soon pushed him from the questionable Decorated to the discredited Perpendicular Gothic. To the pious Ecclesiologists, the use of these styles was heresy, but Bodley thought in aesthetic rather than theological terms. He found in England's late Gothic architecture virtues that no one had seen for a generation: its majestic horizontal character, elegant ornament and essential prettiness. Such a shift had strong patriotic appeal. Bodley offered a kind of restoration, sweeping away the vagaries of High Victorian eclecticism and returning to the solidly English sources used by Pugin. Yet Bodley's theory was hardly Puginian. Instead of truthful or untruthful architecture, he distinguished between buildings that were 'courteous' and those which showed 'bad manners'. His list of principles was headed not by Truth but by Refinement, a quality which Bodley found above all in the architecture of the mid-fourteenth century.

Bodley's church at St Augustine, Pendlebury (1869–74) announced the new approach. Defying the Ecclesiologist requirement that a church be strictly divided into chancel, nave and aisles, Bodley threw these volumes together into a continuous spatial vessel. A clever system of internal buttresses freed the

159 G. F. Bodley and Thomas Garner, Holy Angels, Hoar Cross, Staffordshire, 1871–76; 1891–1900. The fourteenth century that Bodley cherished so deeply was actually the century of the Black Death, which struck in 1349 and disrupted building activity for decades. His Holy Angels presented a serene and idealized fourteenth century, stripped of plague and civil strife, characterized by the graceful and quintessentially English curve of the ogee arch.

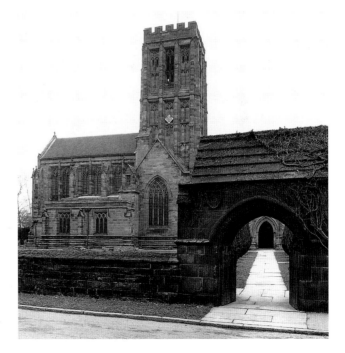

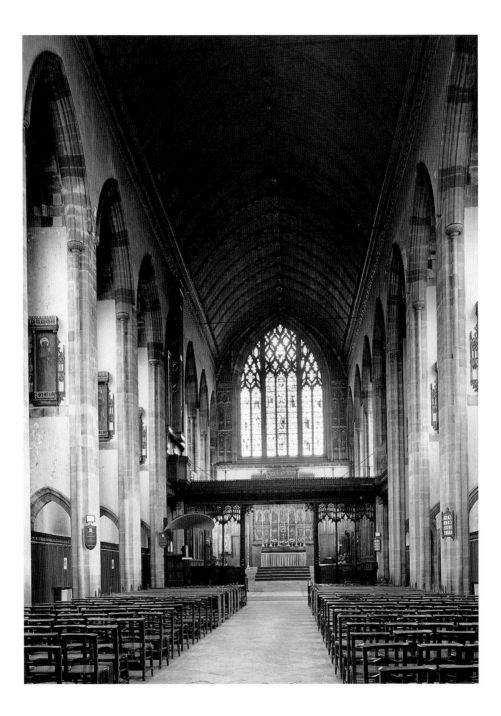

exterior of cumbersome supports, giving it a simple gabled form and compact massing. At the same time, these introverted buttresses beat a stately rhythm, embracing the vestigial side aisles and eliminating the freestanding columns of the arcade so that wall and support became continuous. The motif of the internal buttress was provided by Albi Cathedral, hardly an English source, but one that Bodley seized on for its spatial possibilities, using it again and again. In his mature work, the coordination of the decorative ensemble and the overall unity of composition came to be the central areas of concern. Holy Angels, Hoar Cross, 159 Staffordshire (begun 1870), was the finest of these, a composition of unsurpassed elegance that culminated in a lofty crossing tower, an overwhelming gesture that gave coherence and sublimity to the gathering of gabled volumes huddled about its base, achieving the 'restrained power' that was his goal. The effect of exceptional repose and dignity continued in the interior, which contributed toward its overall effect. Here the subdued lighting of the nave led the eye to the light and colour-drenched chancel, where the sculpture and stained glass formed one of the richest decorative ensembles of the entire Gothic Revival.

Bodley's influence was enormous, although none of his imitators matched the imagination and sheer artistic devotion of his pupil John Ninian Comper (1864–1960). Comper began his long career as a disciple of the late Gothic but soon came to believe that the heart of church design was not the question of style – a secondary matter at best – but the treatment of the altar. He stressed this doctrine unwaveringly throughout his life (each of his five books, written between 1893 and 1950, has it as his subject); it is also evident in his principal work, the church of St Mary's, Wellingborough, Northamptonshire, begun in 1904 and embellished by Comper until the end of his life. (His most visible work, however, is the series of painted windows of Westminster Abbey, depicting medieval kings and abbots.)

In the United States, Bodley's greatest follower was Ralph Adams Cram (1863–1942), who came to prominence just as Richardson's influence was waning. Cram was a pugnacious author, the last great polemicist of the Gothic Revival. With unshakeable Puginian conviction, he carried the architecture of the fourteenth century deep into the twentieth, championing the Gothic in a world of steel construction and tall buildings. Although an accomplished scholar (who wrote an important book about Japanese architecture), he was no mere bookworm. Cram was a font of tasteful, fastidious detail but it was always

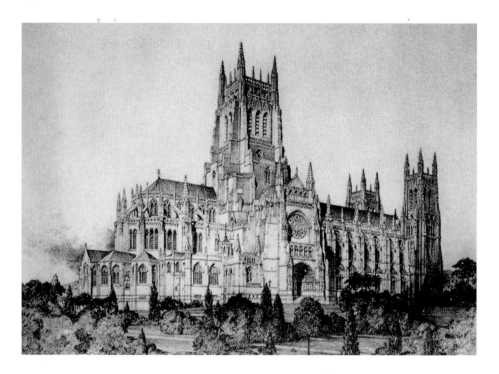

161 The Episcopal Cathedral of St John the Divine, New York, is the masterpiece of Ralph Adams Cram. Eclectic in style, it combines a facade and chevet of Early French Gothic with a crossing tower of four-square English character. Its vertical rise is breathtaking, columns of unparalleled thinness carrying an array of genuine stone vaults.

162 After languishing during the Depression and Second World War, St John the Divine resumed construction in the 1970s. Apprentice stone cutters were hired from nearby Harlem and trained in the building lodge, just as a medieval cathedral engaged the efforts of the whole city. Still retaining its original Romanesque apse and not yet finished, St John the Divine presents a truer picture of most medieval cathedrals – with their multiple building campaigns – than almost any other work of the Gothic Revival.

subordinated to the plastic expression of the whole, which he treated in almost sculptural terms. Together with his partner, Bertram Grosvenor Goodhue, he revised perspective drawings again and again, until each of the masses had the proper degree of heft or tautness – a process of microscopic adjustment better known today in plastic surgery than in architecture. The result was a Gothic that reconciled archaeology with formal abstraction. His vision went beyond the narrow rationalism of the French Gothic. To him the Gothic 'stood for life palpitating with action, for emotional richness and complexity, for the ideals of honour, duty, courage, adventure, heroism, chivalry; above all for a dominating and controlling religious sense and for the supremacy of an undivided Church and all it signified.' All these qualities – except for the different religious core – Cram claimed to find in the Buddhist temples of Japan, a country where he felt medieval values of craftsmanship were still alive.

When given free rein, Cram favoured Bodley's fourteenth-century Gothic, which he admired for its 'breadth, largeness, grasp of mass, grouping of light and shade'. In his most celebrated work, the Cathedral of St John the Divine, New York, this was not an option. The cathedral was begun in 1888 by the firm of

176

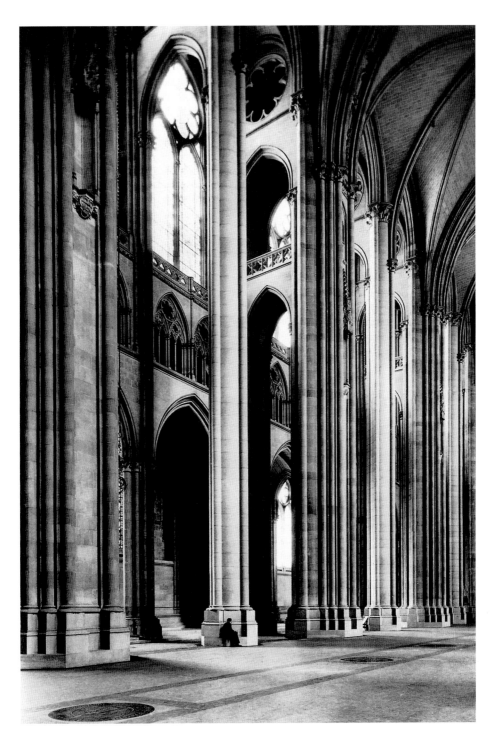

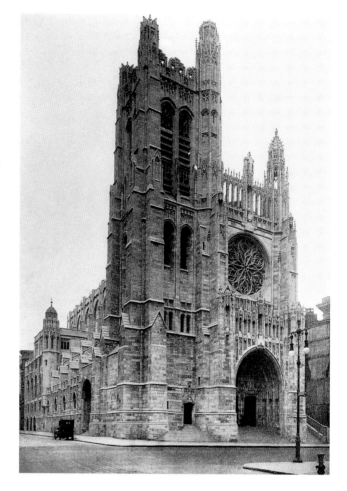

163 St Thomas, Fifth Avenue, New York, begun in 1907, by Cram, Goodhue, & Ferguson, is anchored on a corner tower so massive that it pushed the portal and rose window to the side, juxtaposing solid against cavernous void. Such vigorous plastic expression has saved the church from being overwhelmed by the scale of modern Fifth Avenue. Its sculptural programme relates to the contemporary world, including references to World War One generals, the sinking of the *Lusitania* and even a dollar sign – perhaps a modern version of a medieval devil.

Heins and Lafarge but its eclectic Romanesque style quickly became unfashionable. In 1911 Cram was hired to draw together the already built fragments and make them Gothic. This was just the sort of mental exercize he enjoyed but he was severely constrained by the existing work, particularly the foundations. With their un-Gothic proportions, based on square rather than rectangular bays, the standard quadripartite Gothic vault would be unwieldy. Cram tried to handle the problem as a medieval mason might. He realized that this was precisely the problem faced in France in the twelfth century, which also sought to place ribbed vaults over the square bays of modular Romanesque ground plans. Their architects solved the problem by dividing the square into two rectangles, accomplishing this with an additional trans-

verse rib that came to rest on an intermediate support. The result was a system of alternating supports: strong piers at the corners of the square bay, alternating with more slender supports in between. This form was complicated and soon gave way to the simpler quadripartite vault preferred by the High Gothic. Cram brilliantly revived the form, using it with rigorous artistic consistency. Along the nave he alternated double and single buttresses, precisely describing the interior arrangement of thick and thin supports within. No French cathedral ever had such a feature but the effect was completely plausible, a brilliantly corrected version of the twelfth-century French Gothic cathedral, with the clarity made possible by retrospection.

Such archaeological showmanship no longer impressed the youngest architectural talents, who now saw the Gothic Revival as a conservative movement, tending to scholasticism. Since the 1890s, architectural innovation had moved from the Gothic to the area of free classicism or Art Nouveau, where the most restless young architects strayed. Even within the Gothic ranks, the most interesting developments were at the periphery, where the Arts and Crafts movement had abstracted its vernacular sources so completely that they were scarcely Gothic any more. The neo-vernacular movement was dominated by W. R. Lethaby (1857–1931), who inherited his respect for construction from his apprenticeship with Philip Webb. (It is no accident that the new tendency toward simplification and the vernacular was strongest among the artistic progeny of Street and Butterfield – the most flamboyant of the Victorian Goths, but who took seriously every aspect of craft, metalwork, furniture making, ceramics and decoration.) Lethaby's All Saints, Brockhampton, Herefordshire

164 W. R. Lethaby published *Architecture, Mysticism and Myth* in 1892, exploring the archaic symbolism on which all architecture is based. His church at All Saints, Brockhampton, Herefordshire (1901–2) is his brilliant attempt to show how a church can simultaneously be modern yet connected to the primal sources of architectural meaning.

165 In construction for nearly a century, Giles Gilbert Scott's Liverpool Cathedral (1904–79) not only outlived the Gothic Revival but also modernism itself. 'A meteor from the eclipsed firmament of Gothic medievalism', ran John Summerson's poignant verdict.

(1901–2) was virtually unornamented and of almost archaic character, recalling those rude stone piles that served as churches on the fringes of Christian Europe, in Scandinavia or the Hebrides. He was deeply interested in the symbolic and poetic roots of architecture, and in these primitive sources he sought a vitality absent from the archaeological patternbook exercizes of the mature revival. All Saints was built of concrete, although Lethaby was deeply ambivalent about the new material and its poetic potential, and he clad its structure with rubble and timber.

This Arts and Crafts line of development and the more scholarly direction of Bodley and Cram met in the cathedral of Liverpool, the most important Gothic building of the twentieth century. The cathedral was begun in 1904 by Giles Gilbert Scott (the grandson of George Gilbert Scott), who won the competition at the age of twenty-four. He devoted his life to the building;

166, 167, 168 The plan of Johannes Otzen's Ringkirche in Wiesbaden, 1891, astonished the German profession. Otzen inscribed one square diagonally within another, placing four massive piers at their intersections. All aisles and lines of sight converged at the pulpit, which was placed behind the entrance so that it might be near the physical centre of the building rather than being thrust to one end. Otzen's plan brilliantly commingled late Gothic models, modern American auditorium plans and even such protestant Baroque churches such as the Frauenkirche in Dresden.

when he died in 1960 it was still not complete. So young was Scott that Bodley – a relative by marriage – was appointed to supervise the work and, presumably, keep an eye on Scott. Not until his death in 1907 did Scott win full control, after which he took the building onto increasingly abstract terrain. He learned to consolidate his Gothic elements, reducing their number and increasing their proportions to make a building of more massive character. Instead of a staccato multitude of bays, his nave consists of a very few immense ones, broadly proportioned and capacious. He flattened his roofline into near horizontality while eliminating the march of crocketed gables around its parapet. The effect was that of a marble statue that had been rolled down a flight of stairs, leaving only a mighty limbless torso – precisely the effect that Rodin advocated for sculpture during these same years.

The impact of Scott's design was electric. It is difficult to find an American or English church built in the 1920s that does not show his influence. In particular, his mark was felt in the way that architects designed, who increasingly composed in perspective, manipulating masses to produce sculptural effects, as if slicing into modelling clay. It was the greatest of ironies that this new-found sculptural sensibility was the consequence of the steel frame, which permitted a nearly limitless freedom in fashioning space.

The historicism of Scott, Cram and Bodley was not shared on the Continent, although the impulse toward spatial unity certainly was. This process seems to have affected most protestant denominations at the same time, picking up momentum in the 1870s. At that time protestant churches began to become more centralized in character, chancel and transepts moving into the body of the nave. Some of the liveliest spatial experiments occurred in the United States, where evangelical Protestantism, flexible wood construction and archaeological indifference all exerted equal force. The Methodist-Episcopal church developed an intriguing spatial type known as the Akron Plan, devised in order to separate children into separate classes for their Sunday School lessons but to bring them together rapidly for group song and worship. This suggested a semicircle of classrooms, fronted with sliding doors, arranged to face a central pulpit. Bruce Price devised the definitive form in his First Methodist Church in Wilkes-Barre, Pennsylvania (1875) which expressed it as the chevet of a French cathedral. The model was widely copied with growing freedom in plan, as wedge-shaped or triangular configurations of seats gathered about the pulpit.

In Germany the tendency toward spatial unification was given the force of church policy in 1891 with the design of the Ringkirche in Wiesbaden. This church was intended to serve as 166–6 model for protestant church-building, and to differentiate this as much as possible from Catholic churches. The competition programme instructed architects not to treat the church as the house of God 'in the Catholic sense'; instead it should be treated as a communal assembly room, whose 'unified, unpartitioned space emphasizes the unity of the congregation and the universality of priestliness'. Pulpit and altar were to be given equal architectural importance while spatial unity was to replace the customary division into aisles, nave and chancel. Johannes Otzen, a leader of the Hanover School and a professor of architecture in Berlin, met these terms with a bold and imaginative plan of overlapping squares, with three large galleries in the corners, which comprised the auditorium. This he fronted with a prodigious twin-towered westwork, a form with strong roots in early medieval Germany, and treated in a transitional style midway between Romanesque and Gothic. His church overturned the Eisenach Regulativ and its Ecclesiological tenets, ending the thirty-year stylistic truce between German Catholics and protestants.

Even as Otzen was building his church, the half-century of archaeological discipline that had been forced by Ecclesiologists in England, France and Germany was bursting apart. The spirit of the new century, the heady optimism of the 1890s when the turmoil of the Industrial Revolution seemed at last to have been vanquished and a new era of continual progress and prosperity seemed at hand, encouraged giddy experimentation in all the arts. This process of liberation can be seen in the spectacular unfinished cathedral of the Sagrada Familia in Barcelona, the 16 work of the Catalan architect Antonio Gaudí. In its lowest stages it shows the cautious work of an admirer of Viollet-le-Duc, but at each successive level the design grows freer and less historical. Gaudí's point of departure was the French architect's rationalism but he used the experimental analysis of loads and stresses as a method of structural improvisation – suspending weights from ropes to calculate the proper curve for his wildly soaring arches. In the highest zones of the towers, Gaudí's cathedral approaches a state of architectural ecstasy. Nowhere else in the course of the entire Gothic Revival were structural rationalism and religious rapture merged so effectively and seamlessly. It struck a clear high note, although even as this note was reached, the revival was sliding slowly and unstoppably to its end.

Chapter 8: Height

This was the Gothic Quest, and if we think of it as an historical episode, dead long since with chivalry and faith and the fear of God, we think foolishly.
Ralph Adams Cram, *The Gothic Quest*, 1907

A revolutionary movement cannot remain for long at the same state, and will be transformed as much by success as failure. The early Gothic Revival had the zeal of a militant movement, its champions burning with missionary fervour. In its prosperity the movement grew soft, and long before 1900 there was no one left to shock or outrage. This is not to say that the Gothic was no longer built; now came some of the largest and most original Gothic buildings ever raised, but these were no longer in the central channel of architectural development. They were stylistic orphans, although they continued to be built well into the 1950s. They were no longer part of a coherent Gothic Revival, however, but belonged to another wave of Gothic Survival.

In educational architecture the movement ended on the highest note. There the Gothic had had a distinguished career, having been in continuous use since the 1830s. Collegiate Gothic was first revived in England but quickly moved to America, where A. J. Davis designed New York University in 1833. After the Civil War came a torrent of Gothic campuses, many reshaping themselves in High Victorian garb, including Yale University and the University of Pennsylvania. English influence remained paramount, culminating in 1871 when William Burges himself designed a muscular French Gothic campus for Trinity College, Hartford.

Trinity was characterized by Victorian 'Go' but collegiate architecture soon after came to prefer a more scholarly and less restless Gothic. The finest arose in Philadelphia, where a strong local tradition of masonry construction offset the academicism that dried out so much of the bookish Gothic elsewhere. Beginning in the mid-1880s Walter Cope and John Stewardson developed a collegiate Gothic with a supreme sensitivity to site and materials. At Bryn Mawr they created a cloistered women's

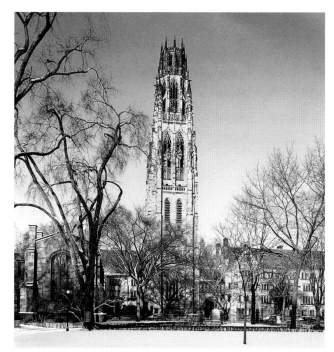

170 Yale University's Memorial Quadrangle (1917–21) shows how the collegiate Gothic had become a kind of free style by the early twentieth century, which could be manipulated abstractly to achieve great sculptural richness. Its architect was Yale alumnus James Gamble Rogers (1867–1947).

college in the Tudor style, expressed in the local mica schist rubble. For the University of Pennsylvania, in urban Philadelphia, the tone was more decorous, a festive mixture of Elizabethan and Jacobean motifs – Jacobethan, as it was humorously called – rendered in brick. Oxford and Cambridge provided the details for these buildings but their composition and siting had a different, more local source: the picturesquely landscaped parks of F. L. Olmsted. Cope and Stewardson arranged them in loose and informal fashion, the quadrangles gently yielding to the line of the landscape and trailing off into groves of trees. The buildings never extended too far before they jogged at a right angle, allowing them to terminate in a bright range of windows, frequently illuminating a broad staircase. At a time when the geometric discipline of the Beaux-Arts was dominating American architecture, the collegiate Gothic was the most conspicuous exception. Cope and Stewardson's national triumph came with the 1899 competition for Washington University in St Louis, where they defeated the country's most prominent classicists with their subtle Gothic scheme – a lovely sequence of spaces that began with a formally composed entrance and that progressively relaxed as it passed from classroom to residential buildings.

After the premature deaths of both Cope and Stewardson their work was developed further by Cram, Goodhue, & Ferguson and the Philadelphia partnership of Day & Klauder – all three of which contributed to the completion of Princeton University's campus. Cram was the principal planner and the strong sense of spatial poetry that distinguishes the campus is his achievement. He insisted that the organization of a university should not be instantly clear, as with the deadening axiality of the Beaux-Arts, but should reveal itself 'gradually, through narrowed and intensified vistas, the unforeseen openings out of unanticipated paths and quadrangles, the surprise of retirement, the revelation of the unexpected.' This Cram accomplished with a very restricted palette of materials, rough fieldstone walls with a sprinkling of crisp limestone trim in the Tudor drip labels, window mullions and the coping courses that capped the walls. His detail came from the end of the Middle Ages: crenellated parapets, ribbed brick chimneys and the occasional oriels that terminated a long horizontal range. Apart from this there was little explicit ornament – or pointed arches, for that matter. The Graduate College (1913–17) at Princeton is his finest academic design, culminating

171 Cope & Stewardson, Undergraduate Quadrangle, University of Pennsylvania, Philadelphia, 1895–. The University of Pennsylvania dormitories show Cope and Stewardson's genius at rendering a long flank in human scale, with a studied irregularity in the arrangement of bays and grouped windows, where each discrete residential unit is marked by a cluster of chimneys. A whimsical array of carved stone gargoyles enlivens the parapet, a rogue's gallery of dozing students and academic grotesques.

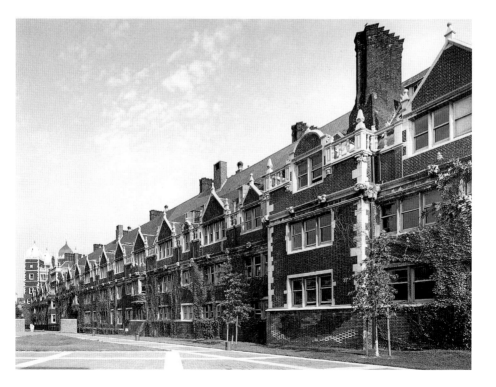

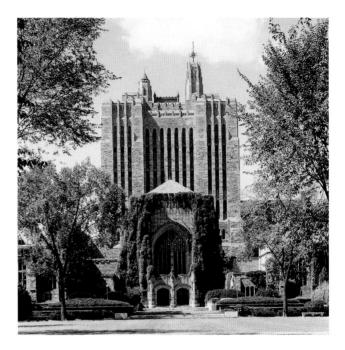

172 The blocky, severely rectilinear forms of Sterling Library, Yale University, 1926–31, is the product of the welded steel skeleton underneath. Within the modern engineering is a delightful play on a cathedral plan: a nave and aisles lead to the circulation desk, creating a processional path like the journey of a communicant to the altar. Behind this a mural fulfils the role of an altar painting.

in the common room which is crowned by one of the most sumptuous hammer-beam trusses of the entire revival.

Princeton was surpassed by Yale, however, where a crowded urban context compelled much bolder experimentation. In 1917 James Gamble Rogers was commissioned to design the Memorial Quadrangle, a residential complex for 630 students. *170* Confined to a large city block, with little opportunity for rambling composition, he was forced to manufacture his own picturesqueness. He first screened off his site by enclosing it with a range of dormitories, loosely composed and animated by an irregular play of gables and bays. Then he divided the interior into six courts of different scale, breaking down the vast complex into visually and socially comprehensible units. Finally, he placed Harkness Tower at one corner, a vertical exclamation that rose above the horizontal dormitories to give visual coherence to the whole. This tower was an imaginative paraphrase of St Botolph's, Boston, England, a Tudor Gothic oddity that had been ignored during the nineteenth century but which enjoyed a vogue during the 1920s.

Rogers also designed Yale's Sterling Library, a revolutionary design that placed sixteen levels of book stacks in a Gothic tower. This deviated sharply from the conventional classical library

type, in which the pristine clarity of regular geometry embodied classical learning. Instead Rogers used the restless and aspiring forms of Gothic architecture to portray knowledge as an active and growing process, not a finite corpus. At the University of Pittsburgh, which had an even more constrained site, this idea was made more explicit. There Day & Klauder built the Cathedral of Learning, a forty-two-storey skyscraper whose towered form – its lines parallel and hence never meeting – was explicitly invoked as a metaphor for the unending nature of learning.

173 The Cathedral of Learning, University of Pittsburgh, built by Charles Z. Klauder in 1926–37, is one of the few Gothic Revival buildings to match the height of the highest medieval cathedrals. Rising to a height of 535 feet (163 metres), it narrowly surpasses the 526-foot (160 metres) spire of Ulm Cathedral.

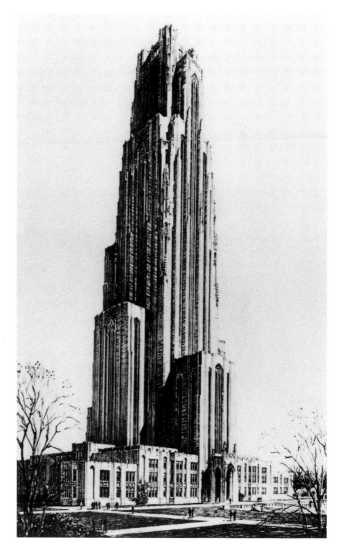

The work of Rogers and Klauder breathed a different spirit, from the poetic archaeology of Ralph Adams Cram. They were now working routinely with steel and had less call to look at actual medieval churches for their lessons. For them, as for Walpole and Wyatt in the eighteenth century, medieval architecture was interesting chiefly for its ornamental forms. In fact, the Gothic Revival was everywhere in headlong retreat during the early twentieth century. Cram and Klauder prospered only because they concentrated on building types which were fundamentally medieval in character and function: the church and the college. So long as a chapel, common room and refectory served as they did in the time of Henry VII, the Gothic presented no incongruity. In one instance, however, it was called upon to address a new architectural problem, that of the tall building. This was a task that modern French classicism, with its essentially horizontal character, could not fulfil. To be sure, a skyscraper could be decked out in the trappings of Roman or Renaissance ornament but these could not easily express the fundamental nature of a tall steel-framed building, nor could most historical styles. Only the thin-membered elements of Gothic architecture – its repertoire of finials, pinnacles, tracery and buttresses – naturally lent themselves to cladding the piers and spandrels of a steel cage. This was the background to the Woolworth Building, the greatest of the Gothic skyscrapers.

The building was the unlikely collaboration of F. W. Woolworth and his architect Cass Gilbert, a Beaux-Arts classicist otherwise known for his sober civic buildings. Woolworth, the founder of the colossal Woolworth corporation, had discovered Gothic architecture during a recent voyage to Europe and, although not a learned man, he understood marketing and advertising. He recognized the overwhelming visual impact of a Gothic tower at the lower end of Manhattan, looming over its neighbours like a lord over his vassals, and insisted that his new corporate headquarters be Gothic and, almost as an afterthought, that it be the tallest building in the world. Gilbert's contribution was to model his building on the late Gothic architecture of Belgium, particularly the Hall of the Cloth Merchants at Ypres. It was an inspired choice: its frothy ornamental forms were splendidly suited to casting in terra cotta, enlivening the prim skeleton of the building with a sprightly incrustation even as it expressed its unimpeded vertical lift. The choice was logical in a deeper sense, drawing a connection to another profoundly mercantile society which likewise took pride in celebrating com-

174 Woolworth Building, New York, built 1913–17 by Cass Gilbert. Woolworth's headquarters occupied only a small portion of his building, the rest of which was a speculative office building. Such buildings, crammed with as much rental space as possible, are often ungainly boxes, but Gilbert cleverly composed his masses to imply that its tower began at the very sidewalk and soared without interruption to a height of 792 feet (241 metres). While the building is essentially a massive four-square block, Gilbert succeeded in giving it the character of a sleek and tapered tower.

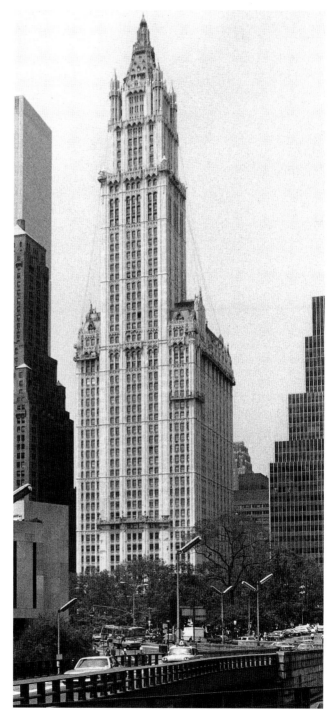

175 Lyonel Feininger's Cathedral of the Future, the mystic emblem that commemorated the formation of the Bauhaus, marks the passing of the baton from the Gothic Revival to Modernism. The Bauhaus inherited Gothic structural honesty, planning freedom and a concern for the cooperative nature of labour. Otherwise they discarded specific stylistic references and the Christian component of the Gothic Revival, favouring the mysticism suggested by the radiant forms of Feininger's woodcut.

merce in architecture. This sense of inevitability was irresistible, prompting a spate of similar Gothic towers, most notably John Howells and Raymond Hood's 1922 design for the *Chicago Tribune* Tower, Chicago.

In this secular architecture little explicit Christian imagery remained. The identification of Gothic architecture with Christianity, so assiduously and lovingly championed by Pugin, had dissolved, leaving only a residue of vapid spiritual associations which lingered in such names as the 'Cathedral of Commerce' or the 'Cathedral of Learning'. The First World War did much to shatter the cultural foundations on which the Gothic Revival rested. After all, the Revival had been an attempt to restore the historical continuity of Europe, which had been frayed by the Industrial Revolution and still earlier by the religious struggles of the Reformation. But the war did great damage to belief in the essential goodness of European culture and tradition, and the rapid success of architectural modernism in the 1920s was in part made possible by its claims to be radically emancipated from the tyranny of history.

Nonetheless, the most self-conscious and influential modernist institution, the Bauhaus, was itself an outgrowth of the Gothic Revival. Not only was its cooperative and guild-like organization based on that promulgated by William Morris but even its name derived from the Gothic Revival, as its founder Walter Gropius admitted. Bauhaus was a play on *Bauhütte*, or building lodge, referring to the many cathedral building lodges established in the wake of the building of Cologne Cathedral. To acknowledge this connection to the Gothic Revival – if only to its democratic character and emphasis on workmanship, not to its Christian associations – Lyonel Feininger drew a cathedral of the future for the first Bauhaus programme, an Expressionist reverie of jagged angles and lines. Bruno Taut made contemporary designs for a crystalline cathedral in the same spirit, reviving the mysticism that was so important to the German Gothic Revival.

Taut's mystic vision found its apotheosis in the work of Dominikus Böhm (1880–1955), the last great architect of the Gothic Revival. Böhm was a pupil of the early modernist Theodor Fischer as well as a devout Catholic, and his entire career was spent working to reconcile tradition with modernity. His inspiration was the spatial richness of the Late Gothic, where the measured rhythm of serried bays and the all-subsuming impulse of interpenetrating vaults co-existed in perpetual and living tension. This Böhm rendered in concrete. His church of

176, 177 Church of Christkönig at Bischofsheim, near Mainz, 1924–26, by Dominkus Böhm. Many of the liturgical changes mandated by the celebrated Vatican Two conference were prefigured by developments in German Catholic theology in the early twentieth century. Böhm's spatially unified churches sought to unite sanctuary and nave but rejected the central plan, deliberately maintaining a longitudinal character to stress the incremental approach to Christ.

178 Church of St John the Baptist, Neu-Ulm (1921–26), built as a memorial to the soldiers of the First World War, launched the career of Dominikus Böhm. As in all of his churches, the spatial solution and structural system were conceived concurrently. Instead, the basic shape was traced by the reinforcing rods, which were covered with wire mesh and then a brick layering onto which the stucco was attached. Only then was the concrete poured, requiring no formwork. The tonal effect of the interior is remarkable, graded from jet black to the pure white around the altar.

179 Grundtvig Church, Copenhagen, 1920–40, by P. V. Jensen-Klimt. This was the most astonishing of Expressionist Gothic in Scandinavia, where the style always had a strong relation to the local architectural heritage – expressed here in the blocky brick massing and the agitated step gables.

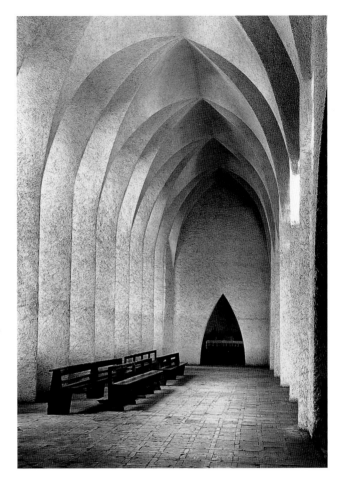

Christkönig at Bischofsheim, near Mainz, consists of a single 176-77 mighty parabola which is relieved by delicate transverse arches, forming a spatial honeycomb of great intricacy in the side aisles . Such work can be called Expressionist and indeed Böhm's faceted shadowy forms have much in common with Expressionist German cinema. But they also show a sense of exaltation and ecstasy which had been an element of the German Gothic since Goethe's day. With Böhm (and his contemporaries Fritz Höger and Hans Poelzig) the German revival ended as it began, in a release of those mystical and irrational elements that nineteenth-century rational Goths had sought to discipline through geometry, archaeology and structural rationalism.

The architectural Expressionism of Böhm had counterparts through northern Europe and Scandinavia, such as P. V. Jensen-

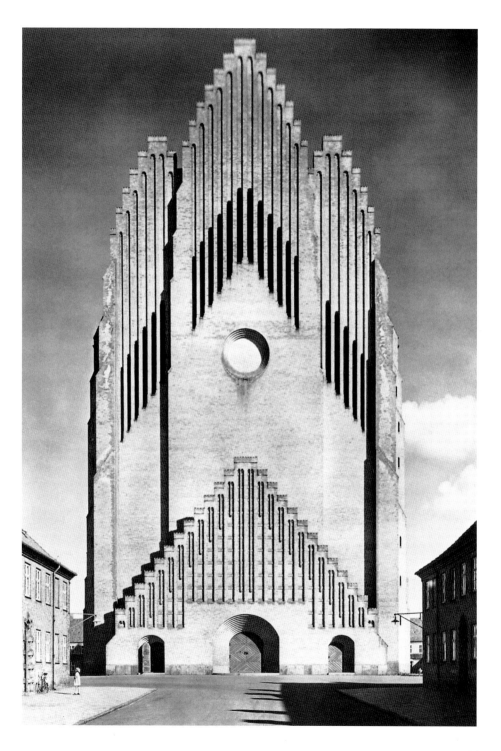

Klimt's ecstatic Grundtvig Church in Copenhagen, begun in 1920. To a lesser extent, Gothic forms were sublimated in the American Art Deco, as in the abstract Gothic helm atop the Chrysler Building (1930). But the dislocations of the next two decades, the Depression and the Second World War, completed the process of discrediting the historical styles and of enshrining architectural modernism. During the second half of the twentieth century, Gothic architecture slowed to a trickle, leaving the style just where it was in the late seventeenth century.

During the 1970s and 1980s, postmodernist architecture brought about a return to the historical styles, but the Gothic was exempted from the general pardon. While classical columns, arches and pediments were widely reproduced there was no corresponding enthusiasm for buttresses, pointed arches and turrets. The few examples are so rare as to be remarkable. The reasons for this are not hard to find. The Gothic Revival had so indelibly attached explicitly Christian associations to the style that it was difficult to use for the frivolous commercial applications that carried the postmodernist style. Likewise, postmodernism depended for its meaning on the ironic manipulation of a rigid grammar of forms. Classical architecture possessed such a grammar but Gothic architecture, with its infinitely pliable forms, did not.

In many of its battles, the Gothic Revival has succeeded. Without its functional critique of structure and planning, and without its assessment of the relationship between architecture and society, architectural modernism would not have been possible. The early modernists, such as Walter Gropius, Le Corbusier and Frank Lloyd Wright, took its liberating doctrines, discarded the ornament, archaeology and religious thought, and left the movement with nothing to fight for. If the Gothic is to emerge again, it will require cultural and social shifts that run deeper than stylistic fads.

180 Robert Venturi's 'Gothic' design in his Eclectic House series is one of the few postmodern designs in the Gothic style.

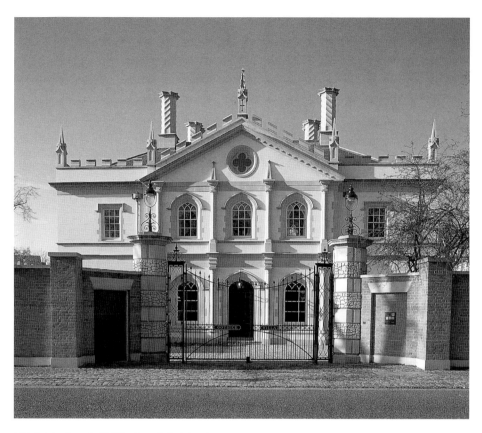

181 Quinlan Terry, Gothic Villa, Regent's Park, London,
1991. Terry recognized that postmodern eclecticism was not
too far removed from eighteenth-century historicism, where
cut-out ornament in the period styles was simply applied to
Palladian boxes. Built during the height of postmodernism,
Terry's Gothic Villa is a crenellated and symmetrical jewelbox
in the Batty Langley spirit, bringing the Gothic Revival back to
its lighthearted origins.

Select Bibliography

General Accounts

Aldrich, Megan, *Gothic Revival*, London, 1994

Block, Jean F., *The Uses of Gothic: Building the University of Chicago*, Chicago, 1983

Brooks, Chris, *The Gothic Revival*, London, 2000

Clark, Kenneth, *The Gothic Revival*, New York, 1962

Clarke, Basil F. L., *Anglican Cathedrals outside the British Isles*, London, 1958

——, *Church Builders of the Nineteenth Century*, Newton Abbott, 1969

Crinson, Mark, *Empire building: Orientalism and Victorian Architecture*, London and New York, 1996

Crook, J. Mordaunt, *The Dilemma of Style*, Chicago, 1987

Davis, Terence, *The Gothick Taste*, Newton Davis and London, 1974

De Maeyer, Jan, and Luc Verpoest, *Gothic Revival (Proceedings of the Leuven Colloquium, 1997)*, Leuven, 2000

Dixon, Roger, and Stefan Muthesius, *Victorian Architecture*, London, 1978

Eastlake, Charles L., *A History of the Gothic Revival*, Leicester, 1970

Fawcett, Jane (ed.), *Seven Victorian Architects*, London, 1976

Ferriday, Peter (ed.), *Victorian Architecture*, London, 1963

Frankl, Paul, *The Gothic. Literary Sources and Interpretations through Eight Centuries*, Princeton, 1960

Fusco, Renato de, *L'Architettura del Ottocento*, Turin, 1980

Germann, Georg, *Gothic Revival in Europe and Britain: Sources, Influences and Ideas*, Cambridge MA, 1973

Goodhart-Rendel, H. S., *English Architecture Since the Regency*, London, 1953

Hersey, George L., *High Victorian Gothic. A Study in Associationism*, Baltimore and London, 1972

Hitchcock, Henry-Russell, *Early Victorian Architecture in Britain*, 2 vols, London, 1954

Kalman, Harold, *A History of Canadian Architecture*, vol. 2, Toronto and Oxford, 1994

Kerr, Joan, and James Broadbent, *Gothick Taste in the Colony of New South Wales*, Sydney, 1980

Kokkelink, Günther and Monika Lemke-Kokkelink, *Baukunst in Norddeutschland: Architektur und Kunsthandwerk der Hannoverschen Schule 1850–1900*, Hanover, 1998

Lemoine, B., *Architecture in France 1800–1900*, New York, 1998

Lewis, Michael J., *The Politics of the German Gothic Revival*, Cambridge MA, 1993

Loth, Calder, and J. T. Sadler, *The Only Proper Style. Gothic*

Architecture in America, New York and Boston, 1975

Macaulay, James, *The Gothic Revival 1745–1845*, Glasgow and London, 1975

McCarthy, Michael, *The Origins of the Gothic Revival*, New Haven and London, 1987

Meeks, Carroll L. V., *Italian Architecture, 1750–1914*, New Haven, 1966

Mignot, Claude, *Architecture of the Nineteenth Century in Europe*, New York, 1984

Muthesius, Stefan, *The High Victorian Movement in Architecture 1850–1870*, London, 1972

————, *Das englische Vorbild*, Munich, 1974

Orbach, Julian, *Victorian Architecture in Britain*, London and New York, 1987

Pierson, William H., *American Buildings and their Architects, Technology and the Picturesque. The Corporate and Early Gothic Styles*, New York, 1978

Pevsner, Nikolaus, *Ruskin and Viollet-le-Duc: Englishness and Frenchness in the Appreciation of Gothic Architecture*, London, 1969

————, *Some Architectural Writers of the Nineteenth Century*, Oxford, 1972

Port, M. H., *Six Hundred New Churches. A Study of the Church Building Commission, 1815–56*, London, 1961

————, ed. *The Houses of Parliament*, London, New Haven, 1976

Robson-Scott, M. D., *The Literary Background of the Gothic Revival in Germany*, Oxford, 1965

Stanton, Phoebe, *The Gothic Revival and American Architecture, an Episode in Taste, 1840–1856*, Baltimore, 1968

Summerson, John, *Victorian Architecture. Four Studies in Evaluation*, New York and London, 1970

Van Cleven, Jean, *Neogotick in België*, Ghent, 1994

Viollet-le-Duc, Eugène Emmanuel, M. F. Hearn (ed.), *The Architectural Theory of Viollet-le-Duc*, Cambridge MA, 1990

White, James F., *The Cambridge Movement*, Cambridge, 1962

Yanni, Carla, *Nature's museums: Victorian science and the architecture of display*, Baltimore MD, 1999

On individual architects

CHARLES BARRY

Barry, Alfred, *The Life and Works of Sir Charles Barry*, reprinted New York 1972

EDMUND THOMAS BLACKET

Kerr, Joan, *Edmund Thomas Blacket*, Sydney, 1983

DOMINIKUS BÖHM
Hoff, August, Herbert Muck and Raimund Thoma, *Dominikus Böhm*, Munich and Zurich, 1962
THEODOR BÜLAU
Maurer, Anna-Kristin, *Theodor Bülau*, Hamburg, 1987
WILLIAM BURGES
Crook, J. Mordaunt, *William Burges and the High Victorian Dream*, London, 1981
WILLIAM BUTTERFIELD
Thompson, Paul, *William Butterfield*, London, 1971
ALEXIS DE CHÂTEAUNEUF
Klemm, David and Hartmut Frank, *Alexis de Châteauneuf 1799–1853. Architekt in Hamburg, London und Oslo*, Hamburg, 2000
SIR NINIAN COMPER
Symondson, Anthony, *Sir Ninian Comper, the last Gothic Revivalist*, London, 1988
LEWIS NOCKALLS COTTINGHAM
Myles, Janet, *L. N. Cottingham 1787–1847, Architect of the Gothic Revival*, London, 1996
CRAM, RALPH ADAMS
Cram, Ralph Adams, *My Life in Architecture*, Boston, 1936
P. J. H. CUYPERS
Cuypers, P. J. H., *Het Werk van Dr. P. J. H. Cuypers*, Amsterdam, 1917
ALEXANDER JACKSON DAVIS
Peck, Amelia (ed.), *Alexander Jackson Davis*, New York, 1992
DEANE AND WOODWARD
Blau, Eve, *Ruskinian Gothic. The Architecture of Deane and Woodward*, Princeton, 1982
O'Dwyer, Frederick, *The Architecture of Deane and Woodward*, Cork, 1997
FRANK FURNESS
Lewis, Michael J., *Frank Furness: Architecture and the Violent Mind*, New York, 2001
O'Gorman, James F., *The Architecture of Frank Furness*, Philadelphia, 1973
Thomas, George E., Jeffrey A. Cohen, and Michael J. Lewis, *Frank Furness: The Complete Works*, Princeton, 1991
ANTONI GAUDÍ
Bergós, Joan Massó, *Gaudí: the man and his work*, Boston, 1999
E.W. GODWIN
Soros, Susan Weber (ed.), *E. W. Godwin*, New Haven and London, 1999

WILLIAM KENT
Wilson, Michael, *William Kent. Architect, Designer, Painter and Gardener, 1685–1748*, London, 1984
JOHANN CLAUDIUS VON LASSAULX
Schwieger, Frank. *Johann Claudius von Lassaulx 1781–1848. Architekt und Denkmalpfleger in Koblenz*, Neuss, 1968
JEAN-BAPTISTE LASSUS
Leniaud, Jean-Michel, *Jean-Baptiste Lassus ou le temps retrouvé des cathédrals*, Geneva, 1980
FRIEDRICH VON LEINS
Seng Eva-Maria. *Der evangelische Kirchenbau im 19 Jahrhundert. Die Eisenacher Bewegung und der Architekt Friedrich von Leins*, Tübingen, 1995
J. J. MCCARTHY
Sheehy, Jeanne, *J. J. McCarthy and the Gothic Revival in Ireland*, Belfast, 1977
JOHN NASH
Summerson, John, *The Life and Work of John Nash, Architect*, London, 1980
JOHANNES OTZEN
Bahns, Jörn, *Johannes Otzen 1839–1911*, Munich, 1971
JOHN LOUGHBOROUGH PEARSON
Quiney, Anthony, *John Loughborough Pearson*, New Haven and London, 1979
A. W. N. PUGIN
Atterbury, Paul, ed. *A. W. N. Pugin. Master of Gothic Revival*, New Haven and London, 1995
———, and Clive Wainwright (eds), *Pugin: A Gothic Passion*, London, 1994
Stanton, Phoebe B., *Pugin*, London, 1971
Wedgwood, Alexandra, *A. W. N. Pugin and the Pugin Family*, London, 1985
HUMPHRY REPTON
Daniels, Stephen, *Humphry Repton*, New Haven, 1999
JAMES GAMBLE ROGERS
Betsky, Aaron, *James Gamble Rogers*, Cambridge MA, 1994
ANTHONY SALVIN
Allibone, Jill, *Anthony Salvin, Pioneer of Gothic Revival Architecture*, Cambridge, 1988
FRIEDRICH VON SCHMIDT
Planner-Steiner, Ulrike, *Friedrich von Schmidt*, Wiesbaden, 1978
GEORGE GILBERT SCOTT
Cole, David, *The Work of George Gilbert Scott*, London, 1980

Scott, George Gilbert, *Personal and Professional Recollections*, reprinted Stamford, 1995

RICHARD NORMAN SHAW

Saint, Andrew, *Richard Norman Shaw*, New Haven and London, 1976

VINCENZ STATZ

Vogts, Hans, *Vincenz Statz, 1819–1898*, Mönchengladbach, 1960

GEORGE EDMUND STREET

Brownlee, David B., *The Law Courts: the Architecture of George Edmund Street*, Cambridge MA and London, 1984

Street, Arthur Edmund, *Memoir of George Edmund Street*, reprinted New York, 1972

GEORG GOTTLOB UNGEWITTER

David-Sirocko, Karen, *Georg Gottlob Ungewitter und die malerische Neugotik: in Hessen, Hamburg, Hannover und Leipzig*, Petersberg, 1997

RICHARD UPJOHN

Upjohn, Everard M., *Richard Upjohn*, New York, 1968

LÉON VAUDOYER

Bergdoll, Barry, *Léon Vaudoyer. Historicism in the Age of Industry*, Cambridge MA and London, 1994

CALVERT VAUX

Kowsky, Frank, *Country, Park, and City: The Architecture and Life of Calvert Vaux*, New York, 1998

EUGÈNE EMMANUEL VIOLLET-LE-DUC

Auzas, Pierre Marie, *Eugène Viollet-le-Duc, 1814–1879*, Paris, 1979

Foucart, Bruno (ed.), *Viollet-le-Duc*, Paris, 1980

HORACE WALPOLE

Lewis, W. S., *Horace Walpole*, New York, 1961

ALFRED WATERHOUSE

Cunningham, Colin, *Alfred Waterhouse*, London, 1974

P. B. WIGHT

Landau, Sarah B., *P. B. Wight: Architect, Contractor and Critic, 1938–1925*, Chicago, 1981

FREDERICK CLARKE WITHERS

Kowsky, Frank, *The architecture of Frederick Clarke Withers*, Middletown CT, 1980

JAMES WYATT

Dale, Anthony, *James Wyatt, Architect 1746–1813*, Oxford, 1936

Fothergill, Brian, *Beckford of Fonthill*, London, 1979

SIR JEFFREY WYATTVILLE

Lindstrum, Derek, *Sir Jeffrey Wyattville, Architect to the King*, Oxford, 1972

List of Illustrations

Index

Page numbers in *italic* refer to illustrations